P9-BYD-355

Arapaho Journeys

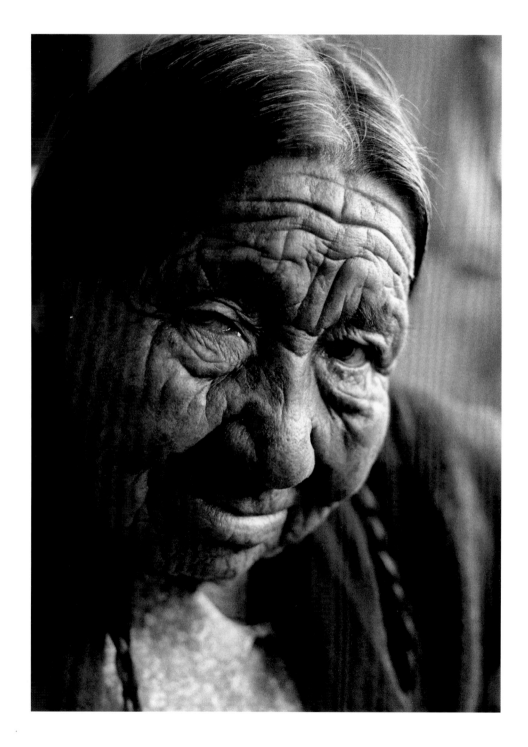

Arapaho Journeys

Photographs and Stories
from the Wind River Reservation

By **Sara Wiles**

Foreword by **Frances Merle Haas**

University of Oklahoma Press | Norman

Frontispiece: **Myra Dorothy Brown, 1979.**

This book is published with the generous assistance of the following programs and organizations:

Northern Arapaho Tribe and the Wind River Casino

Wyoming Cultural Trust, a program of the Department of State Parks and Cultural Resources

Plains Indian Museum of the Buffalo Bill Historical Center

Wyoming Humanities Council

Library of Congress Cataloging-in-Publication Data

Wiles, Sara, 1948–

 Arapaho journeys : photographs and stories from the Wind River Reservation / by Sara Wiles ; foreword by Frances Merle Haas.

 p. cm.

 Includes bibliographical references and index.

 ISBN 978-0-8061-4158-9 (hardcover : alk. paper)

 1. Arapaho Indians. 2. Wind River Indian Reservation (Wyo.) I. Title.

 E99.A7W55 2011

 978.7'6300497354—dc22

 2010037410

Copyright © 2011 by the University of Oklahoma Press, Norman, Publishing Division of the University. Manufactured in the U.S.A.

1 2 3 4 5 6 7 8 9 10

Dedicated to Gladys Goggles Moss, 1934–2009

My sister, friend, mentor, and protector

who led me gently into the Arapaho world

and made me comfortable there

Contents

Foreword

In Sara Wiles's photographs of the Wind River Arapahos, one can see the good and the humbleness in the way the people are photographed in their homes and at social events in the community. If you view the photos as looking through a window, you can see the beauty of the people, the love, the joy and laughter, the uniqueness that is not visible when passing these same people on the street.

Silence among the Arapahos was a time of reflection and prayer. Power could be obtained by listening and observing the natural world. Power is knowledge, and the Arapahos understood that through silence, their worldview was made clearer. Silence was also a sign of respect. Sara has been able to capture the meaning of silence through the images of the elders.

Storytelling among the Northern Arapahos has been a means of preserving past oral histories, customs, and the language. All of Sara's pictures have a story to tell. The picture of my grandmother Inez Oldman praying, with my mother (Frances C'Hair) and LaVerne Brown beside her, reminds me of what Inez told me about the nighttime. Sometimes I found her alone in her home at night, and I would ask her, "Grandma, aren't you scared to be alone at night?" because she was alone and blind and old. But she said the night is just like the day except that it is dark. The Creator made different animals to watch over the land in the nighttime as He did for the day. For us, He gave the night to us for rest and prayer. This picture when she's praying, that's what it reminds me of.

Ni'iihi', "in a good way," is a strong value among the Arapahos that reflects the past when the earth was yet untouched by modern influences and the people lived in accordance with the laws of protecting and caring for the earth. *Ni'iihi'* also refers to "in a sacred way." Sacredness can be seen in the picture of the Sand Creek Runners. The symbol of the circle on the banner symbolizes many things in the Arapaho world. It can represent how the birds make their nest, the drum, and life itself, which begins with a small baby that becomes a child, then an adult, and then becomes old. My grandmother Inez told me that when a person reaches old age they go back to being like a baby. If you look at an old person who is going back to looking like a baby, without much hair, dependent on others, that person is completing the circle of life. The cross in the middle of the circle represents the four directions of mother earth, the four seasons, and the four stages of life. The runners represent honor, bravery, and generosity.

Sara's acceptance of the people's lifestyle and customs has gained her the respect of many on the Wind River Reservation. She has been invited to participate in family celebrations such as Indian

name-giving ceremonies and birthdays, and many times she is asked to photograph these events. She has also witnessed the sorrow felt by the Arapaho people and has stood by families yet respects their privacy during these times.

Sara was adopted as a daughter by traditional Arapaho elder Frances C'Hair and was given an Arapaho name by traditional elder Ralph Grasshopper. Her name, Hono'usei, means Sky Woman. For the past thirty-five years, Sara has camped out with her Arapaho family at the annual ceremonial Sun Dance. She helps with cooking, but that is one time she doesn't have her camera with her.

Sara has learned to love the Arapaho people and has laughed, applauded, honored, and wept tears with them. She has been able to portray many of these feelings with her pictures.

I am honored to know her.

Frances Merle Haas

Preface and Acknowledgments

The Hinono'eino'—known today as the Arapahos—are an Indian tribe that for hundreds of years lived on the high plains and in the mountains of what later became Colorado and surrounding states. They were nomadic hunters and traders, living in many bands scattered throughout their large territory, speaking dialects of Hinono'eitiit—the Arapaho language. Forced out of Colorado Territory in the years following the 1864 Sand Creek Massacre, the Northern Arapaho bands were attacked, harassed, and chased around the northern plains for the next fourteen years. In 1878, they were placed "temporarily" on the Shoshone reservation in central Wyoming. They established their camps along the Wind River and Little Wind River, to the east of the Shoshone villages, and began the painful process of adapting to a very different way of life.

Almost a hundred years later, I too came to that same reservation in central Wyoming, now known as the Wind River Indian Reservation. In 1973, I took a job as a social worker, a job I was to hold for four years. During that time, I began learning about the culture and history of the Arapaho people and eventually completed a master's thesis in anthropology based on my experience as a social worker.

I also started taking photographs, first to document social service programs and later as a way of expressing my intense fascination with Arapaho people and their lives. I started slowly and from scratch, working primarily in black and white, teaching myself the photographic process. I used only the simplest equipment—two Canon thirty-five millimeter cameras with a couple of lenses (and later a Pentex medium-format camera with one lens)—and photographed only in natural light. I used two kinds of standard Kodak film, basic Kodak chemicals in which to develop them, and an old enlarger bought at a garage sale.

In 2004, after more than thirty years of photographic work on the Wind River Reservation, I started writing what Arapaho people refer to as "stories" to accompany the photographs. To do things in a good way—ni'iihi'—I needed to involve Arapaho individuals, families, and organizations in each stage of the process, from the selection of the photographs to the writing of their stories. After one or more interviews, I would review what I had written with the people I had interviewed. Often, they would correct or change wording, make suggestions, and speak or write out statements they wished to have included. Choosing not to insert myself into their stories, I avoided the use of first person in their narratives, allowing the people tell their stories in their own way, in their own voices.

Written between 2004 and 2008, this book was born when threads of experience and

information converged—when over thirty years of photographic work on the Wind River Reservation combined with personal observation, when individuals' stories encountered information from sources such as ethnographies, newspaper and magazine articles, and official documents.

This book is not a definitive account of Arapahos and their world, historic or contemporary. It is instead a mosaic ethnography that touches upon some histories, traditions, revitalization efforts, and the lives of a few individuals. I have divided it into three sections, paralleling my growth both as a photographer and as an adopted member of the Arapaho community. The first section, "1975–1989," represents the early years when I photographed people I knew well and had worked with, mostly members of my extended Arapaho family, and events I attended with them. The second part, "1990–1996," represents more time spent photographing at Ethete, working primarily through the Ethete Senior Center and expanding my circle of acquaintances and knowledge of that community. A few events and individuals from other communities are seen here as well. The third section, "1997–2005," represents a conscious effort to work in a documentary way, to photograph a more representative range of people and activities. My photographic efforts during this time expanded to include younger people and more people from the community of Arapahoe. I examined traditions such as beadwork, hand games, ranching, and horsemanship; during trips to Colorado, I also documented the return of Arapaho people to the site of the Sand Creek Massacre and their ancestral homeland in the area around Boulder, Denver, and Rocky Mountain National Park.

During my years of studying and photographing Arapaho people and their communities, support and encouragement arrived from all directions. Since 1975, when I started writing my master's thesis, the Northern Arapaho Business Council (NABC), the tribal governing body, has always encouraged me to do more, and that has made everything else possible. The NABC oversees a relatively new business, the Wind River Casino, one of whose missions is to promote knowledge of Arapaho culture and history through their Arapaho Experience programs and exhibits, as well as the publication of this book. The Wind River Tribal College, founded and funded by the Northern Arapaho Tribe, has shown continued support as well; any proceeds from this book will be donated to them.

The Plains Indian Museum of the Buffalo Bill Historical Center in Cody, Wyoming, mounted an exhibit of my Arapaho photographs, *Ni'iihi'—In a Good Way*, in 1997. *Ni'iihi'* was exhibited at the Buffalo Bill Historical Center for almost a year and then traveled to over twenty venues, large and small, in Wyoming and other states. The magician and friend who developed the exhibit is Emma Hansen, curator of the Plains Indian Museum at the Buffalo Bill Historical Center. The Buffalo Bill Historical Center is also a cosponsor of this book, as well as of a new exhibit of my photographs

entitled *Arapaho Journeys* that will coincide with this book's publication.

The Wyoming Cultural Trust, a program of the Department of Wyoming State Parks and Cultural Resources, has generously provided grant money that partially funds the publication of this book in addition to the *Arapaho Journeys* exhibit.

Since the 1980s, the Wyoming Humanities Council (formerly the Wyoming Council for the Humanities) has supported me with grants, employment, networking, and friendship. The WHC was a primary sponsor of the *Ni'iihi'* exhibit and another grant that helped me complete portions of this book. I would like to give special thanks to current director Marcia Britton, former director Robert Young, and their knowledgeable and efficient staff.

In my study of the Arapaho language, members of the Arapaho Language and Culture Commission have led the way, especially Alonzo Moss, Sr., and William J. C'Hair. Other Arapaho language teachers, including Richard Moss and Wayne C'Hair, encouraged me to attend and participate in their classes. Linguist Andrew Cowell of the University of Colorado–Boulder has provided in-depth knowledge of the Arapaho language and other aspects of Arapaho culture and has been a constant helper in the crafting of the stories in this book. Both he and Alonzo Moss, Sr., have helped me understand nuanced meanings of Arapaho words and have standardized the Arapaho spelling found in this book.

I have chosen to write Arapaho words using an alphabet first developed by linguist Zednek Salzmann in the 1940s. Despite being controversial, it is the mostly widely used orthography (writing system) among both linguists and school programs on the reservation. A discussion of the use of this alphabet and a pronunciation guide is provided in the section of this book titled "The Arapaho Language." Two symbols—an apostrophe (') for a glottal stop (stoppage of breath) and a 3 for the "th" sound—are the most obvious differences from the English alphabet, though other consonant and vowel sounds are unique to Arapaho.

Many Arapaho individuals and families have been sources of friendship and information. Those who contributed to the stories in this book are mentioned in the notes section, but there are many others to be thanked: first, the large extended family of Gladys and Alonzo Moss, Sr., who have fed me more times than I can count and whose guidance and friendship provided the basis for my knowledge of Arapaho life; elder Helen Cedartree, who died in 2009, gave me insight into a traditional Arapaho world I could only imagine; Yellow Calf Memorial Club members, especially president Marion Scott, allowed me to participate, photograph, record, and ask questions about the club's history; the Soldier Wolf family has allowed me to photograph family-sponsored events on

several occasions. Many other families—the Thunders, Goggles, Browns, Grosbecks, Ridgelys, Willows, C'Hairs, and Wallowing Bulls, to name only a few—have also allowed me into their lives and helped with all of my various projects.

Historians and anthropologists whose decades worth of writings and personal conversations have allowed me to expand my knowledge and understanding of Arapaho and Shoshone history and culture include Loretta Fowler, Jeffery Anderson, Thomas Johnson, Steve Greymorning, and Brian Hosmer. Joanna Scherer of the Smithsonian Institution has been giving me good advice on how to improve my photographs and photographic essays since the 1980s. Most important, Raymond DeMallie of the American Indian Studies Institute at Indiana University, who was my master's thesis advisor way back in the 1970s, has been a constant source of information, support, and friendship.

Wyoming Public Television's documentary *The Photography of Sara Wiles* (produced and directed by my longtime friend, neighbor, and intellectual mentor Geoff O'Gara) has created new viewers of my work and opened new doors that led to the publication of this book.

Thanks also to new friends, editors, and designers at the University of Oklahoma Press, who patiently created this book from the raw materials I sent them: Alessandra Tamulevich, Emily Jerman, Emmy Ezzell, Julie Rushing, Tony Roberts, and freelance copyeditor Sally Bennett.

On a purely personal level, I wish to thank my family and friends in Wyoming and across the country who helped keep me sane during tough times—with talks, walks, dinners, and sympathy. My husband, Steve, has shared every day of our lives at Wind River with insight, curiosity, and patience. Our children, Jessica and Briant (who knew more about Arapaho life at a young age than I will ever know), have gracefully endured their mother's obsessions.

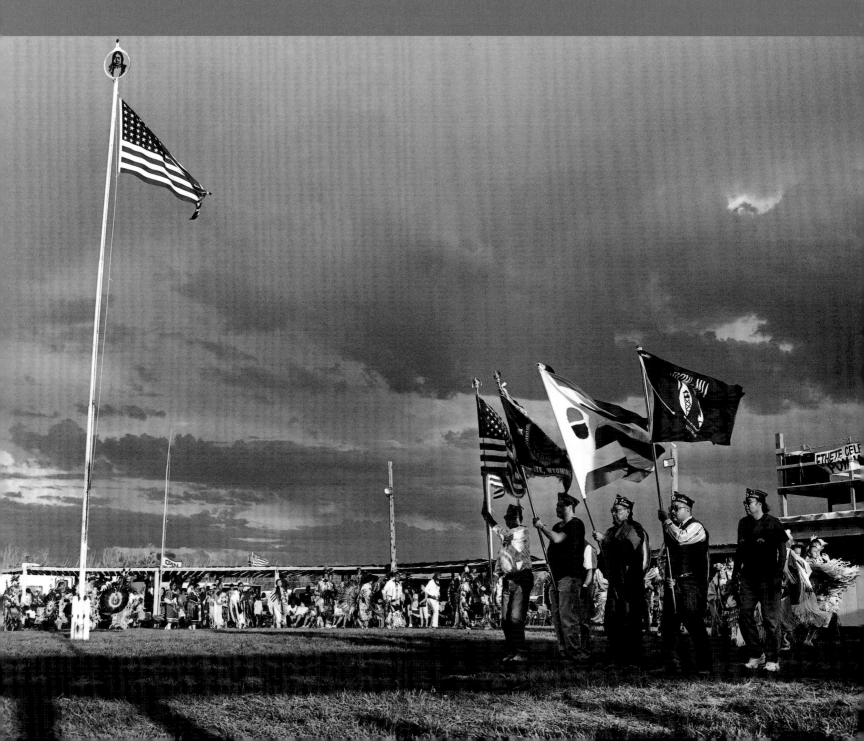

The People Hinono'eino'

They called themselves Hinono'eino', a name whose origin and meaning is uncertain. Some Hinono'eino' say it means "wandering people"; others say it means "sky people" or "wrong root people." Neighboring tribes referred to them in various ways, including Traders, Many Tattoos, Blue Beads People, Blue Sky People, and Cloud People. The name "Arapaho" came from the language of a neighboring tribe, possibly Pawnee. Although Arapaho is now their official name, tribal elders continue to refer to themselves as Hinono'eino' in conversations and in stories told in Hinono'eitiit, their language.

The Hinono'eino' have always carried with them the story of their origin, a story told only in the privacy of ceremonies. Ethnohistorians believe that they moved onto the Great Plains in the early eighteenth century, but many Arapaho people believe they may have arrived earlier. History—the written history of explorers and traders—caught up with the Arapaho people late in the eighteenth century, placing them in what would become the states of Wyoming and Colorado.

A description of their territory was provided by Arapaho elder Paul Moss in stories he told in the 1980s. Their geographic center was where the city of Cheyenne, Wyoming, is now located. "Their land, the Arapahos' land, that was what they had been given by God," he said. In his stories, Paul frequently emphasized the special relationship that Arapaho people had with what he referred to as "that place there, there along those mountains." This is the area that Arapahos still consider their homeland: the area of Colorado around Denver, Boulder, Fort Collins, and Rocky Mountain National Park.

Arapahos of the early nineteenth century lived in semiautonomous bands of nomadic hunters who followed the seasonal movement of buffalo—their primary source of food, clothing, and shelter. They were wealthy in horses and traded among various tribes and with trading posts. Theirs was a complex interconnected world of warrior societies, strong spiritual belief, and adherence to the kinship and community structures that allowed them to survive in a rugged environment. The word *neseihiiniine'etiit* is used by elders to describe their traditional lifeways; it refers to living in the wild, living on the edge of danger, and living in a powerful environment that was both helpful and dangerous. Arapaho linguist Alonzo Moss, Sr., also translates *neseihiiniine'etiit* as "living cautious all the time."

But by the mid-nineteenth century, the Arapaho world had begun to change dramatically. As Anglo-Americans began their westward expansion, Arapahos were forced into signing a series of treaties with the United States, each of which diminished their territory. In 1851, they reluctantly agreed to accept the terms of the Fort Laramie Treaty, which gave them and their allies, the

<

Members of the Ethete American Legion Color Guard led the grand entry procession at the Ethete Powwow in 2003. *From left:* **Paul Revere, Sr.; Robert Felter, Sr.; Tony Shakespeare; Wayne Arthur, Jr.; Raymond Dewey. The Arapaho tribal flag is being carried by Tony Shakespeare.**

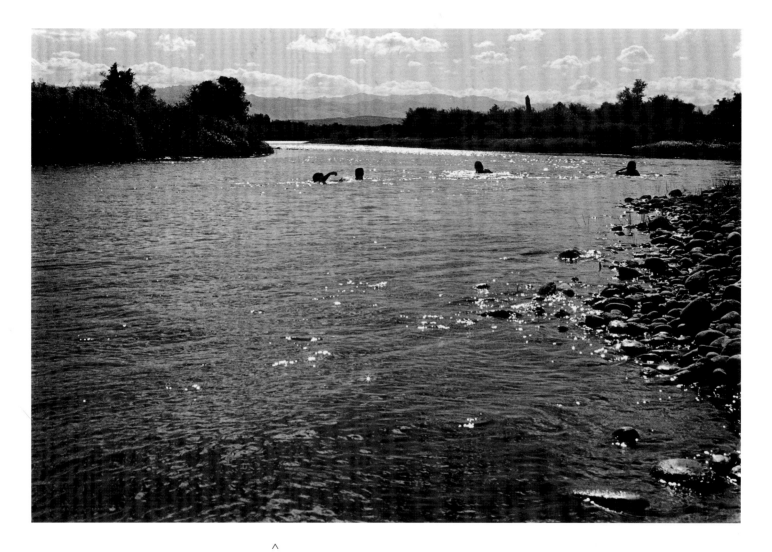

∧

Children swam in the Little Wind River between the communities of Ethete and Arapahoe during the 1989 Arapaho Language and Culture Camp.

Cheyennes, most of Colorado from the mountains eastward across the plains, including small parts of what are now the states of Nebraska, Wyoming, and Kansas. But Americans soon began to settle this territory, too, especially after gold was discovered in Colorado in the 1850s.

The Southern Arapaho and Cheyenne bands were forced to sign another treaty in 1861, relinquishing more territory and leaving them with a small reservation in southeastern Colorado. But the reservation was small and poor, and the bands had to travel elsewhere to obtain food. In 1864, altercations with whites provided the excuse for the governor of Colorado Territory to take action against them. On their small reservation, along Sand Creek, an estimated 450 Cheyennes and Arapahos under chiefs Black Kettle and Left Hand were attacked by several companies of Colorado Cavalry. Over 150 of them were killed. The attack and the brutality that followed provoked several military and congressional hearings the following year.

Following the Sand Creek Massacre, the southern bands of the Arapahos and Cheyennes were permanently placed on reservations in Indian Territory (now the state of Oklahoma). The northern bands continued to wander through Wyoming and the Dakotas, where they were loosely allied with Lakota (Sioux) bands. Arapahos were blamed for most attacks on white settlers in central Wyoming, and at least two attempts were made to remove them from Wyoming Territory. In 1870, an informal militia was organized at the town of South Pass, "to find and annihilate" all Arapahos. It succeeded in locating a small band of peaceful Arapahos led by Black Bear near Lander and killing seventeen people. In 1874, federal troops and Shoshone Indians from Fort Brown (later Fort Washakie) on the nearby Shoshone Reservation attacked a large camp of Arapahos near No Wood Creek: more than twenty-four Arapahos were killed; their food, shelter, and clothing were destroyed; and most of their horses were stolen.

After many years of repeatedly and unsuccessfully petitioning the federal government for a reservation of their own, the Arapaho bands were placed on the Shoshone reservation in central Wyoming. No one wanted them there—not their old enemies the Shoshones; not local white settlers, who accused them of depredations; and not the Arapaho people, who wanted their own reservation farther east. On March 18, 1878, bands under the leadership of Chief Black Coal arrived and were later joined by other bands, including those of Chief Sharp Nose and Chief Friday. There were about a thousand of them, in poor condition. The Indian agent in charge of the reservation resented the Arapahos' presence and only grudgingly issued them rations. Arapaho bands established their camps along the Wind River and the Little Wind River, east of the Shoshone villages. This area gradually became known as Niitiine'etiino', "Where We Live." It is an area of rolling foothills, thickly wooded river bottoms, high sagebrush plateaus, and views of the Wind River Mountains.

>

The Little Wind River valley amid rolling sagebrush hills and, in the distance, the Wind River Mountains.

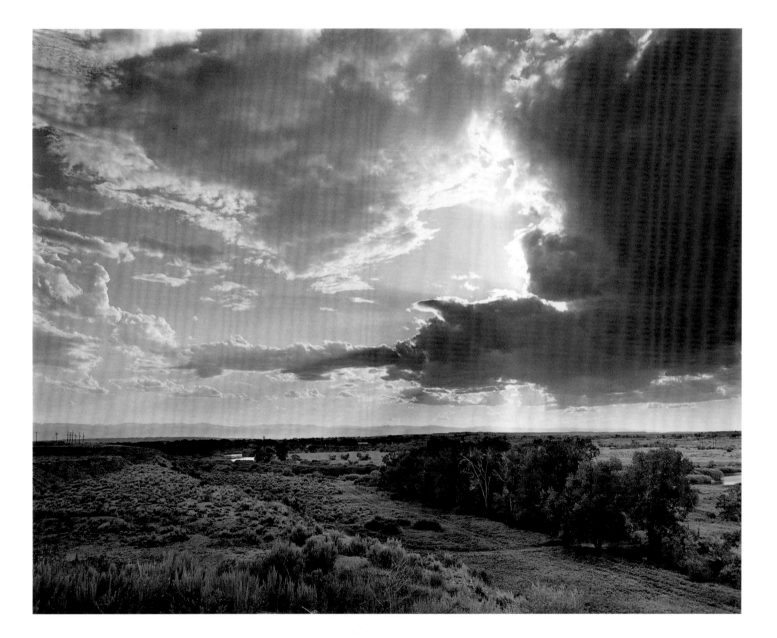

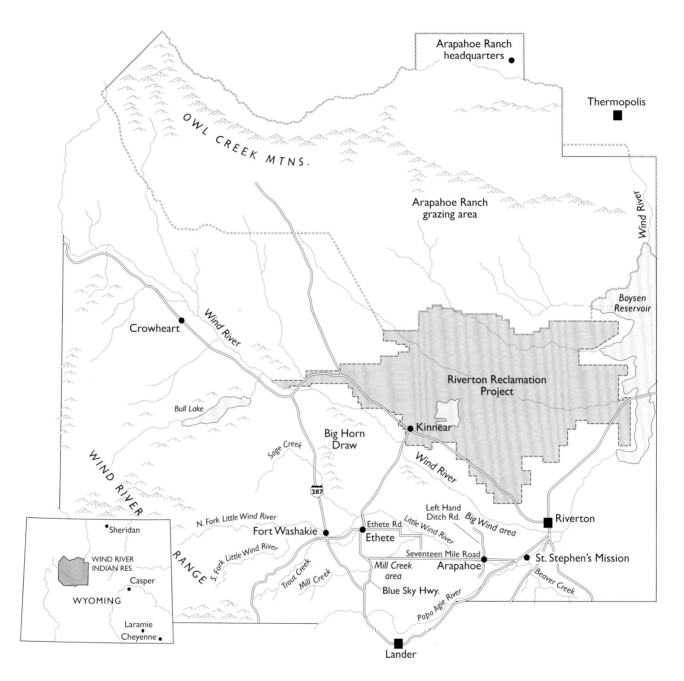

The Wind River Indian Reservation in central Wyoming.

Where We Live **Niitiine'etiino'**

Throughout the remaining years of the nineteenth and twentieth centuries, Northern Arapaho people struggled to maintain their personal and cultural integrity, political identity, and legal residence on what became known as the Wind River Indian Reservation. In the early years, their struggle was in direct opposition to the predominant discourse in the United States—that assimilation was the only possible alternative for all Indians. Indians were "vanishing Americans," a designated destiny that helped rationalize attempts to deprive them of their language, identity, social and cultural networks, and, of course, land and resources.

The Arapaho population at Wind River dropped to 829 in 1892 but by the turn of the century had stabilized and started to gradually increase. However, reservation lands continued to be lost. Beginning in 1900, land was divided among, or allotted to, individual tribal members under the provisions of the Dawes Act of 1887. Much allotted land was eventually sold or lost to debt. In 1904, the federal government forced a land cession from the Eastern Shoshone and Northern Arapaho tribes, and as a result, the entire unallotted portion of the reservation north of the Big Wind River (two-thirds of the reservation) was opened to homesteading by non-Indians.

Many traditional Arapaho ways changed radically after settlement on the reservation, partly because of the forced detribalization policy of the federal government but also because the world in which they lived was transformed. The technology and environmental knowledge that had sustained their prereservation life became increasingly irrelevant. After the turn of the century, fewer and fewer men were initiated into the complex age-grade religious/political hierarchy based in warfare and hunting traditions. Skills and knowledge that related to art, personal adornment, and healing largely had to be passed on in secret. In the early 1900s, the government gave Arapahos Anglo-American first names and surnames and established a system of patrilineal descent that created further changes in Arapaho social structure.

Religion remained a central focus of Arapaho people. Many traditional rituals were practiced (often covertly) and beliefs were maintained, despite attempts to eliminate them. The influence of Christian churches, primarily Catholic and Episcopal, that had begun shortly after the Arapahos came to the reservation grew, becoming a significant part of people's lives. Additional new religious practices such as the Ghost Dance (a widespread pan-Indian revitalization movement) and the Native American Church (another widespread method of worship, structured around the ritual ingestion of peyote cactus) were incorporated into Arapaho life beginning in the late 1800s.

Children were removed from families and forced into church and government boarding schools, where their language and cultural practices were forbidden: St. Stephen's Catholic Mission and boarding school on the eastern end of the reservation; St. Michael's Episcopal Church and boarding school at Ethete; and the government-run boarding school near Fort Washakie. Government and churches often provided the only food and clothing available, as well as training in agriculture, horticulture, and domestic skills necessary for survival in the new reservation world. Gradually these non-Indian institutions became a complex part of the lives of Arapaho people and the new communities that emerged from early band settlements.

The 1920s saw some improvement in the U.S. government's treatment of Indians, who were granted full citizenship in 1924. The Indian Reorganization Act (IRA) of 1934 provided more flexibility for tribes, although the Northern Arapaho and Eastern Shoshone tribes elected not to participate fully in the reorganization process. Other programs and ideas of this era provided employment for tribal members, and bans on traditional religious and cultural practices were eased.

In 1927, the Eastern Shoshone Tribe sued the federal government for violation of its 1868 treaty. Not only had the Shoshones lost much of their land in forced cessions, but the government had also placed Arapahos on their reservation without their informed consent. The federal government had treated Arapahos as full and equal partners in reservation resources from the time they were placed there: they had been allotted land and had received payments from land cessions. In 1937, the Eastern Shoshone Tribe settled the lawsuit, which awarded them monetary compensation while allowing the Arapahos to maintain their partnership in reservation lands and resources. At that time, the reservation's name was changed from the Shoshone Agency to the Wind River Agency. It later became known as the Wind River Indian Reservation.

In 1940, the unhomesteaded land of the 1904 cession was returned to the tribes, leaving homesteaded land in the Riverton Reclamation Project (including the town of Riverton) within the boundaries of the reservation but not under tribal jurisdiction. In 1947, the tribes were able to obtain use of their own money from oil and gas leases, and the funds were distributed as per capita (per-person) monthly payments, with some reserved for the running of tribal government.

In the years after World War II, in which many Indians fought, things changed rapidly. Arapaho elders often say that it was during these years, 1945 through the mid-1950s, that much traditional knowledge and language were lost. The world of the Arapaho was expanding beyond the reservation: returning veterans brought new knowledge of the world and more participation in it, including training in various types of work through the GI Bill; the boarding school system had

ended, and more Indian students began attending reservation day schools and nearby public schools; transportation was more available, and trips to town became more frequent. Especially after the introduction of television, there was less time for telling traditional stories and the learning of traditional ways. The Arapaho language was no longer the primary language spoken in many homes.

The 1950s through the 1970s saw the beginning of cultural and community revitalization efforts. Building on a strong tradition of community dances, powwows were organized. Although modeled on similar events that were part of a national pan-Indian powwow movement, they became an important part of tribal identity and are still being held annually. Many people, both Indians and non-Indians, began to recognize the beauty and importance of American Indian cultures; Catholic and Episcopal churches began incorporating traditional beliefs and rituals into services.

In the 1970s, Arapaho people started to take control of their children's education for the first time in almost a century. They became active on public school boards, and in the 1970s a group from the Ethete community founded Wyoming Indian High School so they could incorporate Indian history, traditions, and language into the school's curriculum. Other public schools on the reservation have followed their lead.

The Northern Arapaho Tribe has continually fought legal battles to maintain its autonomy and political strength, and the tribe has won many of these battles. In 1988, the Shoshone and Arapaho tribes were awarded control of 500,000 acre-feet of water from the Wind River drainage—basically full control of all water flowing through their reservation. In the 1990s, the Northern Arapaho Tribe successfully sued the federal government to separate federally funded programs from those of the Eastern Shoshone Tribe, essentially creating its own governmental structure. In 2005, the Arapaho tribe won a decisive court case that allowed Las Vegas–style gambling; several casinos have since been built.

Other legal entanglements with the State of Wyoming and Fremont County, which surrounds the reservation, continue to consume valuable money and time. The ability to tax, the use of tax monies, the provision of services, elected representation, and jurisdiction are still ongoing areas of conflict. In 2010, however, Shoshone and Arapaho plaintiffs won a decision against the Fremont County Commissioners that creates voting districts and does away with at-large representation, effectively giving the reservation a seat on a commission to which no tribal member had ever been elected.

Sometimes their problems seem overwhelming. Income, health, and education statistics show Arapahos to be well below the national average in each of these areas. Statistics on alcohol and

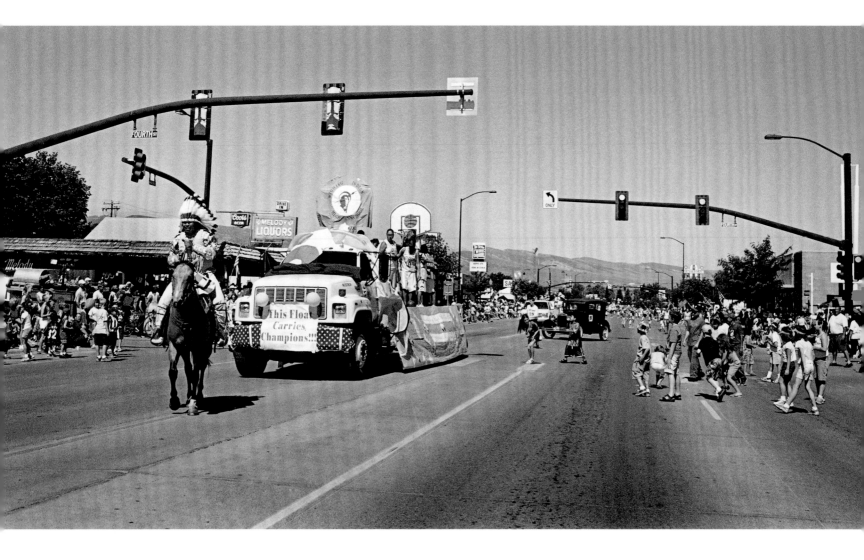

drug use and child abuse are above the national average. Death rates are higher and life expectancy shorter. Arapahos, as individuals, are subject to many forms of economic and social racism: they are harassed and jailed more frequently than non-Indian residents of Fremont County, they are sometimes refused service by banks and other businesses, and services provided by health and social service agencies often seem second-class.

Most non-Indian residents of Fremont County have never been to a powwow, read Indian history, or interacted socially with Indians. They view the reservation as a black hole at the center of their county that prevents economic development and restricts their movements. Indians are caught in webs of hostility and resentment that prevent them from participating in many off-reservation organizations and activities other than tourist programs, parades, and the annual One-Shot Antelope Hunt held in the town of Lander. Fundamentalist Christian churches, both on and off the reservation, refuse to allow any type of Indian symbolism, music, or worship, and their preachers preach against traditional beliefs.

Yet on the reservation, many Arapaho traditions such as extended family–based social organization and religious institutions remain strong and viable, and the revitalization of language and cultural traditions continues. There are attempts to come to terms with history and heritage and to integrate both into contemporary life. And contemporary life is more vital than ever: from a low of 829 in 1892, the Arapaho population has grown to exceed 9,000.

<

The Lady Chiefs of Wyoming Indian High School at Ethete, winners of the 2003 Women's 2A State Basketball Championships, participated in the 2003 Fourth of July Pioneer Days Parade in the nearby town of Lander, Wyoming. They were led down the street by Solomon Brown, dressed as the "chief" mascot, on horseback. The Lady Chiefs threw candy from the float.

Sky Woman **Hono'usei**

One day in 1971, while serving as a VISTA volunteer in Rock Springs, Wyoming, I drove north about 140 miles to the Wind River Indian Reservation just to see what an Indian reservation looked like. I saw signs on Highway 287 marking the reservation boundary, but after that I could see nothing distinctive: houses, some of them impoverished; some clustered settlements; several churches; the administrative compounds. There was nothing very "Indian" to distinguish it from other areas of the state. It was Sunday, and there were few cars on the roads and nothing much to look at but beautiful views of the Wind River Mountains. I got lost and came uncomfortably close to running out of gas.

Two years later, I accepted a job as a social worker with the Fremont County Department of Public Assistance and Social Services (DPASS), a Wyoming state agency that had been asked by the Eastern Shoshone and Northern Arapaho Joint Business Council to take charge of social services on Wind River Indian Reservation. It was 1973, and the tribal government was trying to distance itself from the predatory social services practices of the Wind River Bureau of Indian Affairs, the local branch of the federal Bureau of Indian Affairs (BIA)—the agency that oversees all Indian reservations in the United States. My job included establishing and directing social service programs, as well as community outreach.

I held the job for four years, and it provided an amazing introduction to life at Wind River and to the two tribes—Eastern Shoshone and Northern Arapaho—who live there. I came to know many elders of both tribes, who held positions of respect and authority in these still-traditional tribal communities, and became comfortable working with them in their homes. Indian people who worked in my office became close friends who often invited me to family activities and ceremonies. I slowly learned who to contact about what, how to get things done or undone, how and when to ask or not ask questions. I got to know all the roads, including which ones were impassable during spring thaw or after a rain, and how to follow often-obscure directions to peoples' homes. The Wind River Indian Reservation was no longer a nondescript extension of the rural West but a unique and interesting world.

One evening in 1977, shortly after I had resigned from my job, the family of Gladys and Alonzo Moss, Sr., invited me for dinner at their home in Ethete. Gladys was one of the first people I had met on the reservation, and for several years she had worked with me at DPASS as a "homemaker"

>

Ralph Grasshopper, a well-known storyteller, language expert, and healer, gave me my Indian name, Hono'usei, in 1977. Ralph died in 1985 at the age of seventy-seven, shortly after this photo was taken.

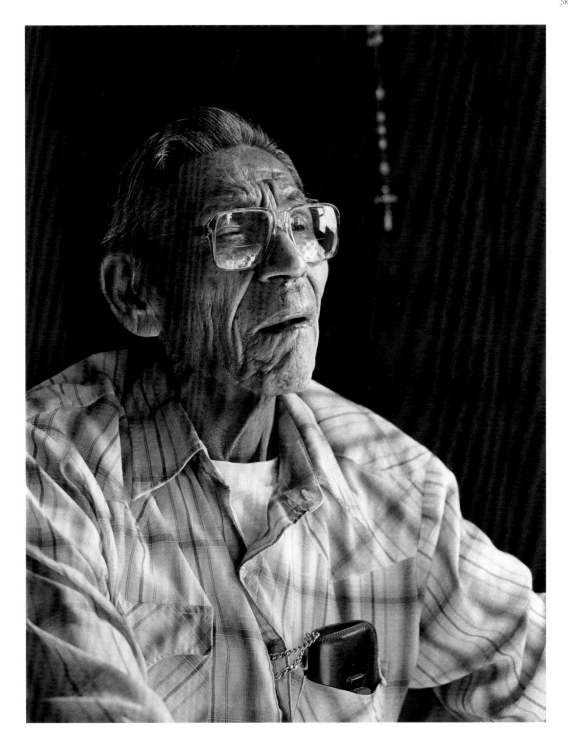

helping elderly and disabled tribal members in their homes. Through Gladys, I had become close to other members of her large extended family. Just before we ate, family elder Ralph Grasshopper honored me by giving me an Indian name—Hono'usei, or Sky Woman. It was a surprise—I knew little about Indian (Arapaho-language) names then and certainly had not known that a non-Indian could be given one. But I recognized it as a blessing, a wish for good health, and a symbol of connection with the Moss family and the Northern Arapaho community.

Throughout the 1980s and the early 1990s, while my husband and I were raising our family in the town of Lander (a border town to the south of the reservation), I continued to participate in many aspects of reservation life and to photograph many individuals and events. Working mostly through the Ethete Senior Center, I photographed elders in that community and displayed their photos at the center. In 1991, a member of my extended Arapaho family, Frances Merle Haas, asked me to display some of these photos at the American Studies Department at the University of Wyoming (UW), where she was a graduate student. In response, I put together a small exhibit that traveled first to UW and then to many other venues. In 1996, Emma Hansen, curator of the Plains Indian Museum of the Buffalo Bill Historical Center (BBHC) in Cody, Wyoming, asked me to help create an exhibit for her museum. With the support of the Wyoming Humanities Council, the exhibit *Ni'iihi'—In a Good Way* was shown at the BBHC in 1997 and later traveled to many other venues around the state and country.

After the *Ni'iihi'* exhibit, I expanded the scope and content of the photographs I was taking. Working through the Arapahoe Senior Center in the community of Arapahoe, I met and photographed many elders and, as I had done at Ethete, displayed their photos at the center. I also started to photograph younger generations and new kinds of events and activities and to travel with friends to other areas to take photographs. In 2004, I began interviewing individuals and gathering information from a variety of other sources for the purpose of writing stories (as Arapaho people call them) about individuals and activities.

>

Reynald "Randy" Wallowing Bull, Sr., was photographed in his home in the Mill Creek area of the reservation in 1998. His daughter Lisa *(background)* **had asked me to come to the house to photograph her father. In the course of our conversation, Randy asked Lisa to show me the photo of his grandfather who had raised him—George Wallowing Bull. The photograph was very important to Randy, who died in 1999.**

Photographs **Wo3oninoo'ootno'**

I am often asked questions about how I go about taking photographs on the reservation. Some of these queries, especially from non-Indian residents of Fremont County, are based on prejudice or ignorance: "Aren't you afraid to go out there?" I am frequently asked. The question is usually followed by a litany of grievances: the drunks, the violence, the freeloading, the messiness of it all. "Culture!" they say; "They have no culture but alcoholism." I have been trying unsuccessfully to respond to these questions and statements for over thirty-five years, and in part, this book is an attempt to finally get it right—to confront ignorance and prejudice with information and understanding of what actually goes on "out there."

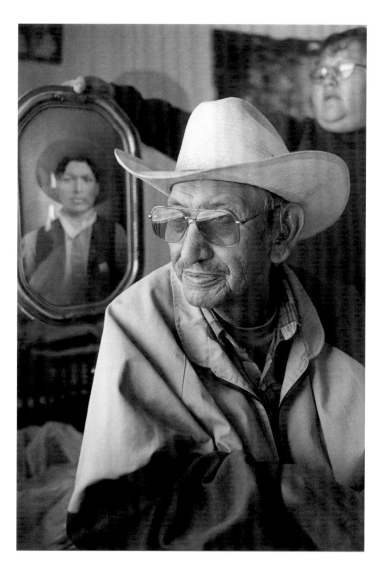

A question frequently asked by those unfamiliar with American Indians is "Don't they think you are stealing their soul?" This clichéd concept dating from the nineteenth century was perhaps true for some indigenous peoples, but it provides little insight into how photographs are viewed today. Indians are as likely as anyone to take pictures of friends, family, and special occasions and to display numerous photos in their homes and offices. They are swift to buy school and athletic team photos, and they respectfully display reproductions of historic photographs. However, I have heard the phrase "stealing the soul" used occasionally by Arapaho and Shoshone people as a metaphor for the inappropriate use of culturally sensitive or ceremonially related materials, including images.

When describing my photographic work on the reservation, I first explain that I try to do things in a good way, a way that is consistent with community etiquette and values. I approach people respectfully, asking to take their photo in public or in their homes. Often I am asked to photograph elders and am invited to family events such weddings, birthdays, holiday celebrations,

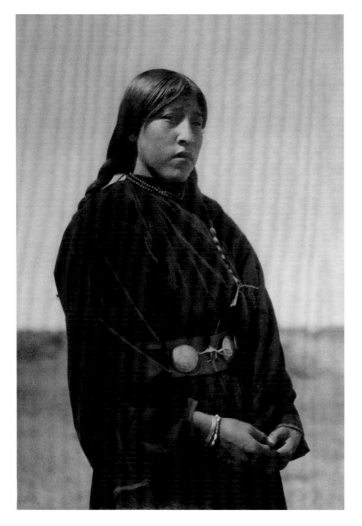

∧

**"Arapaho Maiden" by Edward S.
Curtis, 1910, is a photograph of a
young Mary Agnes Crispin.**
(Courtesy McCormick Library of Special
Collections, Northwestern University
Library)

or naming ceremonies for the purpose of taking pictures. Whenever possible, I comply with these requests, and I always give multiple copies to the people and their families. When photographing at a public event, I try to fold into the situation as unobtrusively as possible.

Knowing when not to take photos is important. I do not take photos at funerals, because these are considered private, and photographing at most ceremonies is discouraged if not forbidden. Also, I personally choose not to be present when alcohol is being used and do not take photos of situations in which alcohol is involved; photographs taken in these situations could perpetuate negative stereotypes that are harmful to the majority of Arapaho people.

When selecting images to be exhibited or printed in a book, I approach an individual with full disclosure in mind—telling them when and how the photo will be used and what the ramifications of that use might be. My photographs of American Indians have never been sold in galleries, used on greeting cards, or marketed to make money. The problems created by commercialization would skew relationships and create problems concerning the inappropriate use of personal images. Instead, I give them away to the individuals, their families, and other community members. The photos are exhibited in nonprofit venues such as museums, art centers, and libraries and at senior centers on the reservation.

Over the past 150 years, photographs of American Indians have often fallen into two stereotypic categories. One stereotype might be referred to as romantic primitivism—the noble "red man" seen in portraits done by many early photographers. Today, romantic primitivism can still be seen in many heads-and-feathers images of individuals, powwows, and ceremonies. In the other category, the Indian is a dehumanized "type"—a conquered people disappearing from history. Today, Indians are still frequently portrayed as victims of colonialism, oppression, poverty, and alcoholism. In one extreme example, they are portrayed as nameless winos lying in the streets of reservation border towns. While

both kinds of images are valid in limited contexts, they fail to tell the more complex stories of people's lives. In both categories, the photos have been decontextualized—removed from any meaningful context—and given a new, independent meaning without basis in the reality of the lives of the people they pretend to represent. Individuals are usually nameless: they have become symbols.

Many photographers, both Indian and non-Indian, working with American Indians today confront these stereotypes and discover a way to create images that move beyond them. Some photographers, however, continue to perpetuate stereotypes for a variety of reasons: for commercial profitability, to call attention to the problems inherent in reservation life, or to express their exotic or romantic ideas of American Indians.

The photographic history of Arapaho people began with itinerant nineteenth-century photographers traveling the West looking for "views" of Indians and in the studios of photographers working in towns and cities in Wyoming and Colorado. They often took official photographs of historic events as well as portraits of individuals; some even established good working relationships with their subjects. Group and individual portraits of tribal leaders were taken as they traveled in delegations to Washington, D.C., to lobby for their people's interests in the nineteenth and early twentieth centuries. Edward S. Curtis, perhaps the best-known photographer of Indians, photographed Wind River Arapahos in 1910. Many photographs exist of Arapahos (dressed in their finest regalia) who appeared in movies made with Wyoming pioneer–turned–movie star Tim McCoy in the 1920s. Government photographers extensively documented poor living conditions at Wind River in the 1930s, showing Indians standing in front of tents, tar-paper shacks, or humble cabins. By at least the 1940s, photographs were being taken by Arapahos.

Photographers like myself working in American Indian communities must engage with

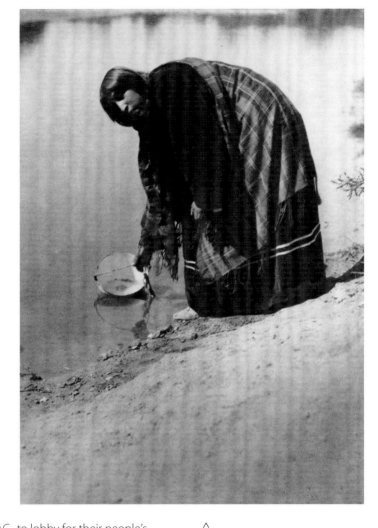

∧
"Arapaho Water Girl" by Edward S. Curtis, 1910, is a photograph of a young Mary Agnes Crispin.
(Courtesy McCormick Library of Special Collections, Northwestern University Library)

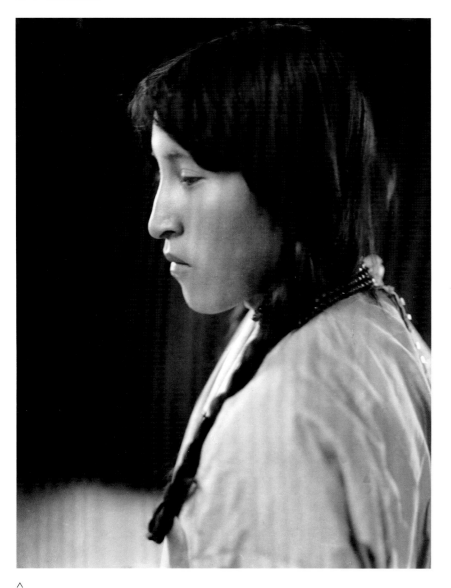

∧

Mary Agnes Crispin, a 1914
photograph by Joseph K. Dixon
of the Wanamaker Expedition
Collection.
(Courtesy Mathers Museum of World
Cultures, Indiana University)

photographers who have come before us. Most notable among them is Edward S. Curtis, whose monumental *North American Indian* project took him to reservations (including Wind River) throughout western North America between 1900 and 1930 and produced twenty volumes of images and written descriptions of native cultures. It was both a commercial venture selling images of noble natives to perpetuate itself and an effort to document and describe what were assumed to be vanishing peoples and cultures. From our vantage point a century later, *The North American Indian* was both honest and dishonest. Curtis and his associates did photograph many individuals and some culturally significant events and wrote some interesting, if limited, ethnography. But many photographs were stereotypical images of the "noble red man," photos that were supposed to be commercially viable but never really were. Rarely were individuals identified. Some photos were staged or later retouched to remove contemporary elements. Since their reemergence in the 1960s, many of Curtis's images have become iconic.

Volume 6 of *The North American Indian*, published in 1910, contained eleven photographs of Arapahos from Wyoming. Two of the photos, "Good Man" and "Eagle Chief," were titled with the name of the individual men translated to English from their Arapaho names, Hinen Hi3eih and Nii'eihii Neecee. These men and several others who were not identified by name are still remembered by today's elders, who delight in looking at Curtis's photos and recounting stories of the individuals photographed.

Two of Curtis's photographs, "Arapaho Maiden" and "Arapaho Water Girl," are of Mary Agnes Crispin Goggles. Mary Agnes Crispin was born on March 13, 1895, and would have been fourteen or fifteen years old when she posed for Curtis. During her teen years, she posed for other photographers, including Joseph K. Dixon (who identified her by name) of the 1914 Wanamaker Expedition. She later married John Goggles and had nine children. For most of her life, she lived in a small cabin two miles east of Ethete and would frequently be seen walking to Ethete, elegantly dressed in the traditional way of Arapaho women. She was considered beautiful. Eventually becoming a respected elder, she was one of the last women to know some of the traditions of the prereservation quill society that created sacred designs from porcupine quills. Her Arapaho name, probably "earned" from a funny incident in her childhood, was Woxeih, or No Good. She died on January 3, 1983.

I knew Mary Agnes, but not well. She was a client in the "homemaker" program I supervised and was often visited by our "homemakers"—women from the community who provided some help

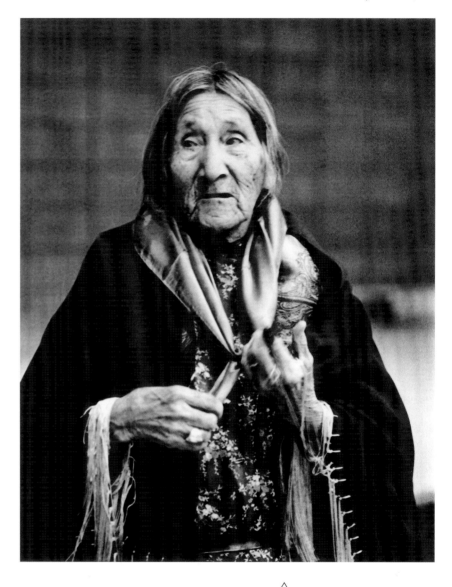

∧

Mary Agnes Crispin Goggles wore the shawl and scarf given to her at her eightieth birthday party in 1975.

with personal and household chores. In 1975, these women held a birthday party for her at the community hall at Ethete; she was eighty years old. I was asked to take photographs that day, but I was an inexperienced photographer and the photos are grainy, overexposed, and out of focus; the images are mundane. This one roll of thirty-five millimeter negatives, however, tells a lot about Mary Agnes. She is seen receiving many gifts: a rug with an elk design on it; fabric for the dresses

she would make for herself; a shawl with fringe and a scarf—things that Arapaho women of her generation always wore. The women who gave the party pulled the shawl around her, tied the scarf around her neck, and brushed her hair.

The photographs taken that day are distinctly different from the work of Curtis and many other photographers of American Indians. They are not formal decontextualized portraits of a nameless woman but informal photographs of Mary Agnes that show her imperfections, her poor health, her weariness. They show her not as a member of a vanishing race but as part of a living community, receiving gifts and being pampered. They were the result of a conversation among the women who gave the party (and asked me to come take pictures), Mary Agnes (who seemed to enjoy having her photo taken), and myself.

Today at Wind River as well as other Indian communities across America, historic, decontextualized photos such as those of Mary Agnes taken in her teen years are being identified, recontextualized, and given new meaning. Photos taken by Curtis and other photographers of the late nineteenth and early twentieth century are copied and hung on walls. The stiff studio made delegation photos are reproduced as posters or tribal logos. Historic photos are being brought back into both private and public spaces as a symbolic link to the past and a confirmation of contemporary identity. Photos, including my own, are used to educate younger generations about the individuals, history, and traditional culture of the Arapaho tribe.

It has been my great fortune to work with people who enjoy photographs, especially photos of themselves and their community. I often have the feeling that Arapaho people view themselves as players in an ongoing historical drama—one of genocide, relocation, starvation, culture loss and revitalization, ongoing attempts to achieve economic and political viability, and, most important, survival. In a sense, photographs confirm their successful struggle and continuing presence in the world.

>

Arapaho elder Chris Goggles talked to a Heritage Day class from Wyoming Indian High School at the Ethete Senior Center in 1998. Using my photos as a starting point, he talked about individuals and their roles in the community.

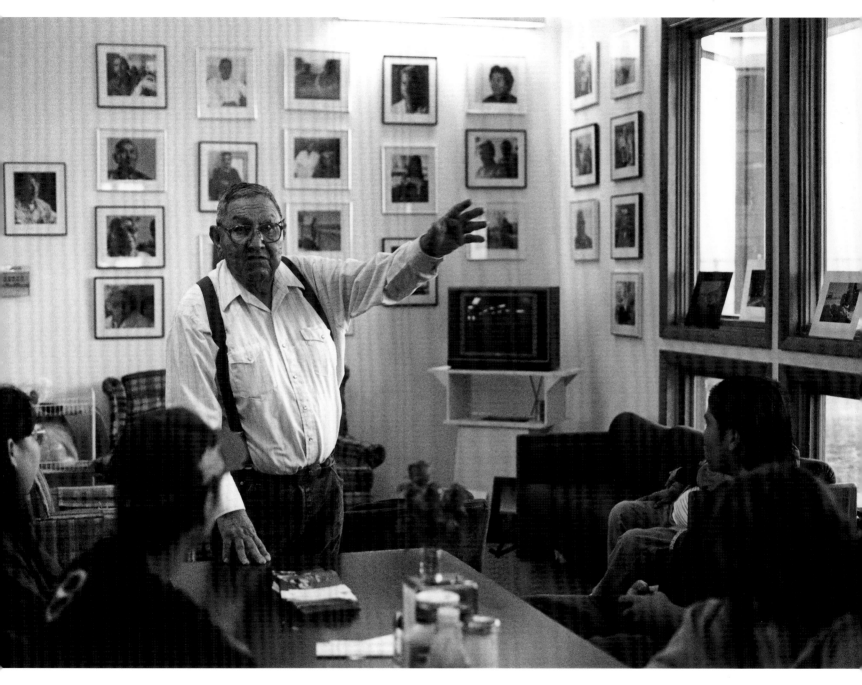

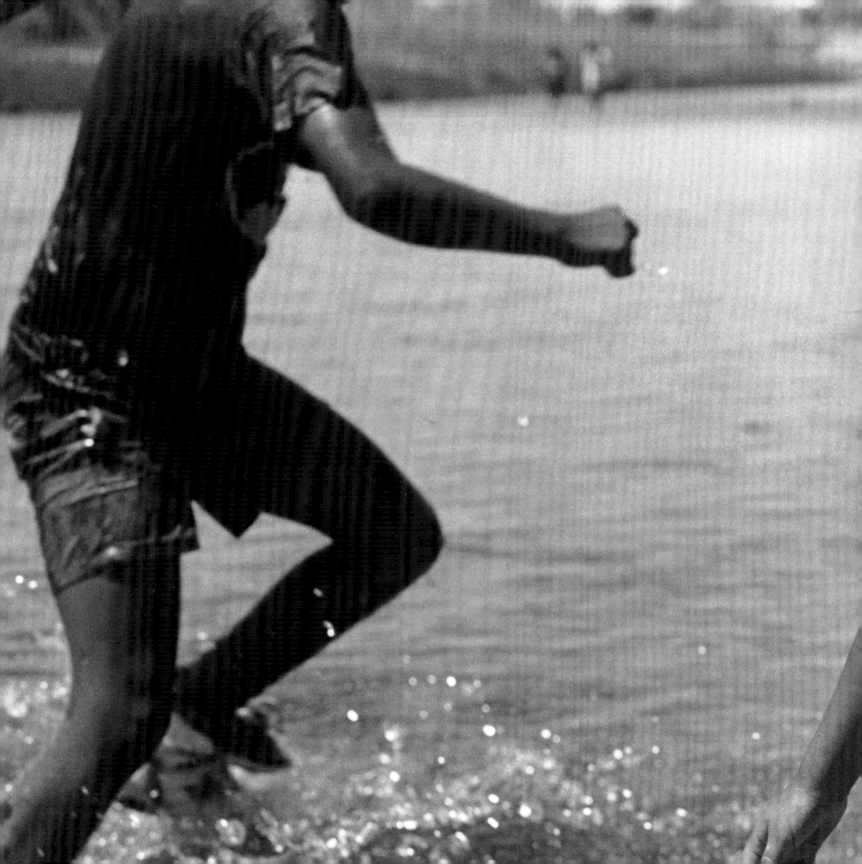

1975 | 1989

<
Tamara Duran played in the Little
Wind River on a very hot afternoon
during the 1989 Arapaho Language
and Culture Camp.

Benjamin Goggles, Jr. **Hoonino'**

The giveaway was to honor our dad's memory. He was dedicated to helping. People would wake him in the middle of the night and he would go help. He was a leading man of our tribe in ceremonials. And to thank people who supported him and the family during his illness. The giveaway is an honoring ceremony.

Dad used to tell us, "Have respect, heeteenebetiit, for all people, the land, the water. Heeteenowoo—respect another person. Respect the ways of the Arapaho." That's how we grew up.

Zona Goggles Moss, 2004

In many ways, Benjamin Goggles, Jr., lived a life typical of the second generation of Arapahos to be born on the Wind River Reservation. He was born near St. Stephen's in 1905 and attended St. Stephen's Catholic Mission boarding school for a few years. Growing up, he rode horses, worked with cows, and enjoyed rodeo. He married, had a large family, and supported them in the variety of ways available to Indian people at the time: he owned some cows, and the family would camp in the mountains in the summer to watch them; he worked construction and as a tie hack, cutting poles from high mountain timber and dragging them to the river. The family had a large garden, and in the fall, they would all move to Idaho to pick potatoes.

As he grew older, Ben became more involved in Arapaho ceremonial and spiritual ways. Years of participation led to his being chosen for several important positions. For many years, he was the leader of the Arapaho Sun Dance, and he "grandfathered" (mentored) many men through this annual ceremony. He was also Keeper of the Wheel (a sacred tribal symbol) and one of the Four Old Men (the spiritual leaders of the community). According to his friend and son-in-law, Abraham Spotted Elk, Ben had a lot of "ceremonial authority" because he lived a good life and took an interest in traditional ways. "When he passed away, things changed—changed quite a bit," Abraham said.

He had learned traditional medicines and doctoring from his grandfather and other elders and was a respected healer, but he never took credit for his ability to heal. "It's not me that's got the power, it's that person above," he told his daughters. Ben exemplified many other Arapaho values—

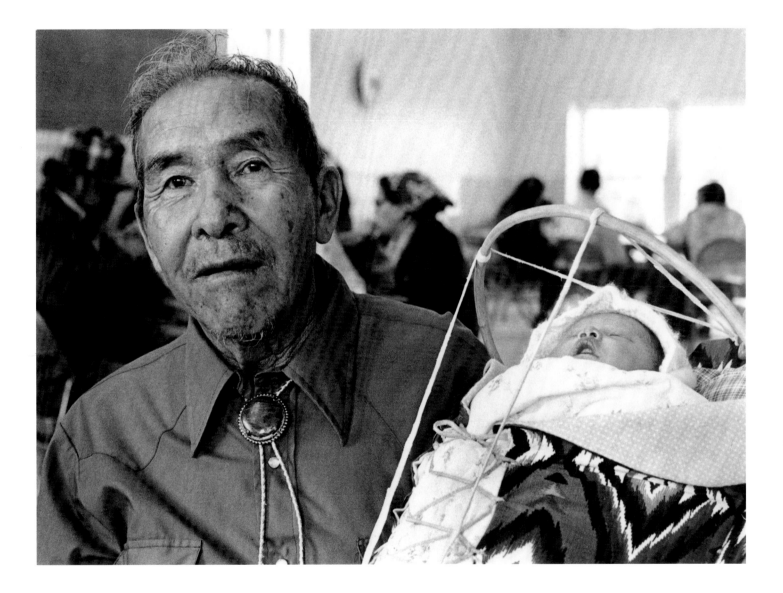

he was quiet and generous and never argued, bragged, or complained. He respected and followed Arapaho ways, which included showing respect for those around him. He never turned anyone away, whether for healing, food, or ceremonial mentoring.

Ben had almost died during the flu epidemic that swept the country in 1918, and later in life he developed diabetes and Parkinson's disease and had several heart attacks. "His doctors would wonder what kept him going," Abraham said. His daughter Gladys Goggles Moss added, "He had a hard life, but it didn't seem that hard to him—he enjoyed his life. My dad used to say, 'Don't cry for me when I'm gone, there'll be many children coming along—two, three at a time.' And that's really come to be."

It is customary for a family to honor someone a year after his or her death—perhaps with a community feast, a special honor dance, a giveaway, or, most likely, some combination of these events. During the 1979 Ethete Powwow, the Goggles family held a giveaway to honor Ben, a year after his death. They saved for a year to buy the large number of items they would give away, such as blankets, pillows, towels, fabric, dishcloths, shawls, and metal and plastic bowls. The giveaway

>

In 1979, family members Frances C'Hair, Gladys Moss, Lucille Ridgely, and Ardeline Spotted Elk prepared the giveaway in honor of Benjamin Goggles, Jr., a year after his death. The giveaway was held in the powwow arena during the Ethete Powwow weekend.

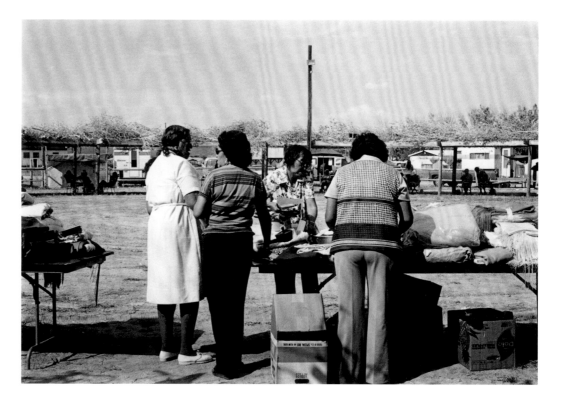

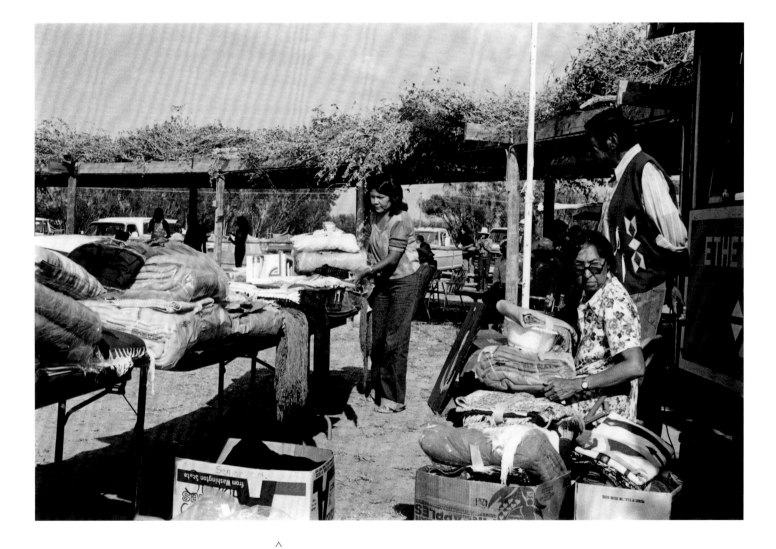

∧

At the giveaway for Benjamin Goggles, Jr., Frances Merle
Haas and Lucille Ridgely organized giveaway goods as tribal
announcer Phillip Warren announced the names of the
recipients.

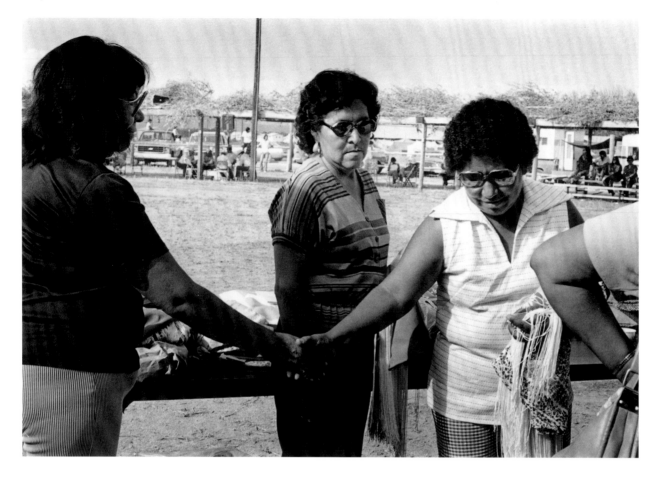

^

During the giveaway, June Amos Yellowman came forward to receive a gift and shake the hands of Zona Moss *(left)* and Gladys Moss.

items were placed on large tables that had been borrowed from the community hall and placed in front of the announcer's stand in the Ethete powwow arena. The women of the family organized the gifts, then a tribal announcer called the names of those who were to receive them. Recipients came forward to accept a gift and shake hands with family members. In Arapaho, the giveaway is called *neeceenohooot,* or chiefs' giving. It is one element of a complex web of respect, honor, and giving that is still an important part of Arapaho life.

Ben was known by his Arapaho name Hoonino', or Quill.

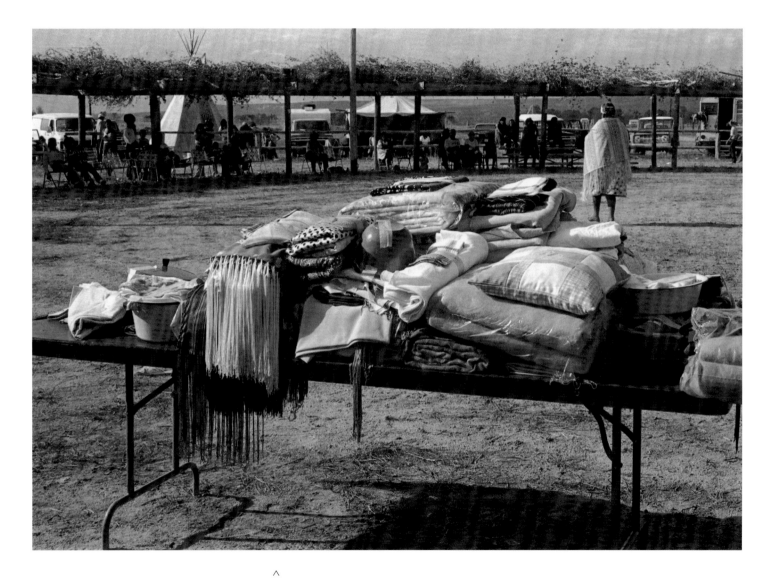

∧

**Having received a gift from the Goggles family during the
giveaway, an unidentified woman returned to her seat.**

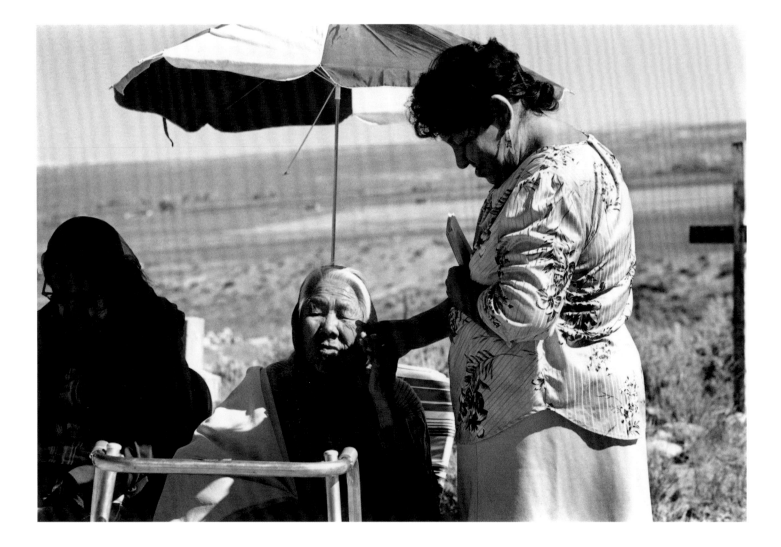

The Yellow Calf Memorial Club **Niiwohoeneseino'**

Tribal respected elder, Helen Cedartree, explains how the Chief Yellow Calf Memorial Club was started. In the past, different families would decorate during Memorial Day, then each family would cook up meals for themselves. This was around the old dance hall which was located across from Josephine White's residence at Bridgeport. There were two old men on horseback who came to the dance hall and thought that there was a feast and they would be able to eat with the people. But the family that they came upon said that the food there was for their own, so the old men on horseback started riding away again. Yellow Calf over heard what had been said and sent his daughter after the two old men to eat with them. Yellow Calf thought about this and some time after called upon his daughter, Inez Oldman, to get a group of women together to form a club. He instructed them that they would cook on Memorial Day for the elderly and the people, and when everyone would get through decorating, they could come to eat together. Inez then asked Frances C'Hair, and they both went to talk to Helen Cedartree, then Theresa Whitewolf. Helen stated that there were others that followed, maybe six or seven more women. Yellow Calf called this group the Ethete Memorial Club. Today, they still cook every Memorial Day for the people, and also help out families on the reservation throughout the year when they lose a loved one.

Chief Yellow Calf Memorial Club

Immediately after the Ethete Memorial Club was founded by Chief Yellow Calf in 1937, members began serving an annual Memorial Day feast to the community. The women also started making crepe-paper flowers and decorating graves with them on Memorial Day morning, and they sponsored games and races for children before they served the community feast. At other times of the year, they would take food to the home of a family in distress and cook large meals for funerals and other occasions. In the early years—the years of depression and war—they raised money not only for their own activities but also to support Arapaho ceremonies. According to Helen Cedartree, Chief Yellow Calf gave them the name Niiwohoeneseino', or Flag Women, because they were to fly veterans' flags on Memorial Day and serve coffee and cake to veterans on Veteran's Day.

Yellow Calf was born in 1861 and was a teenager when Arapaho bands moved onto what was to

<

During the 1986 ceremony to place a new headstone on Yellow Calf's grave, LaVerne Brown greeted Inez Oldman, daughter of Yellow Calf and the first member of the Yellow Calf Memorial Club, who closed her eyes and offered a prayer. Sitting beside Inez was Frances C'Hair, the second member of the club.

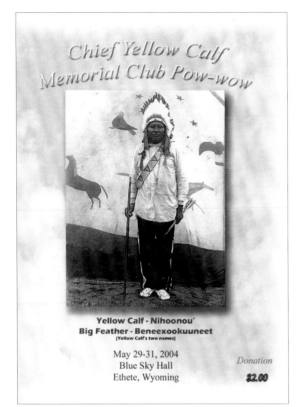

Chief Yellow Calf
Memorial Club Pow-wow

Yellow Calf - Nihoonou'
Big Feather - Beneexookuuneet
(Yellow Calf's two names)

May 29-31, 2004
Blue Sky Hall
Ethete, Wyoming

Donation

$2.00

∧
Yellow Calf was photographed frequently over a period of many years. Today, many of these photographs are used for posters and powwow programs, such as the one seen here from 2004.

become the Wind River Reservation in 1878. As a youth, he had briefly participated in the prereservation life of an Arapaho warrior, scout, and hunter and was one of the last Arapaho men to be initiated into the age-graded men's societies that formed the basis of prereservation Arapaho life—all qualifications for being named a chief. He was appointed by elders to the Chiefs' Council, an early tribal leadership group, in 1904 and held the position for almost thirty years.

Yellow Calf was an important transitional leader who both encouraged traditional ways and accepted new ways. While revitalizing traditional ceremonies, he also donated land to establish St. Michael's Episcopal Mission and boarding school at Ethete. He accepted Western medicine as an addition to traditional healing ways, of which he was a practitioner. He formalized the Eagle Drum, the head drum group of the tribe, by appointing some men, teaching them songs, and showing them how to put the drum together. And according to Helen Cedartree, "He was a great one for helping people with their dances."

After Yellow Calf started the Ethete Memorial Club, now called the Chief Yellow Calf Memorial Club, another memorial club was formed at Arapahoe composed of men—but only the Ethete Memorial Club continues today. Members still decorate graves on Memorial Day, but they do not make their own flowers. They still cook for community feasts, including the one on Memorial Day, and for many years have held a two-day powwow on Memorial Day weekend. Most members are descendents of Yellow Calf and the original members, but any woman in the community willing to work hard may be invited to join. "It's been so long this thing—this club—goes. We just can't die out—it just keeps a-goin'," said Gladys Moss, a member and former president and daughter of one of the original members of the club.

During his life, Chief Yellow Calf had several names. His name in his youth was Nihoonou'u, and the English translation, Yellow Calf, was used during his time on the Chiefs' Council. In the early 1900s, he was arbitrarily assigned the name George Caldwell by the Indian agent; he did not like the name, but it was used for bureaucratic and legal purposes. He was later given the Arapaho name Beneexookuuneet, or Big Feather, the name by which he was known to family and friends and is still remembered by elders. In 1986, the Yellow Calf Memorial Club, with the help of the Northern Arapaho Business Council, raised money to buy a monument to mark his grave at the Yellow Calf Cemetery near Ethete. It reads: "Chief Yellow Calf / Hiine' Seeisi Beneexookuuneet [here lies Big Feather] / George Caldwell / August 13, 1861 / December 15, 1938."

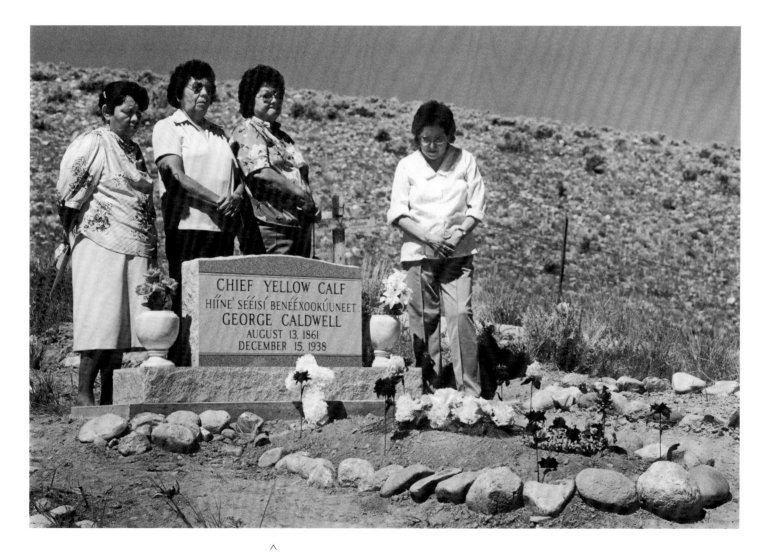

CHIEF YELLOW CALF
HÏÏNE' SÉÉISÍ BENEÉXOOKÚUNEET
GEORGE CALDWELL
AUGUST 13, 1861
DECEMBER 15, 1938

∧

In 1986, Yellow Calf Memorial Club members LaVerne Brown,
Ora Whiteplume, Theresa Wells, and Gladys Moss stood
beside the new monument they had purchased and placed
on Yellow Calf's grave.

Josephine Redman **Beeh'eenesei**

I think it's good to be educated. I'd like to see my children learn all they can, so they can work for themselves and their folks, and so they can be on their own when they have to be.

Josephine Redman, 1990

Josephine Underwood Redman's long life, spanning most of the twentieth century, epitomizes the changes in culture and education experienced by many Arapaho people. According to family tradition, her grandparents were among the first Arapahos to be baptized at St. Stephen's Mission and were given the names Adam and Eve by a priest. Her father was one of the first Arapahos to "wear the red cassocks" as an altar boy there. Josephine was born near the mission on May 17, 1900, and started attending St. Stephen's boarding school at the age of five—so young that the priest would carry her around on his shoulders. She attended the school through the eighth grade, the highest grade possible at that time. On Christmas Day in 1921, she married Elk Redman in St. Stephen's Church.

After their marriage, Elk and Josephine moved to Ethete, to Elk's small log cabin on his family's land. They had nine children of their own, three of whom died in infancy, and raised three of Josephine's brother's children. They took in anyone else who needed a home; sometimes children would come to stay just for a little while but wound up staying a long time. After Elk's death in 1975, Josephine had her sons tear down the old log cabin, long since abandoned. According to her daughter Alvena Oldman, "My mom didn't want the old building left there—it made her feel bad." Josephine also gave away or burned all of his belongings, in the old Arapaho way.

Together and separately, Elk and Josephine were involved in many community organizations and activities and were strong supporters of education for Indian children. In the mid-1960s, they were among the first to start talking about establishing a high school at Ethete, and meetings were held in their living room to get things going. They helped organize concession stands and bake sales to raise money for tribal members to travel to Cheyenne, Wyoming, and Washington, D.C., to lobby for a new school. The result was the BIA-supported Wyoming Indian High School, established in 1972—a school that later, in the 1980s, became a public school district complete with elementary and middle schools. When a new gym and classroom addition was built at Wyoming Indian Middle School in the 1990s, it was named the Elk Redman Complex. Josephine was named the Wyoming Indian Education Association's Elder of the Year in 1990. When she received the award, she said, "I didn't know I was going to get it. I was glad I got it."

Josephine Redman made her own dresses, but she never used a pattern—she would cut the cotton

>
Josephine Redman at her home near Ethete in 1986, wearing a sweater, blanket, scarf, and handmade dress.

fabric into the proper shape, the way she had learned when she was young. Her dresses were simple shifts that came to just below her knees, with loose elbow-length sleeves and a neck opening that was usually cut on the diagonal. When she was young, she had sewed them by hand, but she later used a treadle sewing machine and, later still, an electric one. When she could no longer see very well, family members would buy dresses for her, but she would rarely wear them. Instead, she would buy fabric and give it to her daughter Lucy, who would make dresses for her the way she had always made them for herself. Josephine, like other women of her generation, never left her home without a sweater worn over her dress, a blanket or shawl wrapped around her, and a scarf over her head and tied under her chin. As she got older, her family would buy coats for her, but as with the store-bought dresses, she didn't care for them.

Josephine was an artist who made many other things, including quilts, dolls, beaded buckskin dancing outfits, and tipis of many sizes. Most of her tipis are still owned and used by her family, but a large one was commissioned by the Wyoming State Museum in Cheyenne. Josephine and Elk were frequent participants in parades in neighboring off-reservation communities and would often ride on a float dressed in fully beaded buckskin outfits she had made, standing next to one of her "parade size" tipis. Sometimes she made beaded-medallion tipi decorations that could be attached to a tipi when it was put up and removed when it was taken down.

Josephine made many pairs of moccasins in her life, for herself and other family members. She kept patterns—outlines of the soles of the feet—for those for whom she made moccasins. When she died, her daughter Alvena couldn't bear to throw the patterns away. For most of her life, Josephine wore only moccasins she had made for herself. When she was no longer able to make her own moccasins, she would occasionally buy and wear shoes.

Her Arapaho name, Beeh'eenesei, was given to her when she was young by her grandfather Old Man Sage, a well-known tribal elder, and today no one is sure of the translation or of the story it told. When she was older, she became a giver of names. She named many of her grandchildren, as well as the children of others outside of the family who asked her to do so. People would come to her house or she would go to their homes, and often they would have a dinner for her. In a simple ceremony, she would touch the earth (in winter she would have a can of dirt brought in from outside) and pray that the child would walk the earth a long time.

When Josephine died in 1998 at the age of ninety-seven, she was the grandmother of twenty-six, the great-grandmother of eighty-three, and the great-great-grandmother of seventeen. Many more have since been born. And that is just her close family—the inclusive nature of Arapaho kinship allowed her to be called, and considered, grandmother by almost everyone in the community.

Ben Friday, Sr. **Nonookuneseet**

In a 1982 interview, Ben Friday, Sr., a long-time member of the Northern Arapaho Business Council, talked about his life, as well as the importance of tribal government—its continuity with the past, and its importance for the future well-being of the tribe.

In my days, when I first went to school at government school, the chiefs used to come over there during noon hour. They wouldn't come one or two times. They came pert near everyday to talk to us. They were the Shoshone and Arapahoe chiefs. . . . They used to talk to the Indian children, to us. And we listened to them. They said, "This is the way that life's supposed to be. You're supposed to be good. You're supposed to be a noted man on the reservation. You will be if you listen to us." When they got through, we wouldn't talk back. We'd just sit there and listen to them. They said, "Over there we can see the future. It won't be very many years. You kids sitting right here, you're going to get married to each other." So it's true. It was 1912 and all those kids were married a few years after that.

Of course, I stayed at that school until 1915. Then I left. They had another school at St. Michael's Mission at Ethete. It was just a girls' school at the time, but they opened it up for boys, too. In 1917, I enrolled for Carlisle way over at Pennsylvania. They had a non-reservation school down there. When I got ready to get on the train, well, they wired to the reservation office to say that Carlisle was closed. So the other students and I had to wait another week. We were assigned to go to other schools then. I went over here at Nebraska, west of Omaha. That's where I went for five years. That was a real compulsory school. They had discipline there. I couldn't do anything. It was just like a penitentiary.

When I finished, then I came home. I didn't stay here. I joined the National Guard in the Army. I stayed three years and then I came back home. Then I got married, not the Indian way, but the church way. . . .

In the olden days, there used to be chiefs. They used to have chiefs and subchiefs who are next to the chiefs. Then they had the warchiefs, the defense department. The chiefs were men just like the President of the United States. They were overseers of all the people. They told them the rules and regulations of the tribal government. They didn't want anybody to be bad.

The chiefs did many good things in life. They had to be kind to everybody. The people who were without depended on them in every way. They helped the sick and the needy. They helped the children. They did anything to show themselves to be good men. A person who went out and did what was needed to be done was recognized as a good man. By appointing this man as leader, there would be no mistaking whatsoever. He would be recognized as chief.

To be a good leader, a man had to be everything. He had to know about the tribal government. A leader was a man who would think ahead of time. He would think about things. That's good, you know. They had to know where to go when the tribe went to other places. The people picked him for what good he did for them and what he would do for them in the future. They wanted a better living, better things. . . .

Then they have this other culture coming in—the white culture. This is Indian culture and tradition that we're talking about now. And there's another culture right here. It's part of the Indian's culture, too. When these cultures got together, we learned the English language. We forgot about the Indian language. We forgot about the Indian ways and laws. We have laws from the government, federal laws, state laws or whatever. We're practicing them now. In other words, the traditional ways are just fading away. This is due to the fact that the younger generations are not interested in Indian culture or traditional ways or customs. I'd say in about another thirty years they'll probably all fade away. These traditions are like a story. The younger generation takes it and reads it. They say, "Oh my, that must have been a beautiful tradition, but today we don't know anything about that. We don't live that way. We live a different life altogether now." That's the way that it is now today.

In 1925, they started getting the six-man council. In 1941, I went in as a business councilman. I was voted in. The people got together and they nominated people, and they voted. Well, I was one of them they picked. It was 1941, I entered the Council Chambers and I stayed there until 1968. Then I retired. I never quit one year. Twenty-eight years in there is a real job.

The job of the Business Council pertains to tribal affairs. There were no more chiefs to lead the people, so the Business Council came along. They take care of tribal lands, enterprises, hunting and fishing laws, mineral development and all tribal monies. They work with the federal government to provide funds for jobs and health care. The federal government set up the Public Health Service and the Business Council supervises it on the Indian side.

<

Ben Friday, Sr., at his home near Ethete in 1988.

The tribal government is run by constitutional by-laws. That's what they had in the olden days, but they weren't called "constitutional" because they weren't written down. Now everything is written down. Anytime the people want to put an amendment on the constitutional by-laws, they call a General Council. Everybody gets something to say about how the by-laws are going to be set up. That's pretty similar to the old laws back there.

More than any other tribal tradition, government has served as a bridge between young and old, yesterday and today. It has prepared countless generations of Arapahoes for life's journeys. They are able to greet the dawn with a smile because they know they carry the beautiful traditions in their hearts.

Ben Friday, Sr., was born in 1906 and died in 1994. He was not only a member of the Northern Arapaho Business Council for over twenty-eight years but also an important community leader in other ways: as a noted healer, spiritual leader, and Native American Church leader. He was also one of the Four Old Men, the primary spiritual advisors for the Arapaho communities. His Arapaho name at the time of his death was Nonookuneseet, or Grizzly Bear. Several other names were taken from him or given away by him.

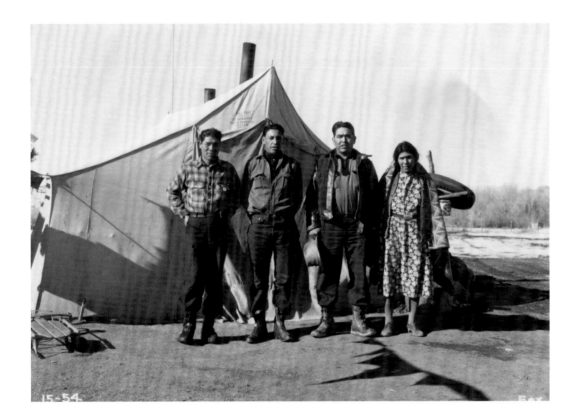

This photograph of family members of Ben Friday, Sr., was taken during the 1930s. *From left:* Ben's cousin Richard Friday; brother-in-law Sherman Welsh; Ben Friday, Sr.; and Maggie Richards Trosper Friday, Ben's wife. "That's our sled, too," said Caroline Goggles and Verna Thunder, Ben's daughters. The photo was taken when the family was camped near the old community hall along the Little Wind River, probably during the annual Christmas festivities. (Courtesy of the Wind River Bureau of Indian Affairs and the Friday family)

We Are Arapaho, Speak Arapaho
Hiinono'einino', Hinono'eiti'

We hope we do something good for the kids, that we give them something good to go on to learn the language. One person said that we were so busy being White that we forgot who we are. We lost part of our values, culture and respect trying to be like the Whiteman. Now we're trying to restore that. It's a tough battle, but we can do it. We hope our efforts keep snowballing, we think it will work.

 Harold Moss, director of the Arapaho Language and Culture Commission, 1988

Under various federal policies, the federal government has tried to divorce the Indian from their traditional culture. These [language and culture] camps are an attempt to avoid total genocide.

* We will not be able to measure the success until the children grow up and have children of their own. The chance of the success of this is like the chances for finding a cure for AIDS. It will happen eventually. But for now it is rewarding to hear small children speak a few words in Arapaho.*

 William C'Hair, member of the Arapaho Language and Culture Commission, 1992

Each morning at the 1988 Arapaho Language and Culture Camp, Richard "Dickie" Moss taught young boys how to make bows and arrows. The bows were carved from red willow *(bo'ooceibiis)* and the arrows from the stems of wild rose bush *(yeiniis),* both of which grew along the Little Wind River near the camp. As they gathered and carved the wood, Dickie would tell the boys to "watch closely when you handle the knife." He showed them how to notch the bow, attach a bowstring made of artificial sinew, and pull it taut. As he worked with the boys, he would tell them the Arapaho words for the things they were doing and making. When they were finished, they took turns shooting their arrows across an open field. In the afternoon, he would tell them traditional stories.

 Dickie was one of many elders who taught at the Arapaho Language and Culture Camps organized by the Arapaho Language and Culture Commission, the branch of tribal government that oversees language and cultural revitalization efforts. From 1987 to 1993, for one week each summer, these day camps were held beneath towering cottonwood trees along the Little Wind River. Funding came almost entirely from the tribal government, with donations from individuals and organizations and grant money provided by the Wyoming Humanities Council. By 1989, the commission had

<

Richard Moss, an instructor at the 1988 Arapaho Language and Culture Camp, tested a bow and arrow he had made.

chosen a simple but effective slogan for the camp: "Hiinono'einino', Hinono'eiti'—We are Arapaho, Speak Arapaho."

The camps started small; just seventeen students attended the first year. By the fourth year, daily attendance averaged over four hundred, and the staff of organizers, teachers, cooks, and maintenance workers was almost as large. There was daily bus service from children's homes to the camp. Two meals a day were cooked and served outdoors, under shades built of willows and tarps, to as many as seven hundred people.

The day started with breakfast, followed by a flag raising, the singing of the Arapaho flag song (the tribal anthem), and a thanksgiving prayer. Elders then talked about the importance of traditional Arapaho values: respect for elders, teachers, your friends, yourself, and nature. Small-group language and craft lessons followed, with shady groves, tipis, and wall tents serving as classrooms. Lunch was followed by various activities: arts and crafts, nature hikes, games, footraces, and swims in the Little Wind River to cool off. Buses picked students up in the late afternoon for the trip home, but older campers and a few adults stayed overnight to listen to stories, play games, and sleep in tipis.

>

Myrtle Oldman taught the hand game to students during the 1988 Arapaho Language and Culture Camp. The children are unidentified.

∧

Jola Wallowing Bull posed with some rag dolls (called doll
rags by the elders) made by herself and other students
during the 1988 Arapaho Language and Culture Camp.

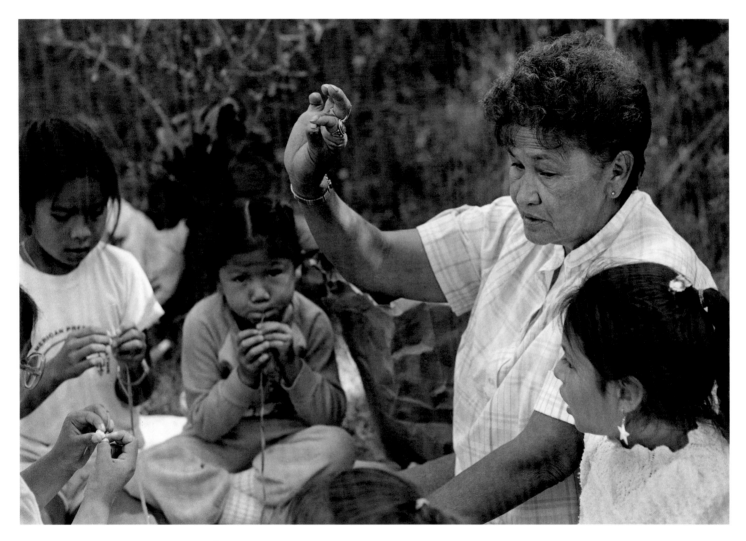

∧

Instructor Marie Willow showed young girls how to bead
during the 1988 Arapaho Language and Culture Camp. To her
right is Tara Brown and to her left is Bernadette White. The
other girls are unidentified.

The camps became a time when activities rarely if ever seen elsewhere by the students were practiced and demonstrated: old crafts such as bow-and-arrow and doll rag (rag-doll) making; the telling of traditional stories; games such as the shinny game, in which players hit a rawhide ball with willow sticks; and certain kinds of dances. Things that are still part of daily life, such as beading and hand games, were also emphasized.

In their heyday, the Arapaho Language and Culture Camps were major events that attracted media attention and visitors from around the world. They were considered by many to be a breakthrough in the teaching and maintaining of native cultures. Crafts, songs, games, and dances were first reintroduced to the community at the camps. But because of budgetary problems, the large tribe-sponsored camps were discontinued after 1993. Smaller camps have since been held by educational organizations on the reservation, closely following the model first developed by the Arapaho Language and Culture Commission in 1987.

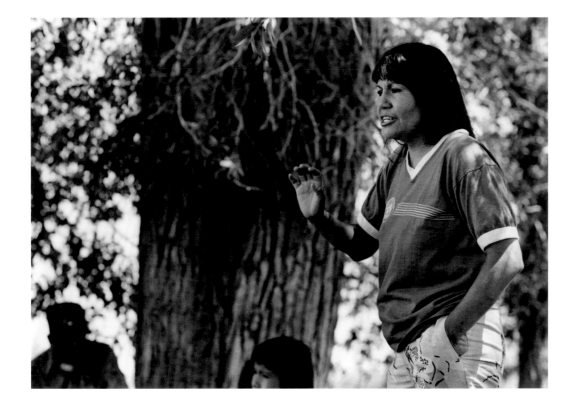

<
Frances Merle Haas, codirector of the 1988 camp, told traditional stories to a group of students.

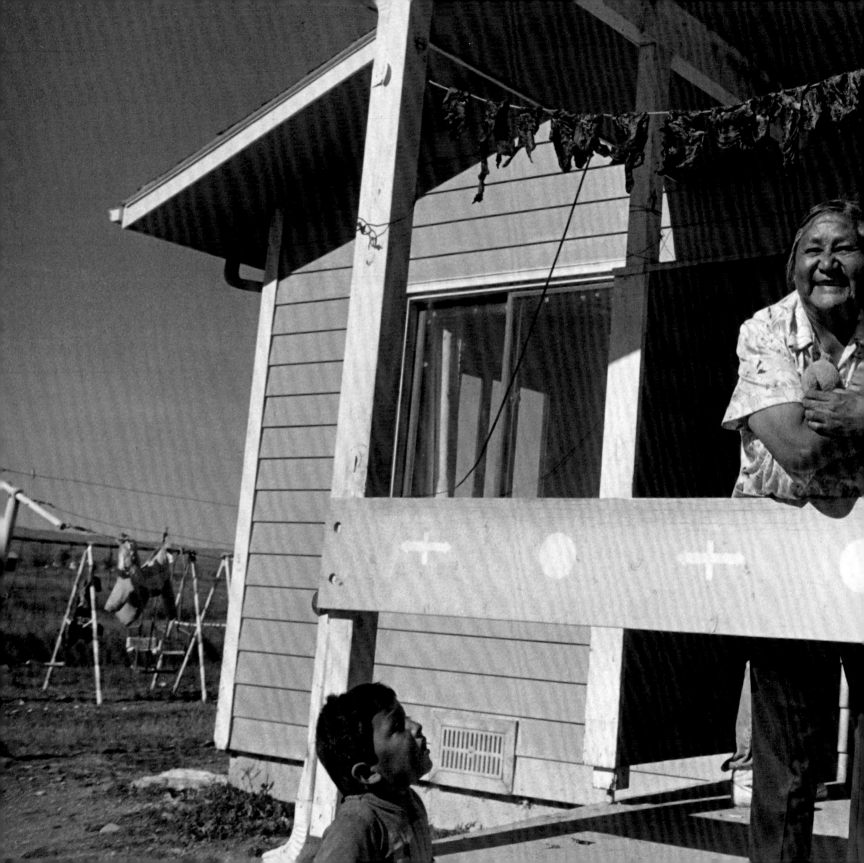

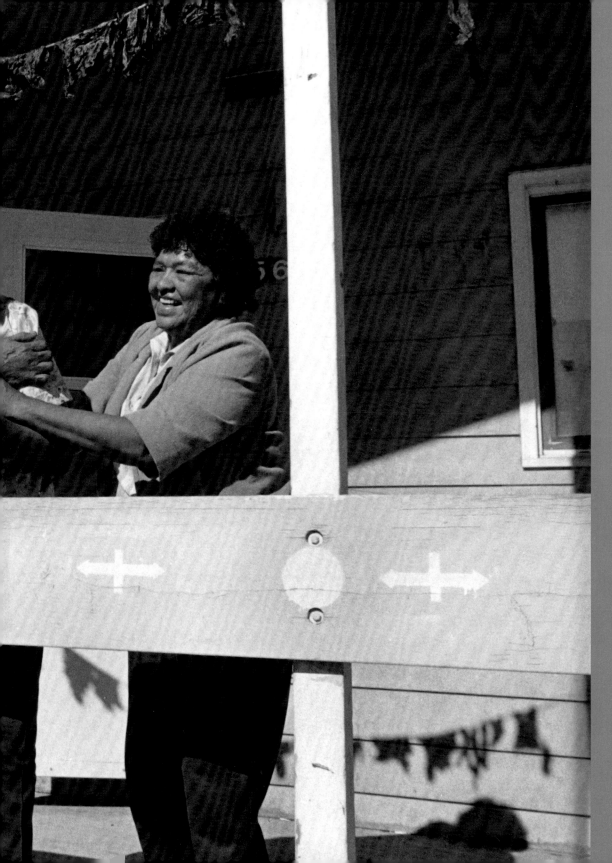

1990 | 1996

<

In 1990, Ian Armour watched as
Ardeline Spotted Elk *(right)* tried to
tease her neighbor Wilma Goggles
into posing with a teddy bear. A line
of drying deer meat hangs from the
porch.

Chris Goggles **Neecee Nookoe'et**

When Chris Goggles and other veterans returned to the reservation after World War II, there was little for them to do—there were few paying jobs and few tribal positions for men their age. So they got busy. They formed basketball teams that played each other frequently and started American Legion posts: the Arthur Antelope Brown Post at Arapahoe and the Trosper Redman Post at Ethete, named after young men who died in the war. As the posts became active in the communities, they were assigned nights for dances during Christmas week festivities. It was through the American Legion and the dances they sponsored that Chris first started announcing. In the early 1950s, he was "taken around the drum," a simple ceremony performed by the official tribal drum group during which people are literally walked around the drum. The ceremony is used when confirming announcers or tribal leaders, bringing singers into the drum group, and adopting members into the tribe.

Tribal announcers are the electrified version of camp criers—men who would walk or ride horses through camp, hollering out information necessary for events or movements. Chris's wife, Caroline, remembered that when she was a child, criers would ride through camps and cry out to people. As the camp sizes continued to expand, additional runners would be sent around to keep people informed. Eventually, loudspeakers and microphones were added, and criers became known as announcers. The technology changed, but the Arapaho word, *noooxneihiino',* remained the same.

The duties of announcers are time-consuming and important. Not only do they work throughout ceremonies to keep participants informed, but they also are called on for dances, powwows, funerals, giveaways, rodeos, and school events. Chris held the position until his death, constantly traveling around the reservation and across the country to fulfill his duties. He was rarely paid much (usually just enough to cover his expenses) but only turned people down when he had a prior obligation or, later, when he became ill. During important ceremonies and large powwows, he would work almost around the clock for days at a time.

After the war, Chris first obtained a job at the Ethete Co-op, a store located at St. Michael's Mission at Ethete that helped to support the veterans and sponsor their ball teams. Shortly after, he received training in surveying through the Bureau of Indian Affairs, and he worked as a surveyor until his retirement thirty-two years later. In the late 1940s, he and Caroline Friday were married and started their family—four sons and a daughter. They turned a small log garage into a home (which they eventually moved to Chris's mother's land), cleared the land of sagebrush, grew a large garden,

>

Sitting in the announcer's booth during the opening ceremony of the 1990 Ethete Celebration Powwow, tribal announcer Chris Goggles spoke to the crowd. Seated beside him was his apprentice, Bruce Armour.

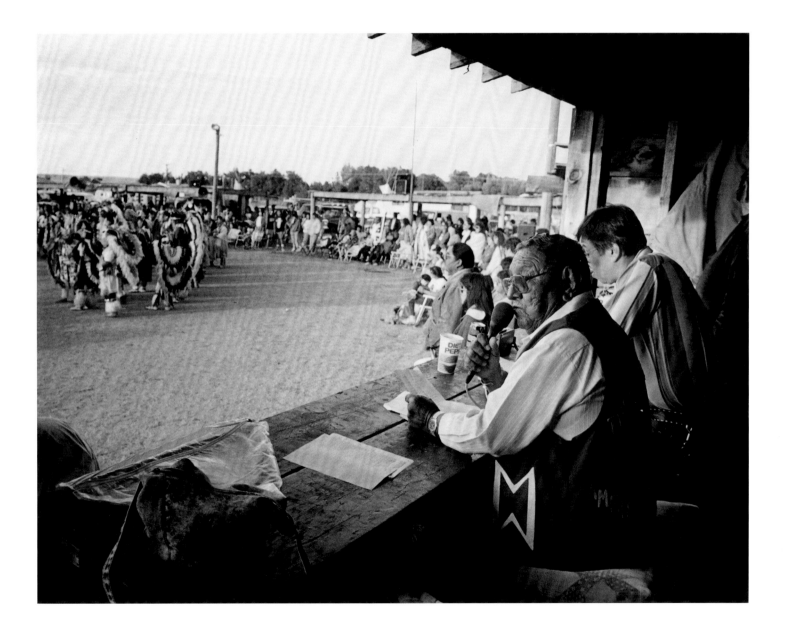

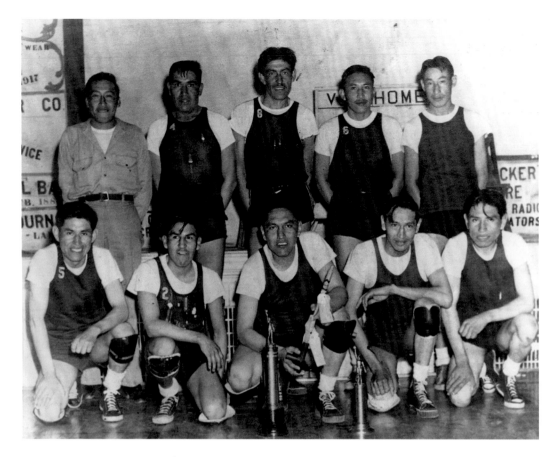

^

The Ethete Co-op basketball team circa 1946–48.
Top row from left: Ralph Whiteplume, George
Brown, Leo Brown, George Sun Rhodes, Hermes
Trumbull. *Bottom row from left:* John Willow, Wilbur
Wallowing Bull, Chris Goggles (holding a pipe),
Bert Whiteplume, Oliver Willow.
(Courtesy of the Whiteplume, Willow, and Goggles families)

started raising cattle, and took in many relatives and visitors who needed help or a place to stay. "We had a heavy load when we were first married," Caroline recalled. "We had a lot of extended family around us then. Our life used to be so full."

Chris also became involved in many committees and activities, including the Entertainment Committee (an elected group that performs tasks needed for tribal events), the Arapahoe Ranch Board, and the Democratic Party. He later served as a state vice-commander for the American Legion.

In the 1980s, Chris's health began to deteriorate. Heart bypass surgery was followed by digestive problems that had first developed when he was stationed in Southeast Asia during the war. The day after Labor Day in 2001, he couldn't eat. An MRI was performed at a local hospital, and the next day he was transferred to the hospital in Casper, Wyoming, 120 miles away. Caroline threw out the food in the refrigerator, packed for three days, and left for Casper with her family. She was there until Chris's death from advanced cancer thirty-eight days later. "He just disappeared fast," Caroline said. In a way it was good, she thought, because Chris had often told his family, "I don't want no machines on me. I don't want no lounging around in the manor. Don't let me be on machines. When God calls, that's when you go." He was seventy-seven years old.

When Chris had returned from the war, he was given a name reflective of his Air Force service, Neecee Nookoe'et, or Chief White Cloud. He was always known by that name. He did not pass his name on. "A name that's earned like that, you don't give up," Caroline said.

In 1985, Bruce Armour was "taken around the drum." He had been selected by the tribal elders to learn announcing under Chris's direction. After many years of service in the navy and the army that included tours of duty in Vietnam and Europe, Bruce had recently been given a medical discharge because of diabetes. The strenuous duties of announcing were hard on him. At one point he wanted to quit but was told by a friend, "You were selected by the tribe. There's no way out." He worked under Chris for fifteen years. "Chris was my teacher," he said respectfully. After Chris died and his own health problems worsened, Bruce gave up announcing except for occasional small events. He died in 2007.

Today, there are several other Arapaho men who have been "taken around the drum" to become tribal announcers. Elders feel it is important that announcers speak the Arapaho language, especially at ceremonies, and many worry that members of younger generations will not be eligible for the position because they do not know the language.

Hugh Ridgely **Ho'nookee Niibei'i**

When folks talk about themselves you hear nothing but good. I want to be the guy who says he was not an angel. I believe in God. I'm not a fanatic—my religion is not the only religion. I am not a holy man, a high priest in the Indian way or one of those picked as the Four Old Men. I'm just a regular guy—I steer away from things like that because of my character. I don't want to pretend I know it all.

I've lived a hard life, brought up in a poor way. We had a wagon to go visit or to town. We set up camp during the summer. I've been a pedestrian the biggest part of my life. I hitchhiked to Mexico, to California and back, twice, and down to Texas and Kansas. I almost roasted down that way. Now I get the itchy feet once in a while but now I drive or take the bus. I've also flown to France, Hawaii, Mexico City. I was up in the Twin Towers, on the thirty-seventh floor, in 1979, for a Business Council workshop. I was on the Business Council for three terms.

I wish I could relive my life—it would be different. I would stay off the booze, get my education, and work. I've just jumped here and there.

Thinking of all my buddies who have died, for some reason I went through two major surgeries, combat, and somehow I've made it this far—seventy-four years. I think it's pure luck. Maybe God and the devil have squabbles over me. God says, "I don't want him—you take him" and the devil says, "I don't want him—you take him." Neither one would accept me. That's just kind of a joke, but it seems that way sometimes. You wake up every morning, you have colds, a flu. As you get older you weaken physically, mentally—that's part of life. We're all replaceable. And we don't know from one day to the next what's gonna happen. We hope for the best.

Now I'm seventy-three. I think I kind of have an open mind. At my age I'm living on borrowed time. I try to enjoy my freedom as much as possible. What few years I have left, I want to devote time to myself. I'm at an age where the big man upstairs might say it's time to come home. Men I grew up with on the reservation are gone now. A lot died of cirrhosis, car wrecks. It's kind of that way.

Hugh Ridgely, 2005

<

Hugh Ridgely leaned against his 1981 Camaro in the parking lot of the Ethete Senior Center in 1990.

If you ask Hugh Ridgely about his life, the first thing he tells you about is his military service. First, he joined the U.S. Army National Guard in 1948 in South Dakota, where he was attending Flandreau Indian Boarding School. Then in 1951 he joined the U.S. Marines, serving as an infantryman in the First Marine Division in Korea. In 1952, he fought at the Battle of Bunker Hill and the Battle of the Hook—both intense combat situations. After those battles, only 9 men (including Hugh) in a company of 250 were left. "Three good friends I lost over there, and when I lost them—it's something I remember to this day. They died young. We didn't realize how young we were—I was just twenty when I was in combat. Some came out without a scratch, some were traumatized. There were crying and dying men, and enemy dead lying all over. At night you visualize what you saw. I can't deal with it. I don't deal with it. It is always there in my mind. I used to fight it by drinking heavily." He received many medals and honors from his service in Korea.

Hugh liked the structure of a military life. After Korea, he joined the Air Force Reserve, the Air National Guard, and the U.S. Army. Between 1948 and 1975, he saw fifteen years and twenty days of active duty.

During breaks from the military, he would return to Wind River, where he married, later fathering seven children. He worked at various places—the Arapahoe Ranch, a school for the developmentally disabled, an iron ore mine, and on the railroad as a gandy dancer. He ran as many as 75 cattle and 250 sheep for many years: "I didn't go hungry when I had sheep and cows. We were a poor family but we always had meat." Later, he attended Central Wyoming College in Riverton, where he received a high school equivalency degree and an associate degree in criminal justice. He has been a judge in the Wind River Tribal Court on a part-time basis since 1973 and served three terms on the Northern Arapaho Business Council. He traveled extensively for military and professional reasons and later for pleasure.

Hugh was baptized a Roman Catholic at St. Stephen's Mission but has always remained active in Arapaho ceremonies. He also travels to attend and participate in ceremonies on other reservations, as well as various Christian churches. "The prayers all went the same direction as far as I know. We all come for the same reason. We are all children in the eyes of God."

Hugh feels he neglected his family, mostly because of liquor. "That will always stay with me and hurt me. But I did the best I could. I never abandoned them." Two of Hugh's sons died in alcohol-related accidents, and other sons drink heavily. His daughter is working on a Ph.D. at the University of Wyoming.

In the 1980s, Hugh bought a used Camaro. "An old man bought a kid's car because he was

‹
**Hugh's photograph was taken
with well-known entertainer
Mickey Rooney in 1952, at a
base camp near Freedom Bridge
on the Imjim River, South Korea.**
(Courtesy of Hugh Ridgely)

never able to afford one," he said. It had mag wheels, and he always kept it shiny. When he drove
the Camaro, the police would stop and harass him, especially at night. "I noticed that," he said. "They
thought it might be kids in the car with drugs, booze. That was their excuse as to why they stopped
me. The only time they didn't bother me was when I drove my old truck." He drove the car for five or
six years before giving it to a granddaughter.

As a child, Hugh was given the name Ho'nookee Niibei'i, or Rock Singer, and today he is called
upon to give names to others. He lives alone in a small cabin near where he grew up, a mile or so
from the Little Wind River.

Eddie America
A Gulf War Veteran's Return

Back in the old days, warriors achieved honor by counting coup. War was an honor for our men. When the government put the Indians on the reservation, there was no more honor. Fighting for the United States allows men to achieve honor. The philosophy is to protect this land, to protect Mother Earth. That's where the honor is.

Diane Yellowplume, 2004

Several hundred people gathered at the airport in Riverton in March 1991 to welcome Edlore Quiver, Jr., home from Saudi Arabia. He was the first of several Arapaho soldiers to return home from fighting in the Gulf War, and he received a hero's welcome. Most members of his large extended family were there to greet him, along with other tribal members and many non-Indians as well. The Arapaho Eagle Drum, the tribe's official drum group, came to sing honor songs. A color guard from the Arthur Antelope Brown Legion Post of Arapahoe, dressed in green fatigue uniforms and feather headdresses, displayed American flags.

Among those gathered were Eddie's sister-in-law Diane Yellowplume, her daughter Alice Thomas, and her year-old son, Royce "Jake" Yellowplume. Alice, a teenager at the time, remembered waiting inside the small, crowded terminal and watching out of the window for the plane. At first it was just a little blip in the sky, but as it came closer, people became excited and some started to cry. Alice cried too, for Eddie, and because so many people had come to honor her uncle. She remembered the songs sung by the Eagle Drum. She remembered the long line of cars that stretched all the way from the airport, down airport hill, through the city of Riverton, and out to the family home on the reservation.

Many people were waiting in the parking lot, including Diane, holding Jake in her arms. Jake kept reaching for one of the small U.S. flags the other nephews were waving, and his grandmother told one of the boys to give a flag to Jake. Another sister-in-law, Janie Brown (who helped organize the welcoming), remembered her son and other nephews running around the airport parking lot waving their little flags and hollering, "Eddie America! Eddie America!"

No one had quite expected the large number of people who followed Eddie to the family home. Cars filled the large dirt driveway and spilled out onto road and all the way to the highway, and then along the highway all the way to the bridge over the Big Wind River. Eddie's mother-in-law had

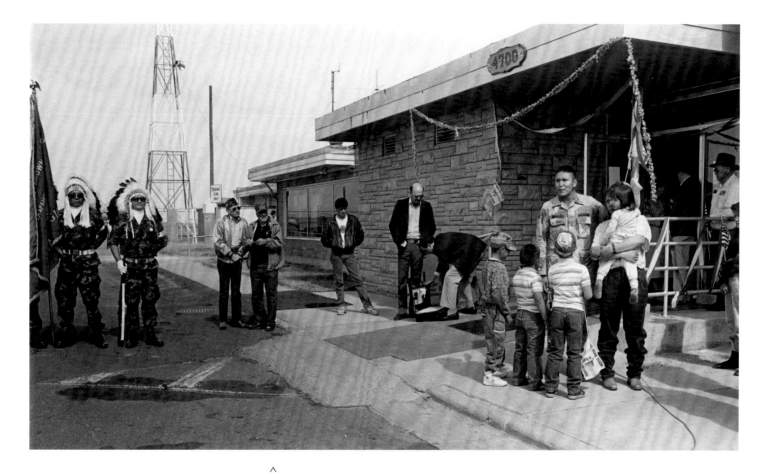

∧

Returning from the Gulf War in 1991, Edlore Quiver, Jr., was greeted at the Riverton airport by his wife, Valerie Brown, and their daughter, Darci (in Val's arms), as well as by his nephews Dawson Smith, Paul Toliver, and John Duran. A color guard from the Arthur Antelope Brown Legion Post of Arapahoe was also there to greet him. Color guard member Wayne Brown is on the left; the other man is unidentified.

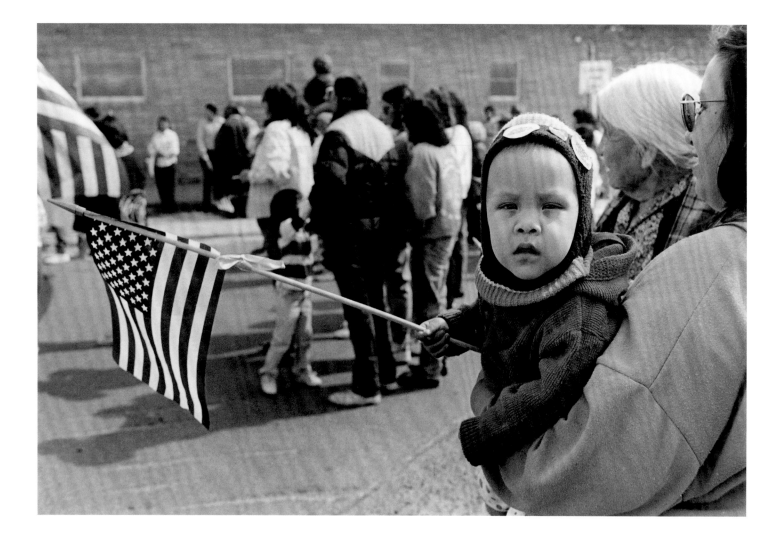

cooked some beans and stew; spontaneously, visitors brought more food. The Eagle Drum sang for two or three hours while people ate and visited. This was just an informal homecoming—three days later, a large feast and welcoming ceremony were held at a community hall.

Diane Yellowplume comes from a military family. Her father, a non-Indian, was a career military man who married her mother, a member of the Oglala Lakota tribe, while he was stationed at an air force base in South Dakota. She didn't know her parents well—her mother died young and her father was transferred away. She was raised first by her grandmother and later by her aunt, who had married and moved to Wind River. Her father always supported her, though, and when she was fifteen years old, she was able to spend several months with him in California before he was killed by a drunk driver. For most of her life, Diane has considered Wind River her home and her aunt's large extended family hers. Their relatives have served in World War II, Korea, Vietnam, the Persian Gulf, and Iraq.

Diane has three children of her own and has adopted twenty-three others "in the Indian way," including the many foster children she has raised. Jake, her youngest son by birth, was born prematurely in 1990. "He was tiny, tiny, tiny. He stayed a baby for the longest time," Diane said. He wore a stocking cap every day because he often got ear infections. When they took him for his checkups, the doctors would give him a sticker and Diane would put it on his cap. He had physical and learning disabilities to overcome during his early years, and he made many trips to the doctor.

A couple of days after Eddie came home, he brought Jake a small teddy bear dressed in army fatigues. They took the clothes off the bear and put them on Jake—the clothes just fit, because he was still so small.

<
Edlore's sister-in-law Diane Yellowplume stood outside the airport awaiting his return from the Gulf War in 1991. She was holding her year-old son, Royce "Jake" Yellowplume, who wore his stocking cap with stickers on it and waved an American flag. Standing beside them was elder Margaret Spoonhunter.

Annie Martina Bull **Ceeh'eenesei**

She talked about how she had struggled when her parents passed away. Through these struggles she gained determination to overcome barriers that otherwise may have hindered her both physically and spiritually. Through the instability in the beginning she became a really stable woman. Materially she didn't have a lot, but she cherished what people gave her. She was always thankful to be alive to enjoy life. She always started out the day with prayer, not only for herself but others as well. She thanked God to be alive to live that day. She enjoyed receiving communion each Friday when the Sisters came to her house. She was delightful and funny.

Irene Houser, 2005

Halloween was Annie Martina Bull's favorite holiday. At times, over two hundred trick-or-treaters would come to her house for treats and to see her dressed up. She would say, "Take off your mask," and if she recognized one of her grandkids she would laugh. Her niece (or daughter, in the Arapaho way), Irene Houser, would help her decorate her house and get dressed up. Once they drove all the way to Casper just to find an outfit for her to wear, and Irene bought a large pumpkin sweatshirt for Annie and a matching hat with a bill in front and one in back. Annie loved it and wore it every Halloween after that.

Annie's life began in hardship in 1924. Her mother, Irene Black Bull, died when Annie was very young. After that, she lived with relatives until she and her sister, Mae, established their own home. Born with a form of dwarfism, she always had trouble getting around, and arthritis caused her to be in pain much of the time. Over time, she also experienced hearing loss. Though she had never attended school, she learned to speak English from her family and other children and learned to sign documents using a stamp or thumbprint.

In the 1960s, Annie moved into a house provided by the Arapaho tribe through a government-sponsored Housing Improvement Program (HIP) for the elderly and disabled. The house was located in a new development near Arapahoe that quickly came to be known as "Ben Gay Heights," a joking reference to an ointment used by elders to relieve arthritis pain. Annie loved her house and took good care of it. Neighbors living in the other HIP houses nearby would come daily to visit and have

>
Annie Martina Bull, with her black and white cat, in her home in 1991.

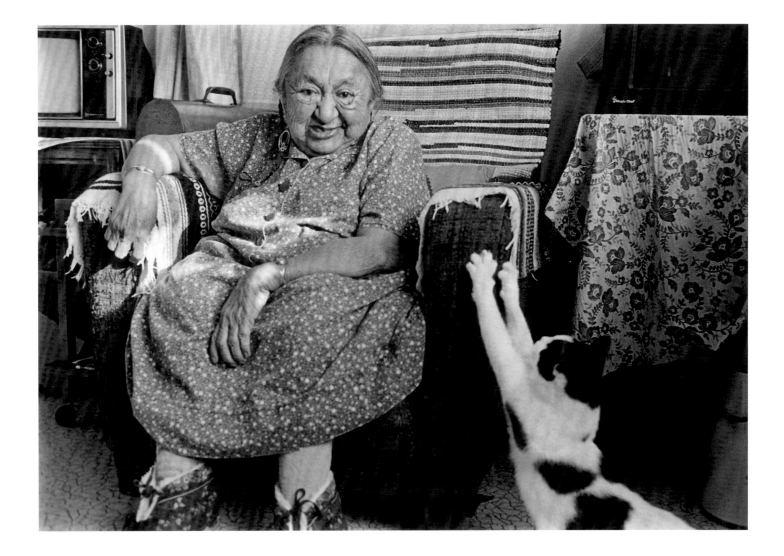

coffee, and she would always provide a meal for them. They would play hand games, tell stories, listen to Indian music, and dance—she always enjoyed making people laugh by standing up and dancing. She lived there for over thirty years, and when she died in 2004 at the age of eighty, her house and only one other were still occupied—most of her elderly neighbors had died and their houses had been abandoned or destroyed.

Annie liked to sit on the porch of her home and wave to people as they drove by on Left Hand Ditch Road. Many would stop to visit her—she rarely was without friends or relatives around. Public health nurses checked on her frequently, and the police would drive by to make sure drunks didn't bother her. She always had cats named after her brothers-in-laws, who were in a joking relationship with her according to traditional Arapaho kinship rules. One cat, a black and white one, would try to please her by bringing her mice and acted as her protector by chasing away stray dogs.

When Annie's niece, Irene Houser, was born in April 1954, Annie helped raise her. . "Annie was there when I was born," Irene said. Irene grew attached to Annie and spent most of her time with her aunt. "She explained the traditional ways. I learned Arapaho from her, and she would always speak Indian to me all the time. She told me about God and that I should pray every day. She gave me a strong foundation in prayer."

Annie always had trouble getting around; after she broke her hip in a fall at an annual Arapaho Sun Dance ceremony, she became wheelchair bound. "She called her wheelchair her wagon. She would say, 'Bring my wagon over here,'" Irene said.

Irene remembered, "She prepared herself before she died." Annie had packed a suitcase, filled with two dresses she had made on an old Singer sewing machine, along with everything else she wanted for her trip—blankets, photographs. The suitcase was buried with her.

Annie was loved and respected throughout the community and was known as a woman of spiritual strength. She was often asked to pray during ceremonies and at feasts and to give Arapaho names. Her Arapaho name was Ceeh'eenesei, or Cedar Woman, a reference to the act of smudging or blessing with cedar smoke.

<

Annie Martina Bull on the porch of her house in "Ben Gay Heights" in 1994.

William Calling Thunder **Woonbisiseet**

When he was eighteen years old and a junior at Lander Valley High School, Bill Calling Thunder enlisted in the navy. He served in the Pacific for several years during and immediately after World War II and was the last of many Arapaho soldiers or sailors to return home from the war. In recognition of this, he was given the name Woonbisiseet, or Last to Return, by Old Man Chester Yellowbear.

Shortly after his return, Bill married. He and his wife, Verna, lived in a small frame house near the Little Wind River west of Ethete, back in the days when the river was clean and clear and bobcats and other wildlife were abundant. There, Bill and Verna raised their six children, as well as several other relatives and foster children, and the river was an important part of their lives. They hauled water from the river in an old black car. They would skate on it in winter, fish from it in summer, and eat the wild game they hunted there.

The river also helped support their cattle and horses. After they married, Bill and Verna obtained ten cows from the Arapahoe Ranch through a repayment program. They repaid the loan with two heifers a year for several years and eventually built up a large herd. Horses were a Thunder family tradition—Bill's father had raised and trained racehorses, and Bill carried on and expanded the line. He used the traditional ways of working with horses taught him by his father and other elders—gentle handling and training, and doctoring in the Indian way, according to the moon.

For many years, Thunder cattle and horses grazed along the river and just on the other side of it in Big Horn Draw, a large unfenced area of 32,000 acres that stretched from "river to river, highway to highway" in the center of the reservation. Bill would tell his children stories of the draw—stories of ancient burials, cattle rustlers, and two dead soldiers propped against a rock. As they rode after their stock, they would see wild horses and wild dogs and, once, an albino coyote. One of their stallions, a black Thoroughbred named Okie, would bring his mares in from the draw every year just before the spring runoff, cross the river, and come all the way into the corral. Bill would say, "Okie's bringing 'em in, showing us the colts." After the runoff receded, Okie would take them out again.

Bill and Verna raised their children to work hard on the ranch and to take care of the livestock no matter what. Bill would tell them, "If you ride, take care of your horses before yourself. Feed them. Water them. Then come in and take care of yourself." The children worked all summer and after school in the winter hauling water, feeding livestock, and driving tractors. After all the chores were

>

William Calling Thunder at his home near Ethete in 1991.

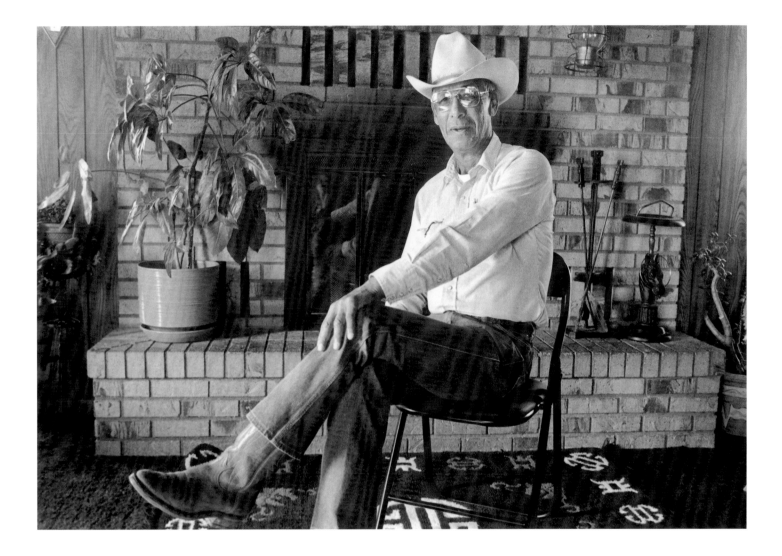

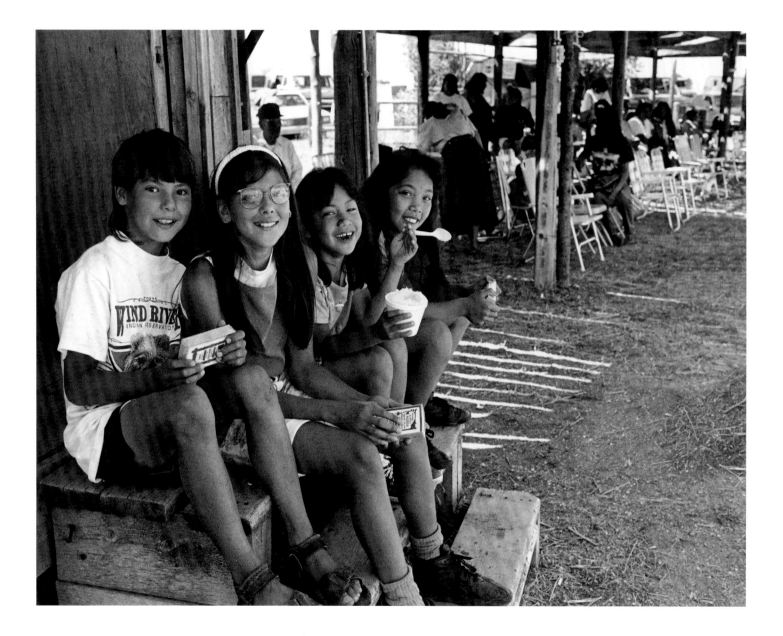

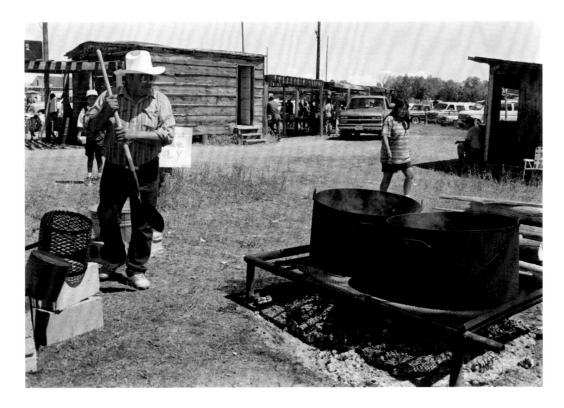

< Bill's nephew Keith Goggles used a shovel as a spoon to stir pots of boiling meat for Bill's memorial feast in 1994; Keith's wife, Cleo *(background),* helped.

done, they would ride horses for fun or maybe "watch on" at a powwow. But work came first, and Bill would tell the children, "Families that powwow all summer never own anything."

In addition to ranching, Bill worked for over thirty years for the Bureau of Indian Affairs roads department as an engineer and surveyor. He died in 1993 at the age of sixty-six, just a few years after he retired. A year after his death, his family held a memorial feast and giveaway in his honor. Friends and family traveled from around the nation to attend.

Bill got his children and grandchildren started with their own herds of horses and cattle, and today they maintain their herds in part as a remembrance of their father and grandfather. They don't have as many animals they once had, and their stock is all under pasture, not out in Big Horn Draw.

< Bill's grandchildren Teke Thunder and Rainebo Thunder and family friends Lillian and Isabel Yasana passed out prayer cards during the feast and giveaway in his honor.

Each summer, the Thunder family sponsors the Bill Thunder Memorial Horse Races during the Ethete Powwow weekend, and they eventually hope to establish a riding and rodeo arena at Ethete that will also bear his name.

The old frame house where Bill and Verna first lived was torn down a few years ago, so no one would get hurt if it collapsed. Bill had long ago built a larger house next door; Verna and other family members still live there.

>

Clarinda Burson, Oskie Yasana, Rhonda Glenmore, and Janell Thunder *(left to right)* **waited for the memorial giveaway to begin.**

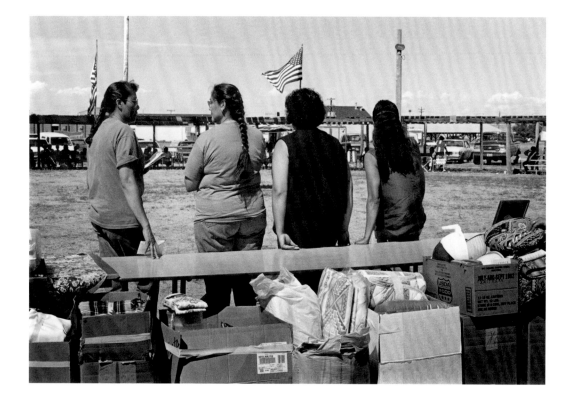

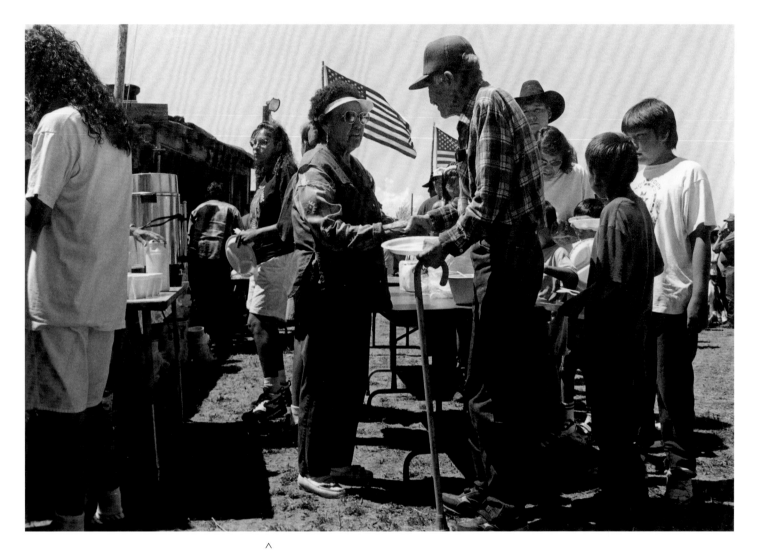

^

At the community feast, Bill's sister-in-law Bernadine Friday
greeted elder George Sun Rhodes as he passed through the
serving line. George was accompanied by his grandsons
Michael Yawakia and Elliott Sun Rhodes.

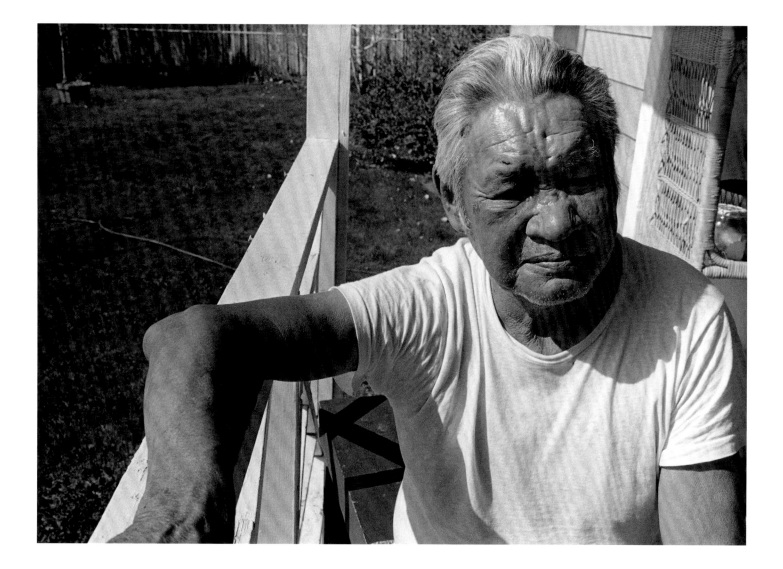

Herman Walker **Hoowoobeh'ei**

Herman Ambrose Walker's Arapaho name was given to him shortly after he was born in 1926. The family asked an old warrior named Teestou', or Strikes on Top, to give the boy a name. Teestou' was from the Gros Ventre tribe, a Montana tribe closely related to the Arapahos, but had lived at Wind River for many years and had given many names. As a young man, Teestou' had been going along a river where there were many chokecherry trees. Enemy warriors were nearby trying to find him. A chokecherry tree spoke to the warrior and told him, "Come here," and then "Get up in here." In honor of the chokecherry tree that hid and saved him, Teestou' gave the name Hoowoobeh'ei, or That Old Chokecherry Tree, to Herman.

Despite having only a sixth-grade education, Herman was a "jack-of-all-trades" who knew plumbing, wiring, and carpentry; over many years, he had built or remodeled many of the houses in the Ethete area, where he lived with his wife, Sarah. His Arapaho name and the story behind it were a strong part of Herman's identity, and he enjoyed recounting the story to anyone who was interested.

Sarah Angela Armajo, whose Arapaho name was Wooniitouu, or One Who Hollers, was born in 1924; she married Herman when she was twenty-one. Neither of them ever owned a car or learned to drive, and she would frequently be seen on reservation roads walking to one of the many jobs she held over the years or to the store or to town. Because she was always friendly, people would pick her up and take her where she needed to go, and once there she would wait for someone to come by who could take her back home. After years of working as a cook and housecleaner in Lander and on the reservation, she was forced to stop working outside of her home because of complications of diabetes and other health problems.

Sarah had learned to sew when she was a child—first from her mother and then as a student at St. Stephen's boarding school. She sewed for herself and her family, and because she was always looking for ways to make money, she gradually started selling things. After she retired from wage work, she devoted most of her time to sewing dresses, shawls, dancing outfits, and quilts for others. She would go to yard sales to find old clothes from which she made patchwork quilts, and she taught herself to make star quilts from a magazine. "Word got out," said her granddaughter Avis Blackie. "She made quilts for everyone." Her star quilts, used in ceremonies, were ordered months in advance. In the summer, she would set up her quilt frame in her yard, and during the school year she would be asked to demonstrate sewing and quilting to students.

<

Herman Walker on the porch of his home at Ethete in 1992.

Avis has good memories of being raised by her grandparents. They provided a warm, safe home for her when her parents could not. Her grandmother taught her to sew, and Avis would help her and get paid a little. Her grandfather Herman taught her the Arapaho ways and told her old stories. He would talk about the importance of having an Indian name and of giving Indian names to children and grandchildren. And he was fun, too. One day Herman announced they were going to Disneyland—"to go see Goofy"—so they boarded a bus to California, went to Disneyland, and then came home.

There is another side to the story of Herman and Sarah Walker. Avis Blackie is one of the few Arapahos who are willing to talk publicly about the problems of alcohol and drug addiction on the reservation, and although she loved her family, she does not hesitate to speak of the problems it caused them. Herman was an alcoholic. Of Herman and Sarah's five children, four died alcohol-related deaths, including Avis's mother. One of them was a "park ranger," the reservation name for the "winos" who hang out in Riverton City Park. Another son was beaten so badly that he is permanently disabled. Avis's brother also died in an alcohol-related suicide. Only Sarah never drank—she had tried it once and hated it. Avis wondered, "I don't know how my grandmother was able to keep going. She was very religious."

Avis was teased (her mother called a drunk) and dropped out of high school, married, and started partying. But Avis eventually decided that "just because my mom was a drunk, that doesn't mean I'm gonna be one." She obtained a high school equivalency degree from Central Wyoming College in Riverton and a bachelor's degree in psychology and a master's degree in counseling from the University of Wyoming. Herman encouraged her and kept her going. "Stick with your education, Avis," he said. "You have what it takes." She now works for a counseling service and speaks out on the problems of alcoholism. "I have no family because of alcoholism. It makes me angry. I'm all I've got for family—me and my kids. I'm all they've got. They don't have a grandmother or grandfather to help them."

Herman died in 2000; after the death of his daughter, Avis's mother, he had given up drinking for the last ten years of his life. Sarah died two years later.

>

Sarah Walker sewed star quilts in the back room of her home in 1992.

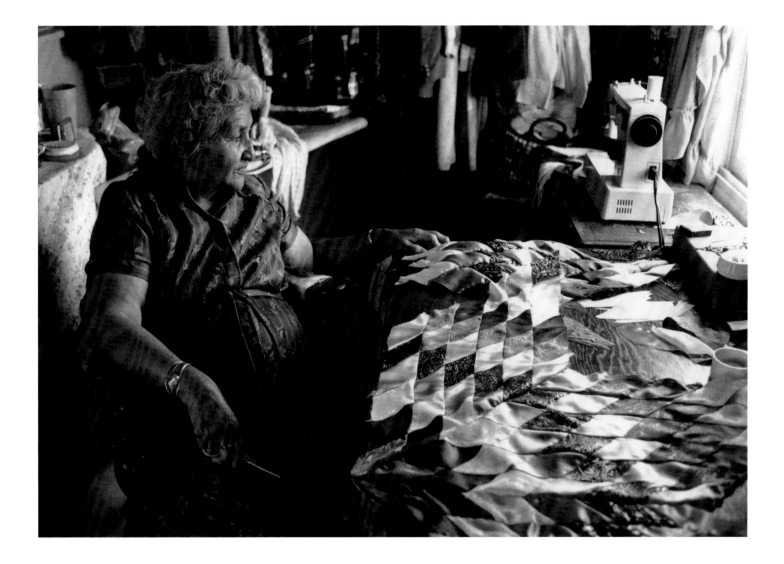

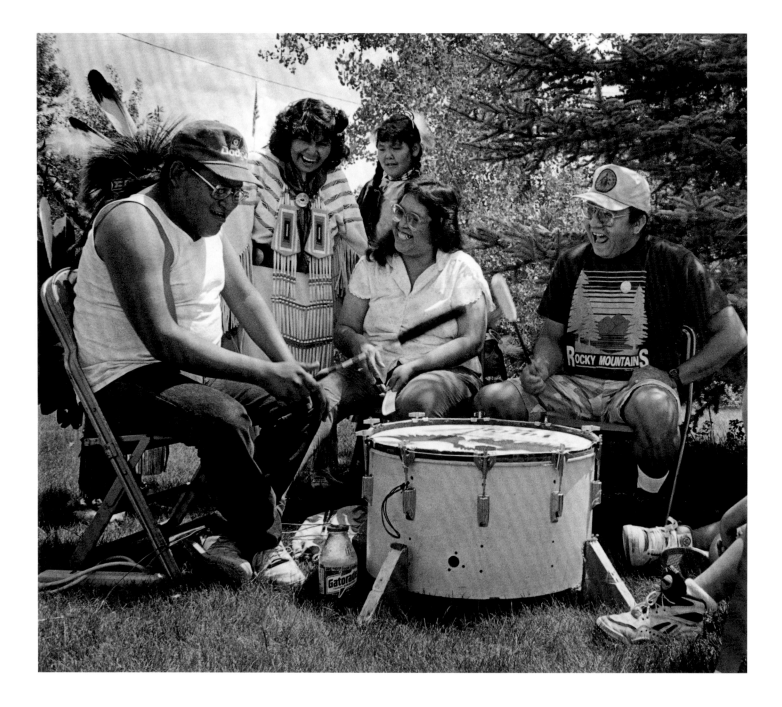

Iron Cloud
A Powwow Family

Pat and Sandi Iron Cloud and their children and grandchildren are a self-described "powwow family." All year long, but especially in summer, they travel to powwows throughout the western United States. It costs a lot of money, and they travel frugally. Often, they take turns driving through the night so they don't have to get a motel room; when they reach a powwow grounds, they camp out (sleeping in their van and tents) or stay with friends or relatives. "We take lots of blankets and bug spray," Sandi said. They also take along food and snacks so they don't always have to eat in restaurants or at expensive concession stands near the powwow arenas.

The Iron Cloud family forms its own drum group; they take turns with other drum groups at a powwow, playing and singing during competition dances (open only to enrolled or associate tribal members) and intertribal dances (open to anyone). Sometimes they are asked to be "host" drum—the group that sings honor or grand entry songs—and they will be paid a little money. Individual family members also dance in competitions, and sometimes one of them will win prize money. They save up the money made at one powwow to go on to the next powwow. Like many other American Indians, they are part of an all-Indian, intertribal world that stretches across North America.

Shortly after Sandra Moss of Ethete married Pat Iron Cloud, an Oglala Lakota from the Pine Ridge Reservation in South Dakota, in 1982, they started a drum group called simply Iron Cloud. They bought an old bass drum, painted an eagle design on it, and used it for many years. Later, with the help of the staff at Wyoming Indian High School, where Sandi is an English teacher, they made a drum of hide. They call the drum "the old man." Sandi said, "You take care of it and it will take care of you. Don't let it sit out by itself. Respect it. No one using drugs or alcohol is allowed to sit there. You cover him if it is raining." In 1999, they changed the name of their group to Little Sun, or Hiisiis Hokecii, the Indian name of Sandi's grandpa Paul Moss. The name had been given to Paul when he was young, and after he died the name went to his son Paul Jr. After Paul Jr. died, Sandi asked the family if her youngest son might have that name; at the same time, they also took the name for their drum group. In the 1990s, they started another drum group, High Eagle, made up of students from Wyoming Indian High School, which performs primarily at school events.

Drum groups such as Iron Cloud follow a strict social pattern and rules of etiquette. A group consists of men who sit in chairs around a large drum; each man sings and beats the drum with a

<

The Iron Cloud Drum Group took a break during a "request" performance in Lander, Wyoming, in 1992. *From left:* **guest singers Charles Dewey and Frances Merle Haas, dancer Inez Haas, and drum organizers Sandi and Pat Iron Cloud.**

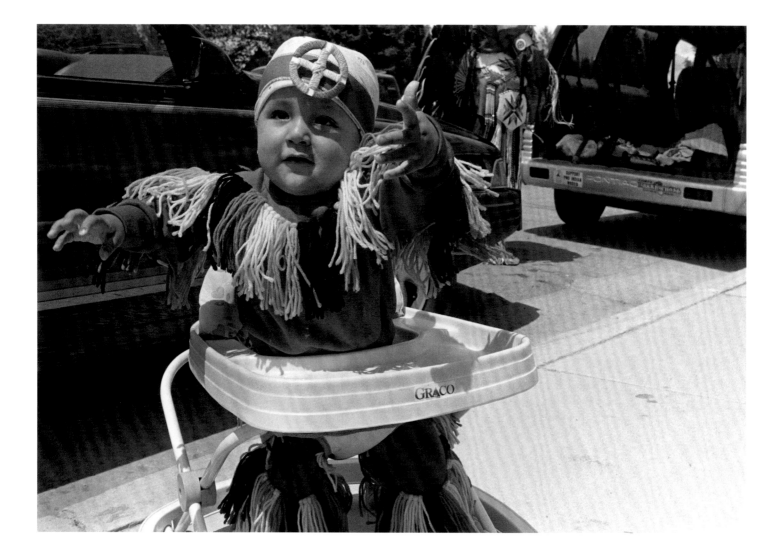

single drumstick covered with soft leather. Women stand behind the men at the drum and sing with them, coming into the song at appropriate times and singing at a higher pitch. Pat Iron Cloud, as leader of his family drum group, chooses a song and determines its speed, rhythm, and range, as well as the number of repetitions. Other family members and guest singers follow his lead. He determines which man will take the "honor beats," or strong, loud beats that punctuate a song; the right to take "honor beats" must be earned. In making his decisions, Pat pays close attention to the response of the dancers and spectators and in turn responds to them. As with all drum groups, they must know a vast number of songs: songs belonging to particular tribes or families that they sing upon request, as well as a large and ever expanding repertoire of intertribal powwow songs.

 In addition to playing at powwows, they are also called upon to sing the Arapaho flag song and honor songs for community events when the Eagle Drum, the official head drum group of the Northern Arapaho Tribe, is not available. Before they sing that kind of song, however, they ask permission from the Keeper of the Eagle Drum. "We don't like to step in front of that drum," Sandi said.

 They are also asked to give what they call "request" performances, usually for visitors and tourists unfamiliar with the American Indian powwow tradition, and they have developed a program specifically for these occasions. They sing a grand entry song (the first song of a session of dancing), a flag song (a tribe's equivalent of a national anthem), an intertribal song (a social dance song for everyone), and songs for each style of dancing: fancy, traditional, jingle, and grass. They end with a friendship dance in which audience members are encouraged to participate. In May 1992, they gave a "request" performance at a park in Lander, a performance that was videotaped in preparation for a trip to Europe. Among the dancers they brought with them was their nephew, seven-month-old Mylan Glenmore, Jr., who danced in his stroller wearing a grass dance outfit.

<

Mylan Glenmore, Jr., danced in grass dance regalia in his stroller at a "request" performance in Lander, Wyoming, in 1992.

Ada Whiteplume **Hiseikusii**

Every spring, Ada Whiteplume would have one of her relatives clear a spot and dig a fire pit in her backyard. She would place bricks around the edge, then place a sturdy grate over the fire. Almost every day, all summer long, she would build a fire in the pit with wood her family had collected along the river or in the mountains. There, under the large cottonwood trees that kept her yard shady much of the day, she cooked for her large family and for others who requested her help.

Frequently and often without advance notice, people would bring Ada the ingredients for stew, frybread, or fried chicken and ask her to prepare these foods for family or ceremonial feasts. She never refused to help anyone. "Until the last year of her life when she didn't feel well, she did a lot of work for other people," her daughter Lucy Whiteplume Mesteth said. "Everybody really liked her cooking, especially her frybread." She was rarely paid and never requested payment.

Lucy watched and tried to learn how to make frybread the way her mother did. Ada had no recipe—she would just mix up the dough using flour, baking powder, salt, and water and fry it in Crisco oil. Ada also sliced meat the traditional way, into thin strips, for her family and others, and Lucy learned the technique from her mother: "She said cut it right in the middle to where it is real thin, then cut it sideways. Put your hand underneath and feel the knife through the meat, to know how thin you got it. Just keep trying till you get it. You have to have a lot of patience."

Ada Waterman had been born in 1929 in a hospital on the reservation, and as a young child she lived for many years at St. Stephen's boarding school. In 1943 she married Bert Whiteplume, and they moved to Ethete, near Bert's family, where they lived for the rest of their lives. They were together for forty-seven years until Bert's death in 1990; they had eight children, two of whom died young. While growing up at St. Stephen's, Ada had been forbidden to speak the Arapaho language, and she and her husband made little effort to teach their children the language or give them Indian names because they didn't know how life would be in the future. The Arapaho name that she had been given when she was very young, Hiseikusii, was rarely used, and today no one is sure of the name's meaning.

After leaving St. Stephen's school, Ada tried a lot of other religions besides the Catholicism taught at the mission; she eventually settled into a small Pentecostal congregation near Ethete. Although she didn't participate in traditional Arapaho ceremonies, she often helped her husband and her brother, Joe Waterman, by preparing food for ceremonial feasts. "They respected each other's

>
In 1992, Ada Whiteplume shaped pieces of dough into frybread and fried them in hot oil over a fire in her back yard.

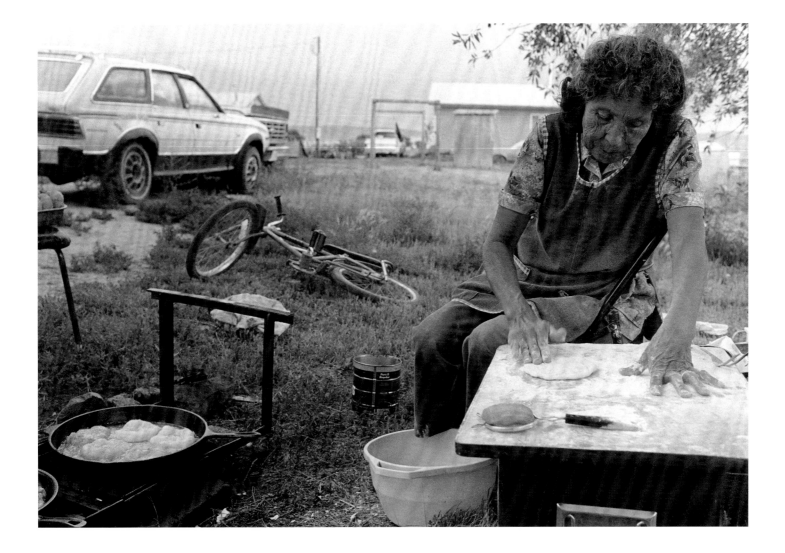

ways," Lucy said. "They would never say anything bad about each other's religion or beliefs, because they loved one another."

Ada had been a sickly child, and while at St. Stephen's she had spent a lot of time at the infirmary. Her scalp was scarred from childhood illnesses, and she always wore her hair fluffed up to hide the scars. In later years, she suffered from lupus and arthritis, and she died, in 2000, at the age of seventy-one. Her last year was a real struggle, Lucy said, and toward the end she would say she was getting tired and wanted to go home. At the time of her death, she had at least sixteen grandchildren and twenty-three grandchildren, and many more have been born since.

Today, Lucy lives with her family in Ada's old house near Ethete that Ada left to her and a grandson she was raising. Lucy had met her husband, Philip Mesteth (an Oglala Sioux originally from Pine Ridge, South Dakota), while they were students at Central Wyoming College in Riverton, and they have been married for many years. They have two children of their own and have raised a niece and a nephew. Philip is a hunter, and Lucy still slices the wild game meat he provides, the way her mother taught her. She still makes frybread, though she has to guess at Ada's recipe. And she still misses her mother: "Not a day goes by I don't think of her. I spent most of my life with her. She lived for her grandkids. It broke my heart when she left."

>

In 1992, Ada's daughter Lucy Mesteth worked on the other side of the fire, watching the frybread, turning the pieces over, and removing them from the hot oil.

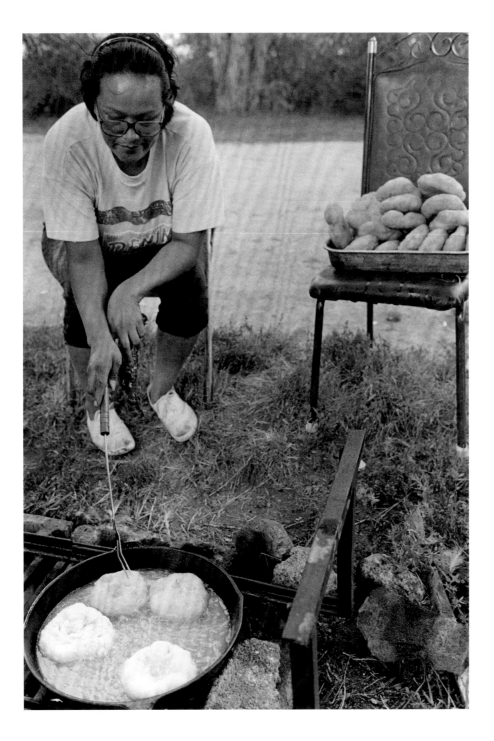

Ben Friday, Jr. **Wo'teenii'eihii**

My name is Ben Friday. I'm sixty-seven years old. I was born May 2, '33. Today I'm going to talk about the Arapahos....

Now on my father's side, my grandpa, we figured he was born in 1830 and that was the Arapaho Indian that got lost down along the Cimarron or Arkansas [River], whatever they call it. But at that time that's where the Mexican border was. And they lived around Bent's Fort. And my grandpa was educated ... but I'm getting ahead of my story now.

He was out hunting one day, I think he was age 13 or 14, and he was out hunting for rabbits. And the warning came that the tribe had to move. So they moved and they tried to come back and look for him, but when he got home he didn't find no tipis, nothing. Only thing he found was a dugout where they put branches over it and put dirt on top of it and that's where the dogs used to sleep and live. So he couldn't find anybody, and they sent warriors back to look for him but he thought that was the enemy so he hid. And he managed to survive there, I don't know how long, until Fitzpatrick and Kit Carson found him and they said he was wild as an animal, they had to tie him. And every time they let him loose he'd try to get away from them. That winter they went back to St. Louis, Missouri and they took him back with them. Fitzpatrick found a school for him, to put him in, and he lived with some people there for quite a while. I think about seven, eight years. And he found a girl he was pretty fond of but, I don't know how to call this, but that girl couldn't marry him because he was an Indian. And he got wind of that and that's why he told Fitzpatrick he wanted to come back west.

Well, when he was 21 or 22 years old, they brought him back. Fitzpatrick was out here and he asked these camps where these Arapahos were and they said the boy that had been lost was called Black Spot. He had a birthmark on his back toward his hip. And he showed these people that birthmark and people said that was him. So he stayed with the Arapaho and Fitzpatrick went back. And then, he was an interpreter for a lot of the different tribes, because he could talk English.

Now, going back. That's the story of my great-great-grandfather.

Ben Friday, Jr., 2000

>

In the fall of 1993, Ben Friday, Jr., and two of his grandsons, Turning Star Friday and Winslow Friday, examined deer just killed by family members.

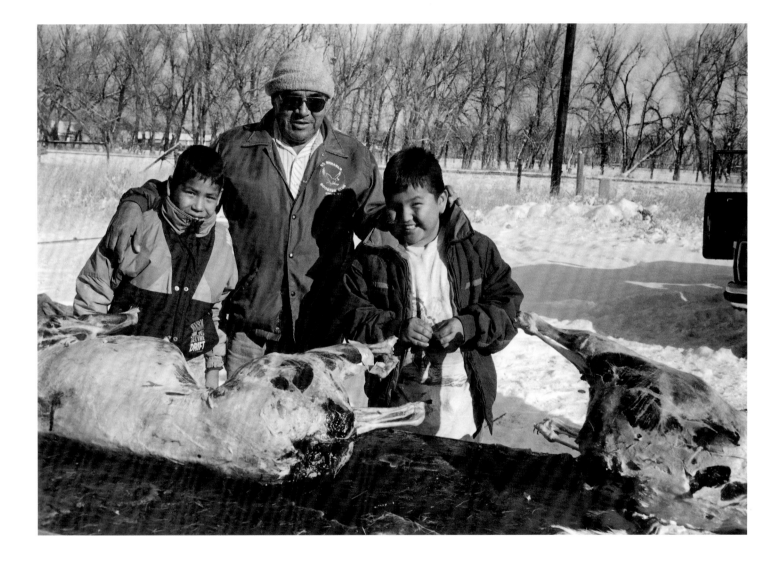

Ben Friday, Jr., was one of several Arapaho elders who participated in the Sand Creek Massacre Oral History Project conducted by the National Park Service and the Northern Arapaho Tribe. Ben, who had always enjoyed collecting family histories and genealogies, told the story of his great-great-grandfather, who was given the name Friday by the mountain man and trader Thomas Fitzpatrick. Fluent in English in the days when it was not understood or spoken by Arapaho people, he became an important interpreter and intermediary between Arapahos and non-Indians. Chief Friday moved his band to Wind River in 1878, when Northern Arapaho bands were placed on the reservation, and died three years later. He left behind a large family, many of whom have become tribal leaders.

Like his great-great-grandfather Chief Friday, Ben was an intermediary who frequently met with government officials and lobbied for better treatment of Indian people, even participating in sit-ins in Washington, D.C. He was especially concerned about education, and in the 1960s and 1970s he helped establish Wyoming Indian High School and served on its board for many years.

For most of his adult life, Ben worked at Susquehanna Uranium Mill on the reservation and later at the Atlantic City Iron Ore Mine in the mountains to the south, where he was a "spell foreman," the man in charge when the foreman was gone. He retired when the mine closed in 1983.

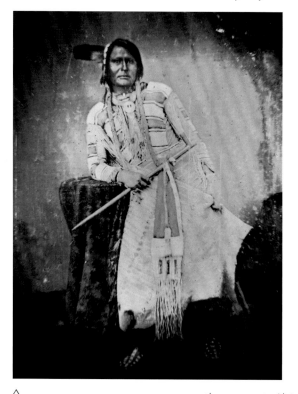

^

This daguerreotype of Chief Friday was taken by John H. Fitzgibbon in St. Louis, Missouri, 1851–52. According to Paula Fleming in *Native American Photography at the Smithsonian: The Shindler Collection,* **Friday went to Washington, D.C., after signing the Treaty of Fort Laramie in 1851, as a member of a mixed tribal delegation, and this portrait was taken on that journey.** (Courtesy of National Anthropological Archives, Smithsonian Institution, NAA INV 06098800)

But his love was for his family and the outdoors. Ben was married for fifty-three years to Alvina Willow Friday, and they had nine children and many grandchildren and great-grandchildren. He, his family, and close friends often camped in the mountains to hunt and fish. During hunting season, he would take a pack train of horses into the mountains for a week, come back for supplies, and go back up for another week. He especially liked the St. Lawrence Basin area and often went to Yanti Lake, one of many pristine mountain lakes on the reservation. After he died, the family journeyed there and found the trail steep and full of shale; they realized what an excellent horseman he must have been to take a pack train of horses over the trail. After his health deteriorated—he had heart bypass surgery in the 1980s and was diagnosed with cancer in the 1990s—he was no longer able to hunt, but his children, grandchildren, nieces, and nephews continued the tradition of providing wild game for their family and other elders in the community just as their ancestor Chief Friday had done.

Ben's Arapaho name Wo'teenii'eihii, or Blackbird, was given to him when he was young by a grandfather from Oklahoma. Before he died in 2003, he gave the name to one of his great-grandsons.

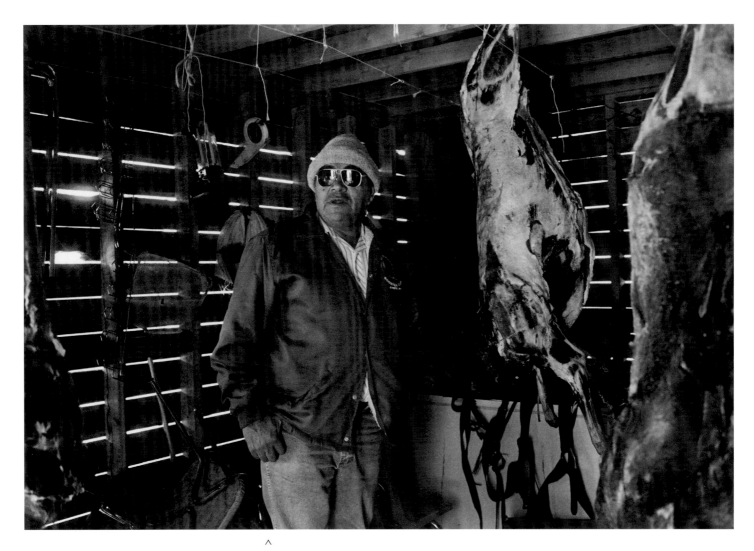

Ben Friday, Jr., admired the freshly killed deer carcasses hung
in his shed in the fall of 1993.

The Name Giving **Neniisih'oot**

It was given to me to pass on to him, 'cause he's named after Raphael—Sugar Ray. I got this discharge from the Marine Corps, and the flag. I gave him a name, same time, with this discharge here. I gave him a name along with the flag.

I gave that Indian name over there. Oh, it's that eagle. They call that eagle hiinooko3onit—with the black-tipped feather. Hiinooko3onit. We used to listen to him when he comes. He's just a sound like a rushin' wind.

I was calling on the old people, "Come, give us a name." Then the eagle flew. He screamed up there. He was way up there. You know, you never know what's gonna happen when they hear up there. They come from up there—Estes Park is where their home is. I see him comin' way over there. He hollered. He screamed. I don't know if anybody heard all the screamin' up there.

Down here, we could hear him comin'. We know who it is. He's like a mighty rushin' wind. He come down. We waited and he come. His name I gave to him, Raphael Allen—Sugar Ray, and now an Indian name is derived from that eagle, hiinooko3onit.

He gave a blessing from up there on to him. I heard that eagle come. I don't know if anybody heard it but I heard it coming. Hiinooko3onit—the eagle with the black tip.

He went way back up there, screaming "iiiiiiii"! I don't know if anybody heard it, but I did. Hiinooko3onit. Back to Estes Park.

I pass it on, the message I gave them. You carry on that message—the message that you get from an old man who spoke.

Paul Moss, 1994

On a Sunday afternoon in February 1994, Paul Moss, Sr., gave an Arapaho name to his two-month-old great-grandson. At birth the child had been given the English name of his great-uncle (Paul's son) Raphael Allen, a Vietnam veteran who had died many years before. He had also attracted Raphael's nickname, Sugar Ray.

Relatives and friends slowly gathered in the parish hall of St. Michael's Mission at Ethete while Paul waited quietly, the baby sleeping on his lap. He had brought with him his son's veteran's flag and honorable discharge to present to the new Raphael. When all was ready, including the food for

<
Paul Moss gave an Arapaho name to his great-grandson Raphael Allen Glenmore in 1994. Sitting with him were his granddaughter Avalene Glenmore, mother of Raphael; Raphael's brother Mylan Glenmore, Jr.; and Raphael's father, Mylan Glenmore, Sr. Gifts for Paul were placed at his feet, including a blanket, towel, gloves, and cash.

the feast to follow, Paul was escorted to the front of the room and sat down in one of three folding chairs placed there. On his right sat his granddaughter Avalene Moss Glenmore and Raphael's older brother, Mylan Glenmore, Jr., and on his left sat the children's father, Mylan Glenmore, Sr. The children's maternal grandmother, Gladys Moss, and other family members laid gifts at Paul's feet, the kinds of gifts usually given to an elder for performing naming ceremonies: a blanket, a towel, clothes, and cash. Gladys then presented Raphael to Paul and quietly asked, with bowed head, for a name to be given.

Paul spoke in Arapaho, in the formal oratory style of the elders. He called on the grandfathers for spiritual aid. He summoned the eagle to come from the traditional Arapaho homeland of Estes Park, Colorado, and the peaks that surround it. Then Paul said the name that had also been the Arapaho name of his son Raphael—Hiinooko3onit, or Golden Eagle.

Following the giving of the name, the child was handed to his maternal grandmother, who held the child and spoke his name. She passed the child to his maternal grandfather, Alonzo Moss, Sr., who also held the child and spoke his name. Hiinooko3onit was then passed around the room to other relatives and friends, who did the same. The prepared dinner was served, and for dessert there was a cake with the sugary inscription "Welcome Raphael Allen, Sugar Ray." A baby shower followed, and presents such as clothes, blankets, quilts, and toys were given to the baby's family. Hiinooko3onit slept through everything.

The Arapaho word for the giving of a name is *neniisih'oot.*

<

Raphael's grandmother Gladys Moss displayed a cake with Raphael's name on it that was served at the dinner following his naming ceremony.

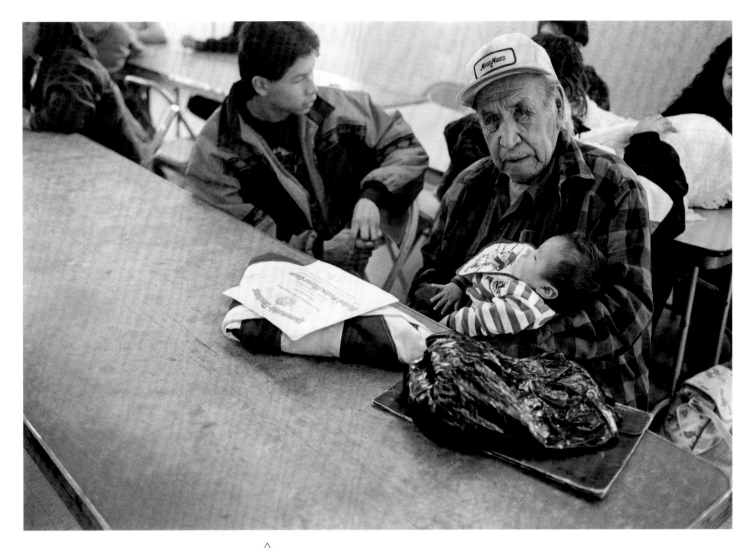

∧

Paul waited with Raphael in his arms for the naming
ceremony to begin. His grandson Norcees Carrier, Jr., sat
beside him, and his deceased son's military discharge and
flag were on the table in front of him.

∧
Immediately following the naming ceremony, Raphael's
grandfather Alonzo Moss, Sr., took the child, spoke his name,
and passed him to other relatives.

^
Raphael's father, Mylan Glenmore, Sr., watched over him as
he slept following the naming ceremony.

Flora Dewey **Noobesei**

One day in 1926, when Flora Goodman was sixteen years old, a young man brought two horses to the home she shared with her family. Her parents came out, and the man presented the horses to them and asked for Flora. Flora had never seen the man before and had not been told by her parents that her marriage to this man had been arranged. "He is a good man, you must go with him," her parents said. The new couple went by wagon directly to St. Stephen's Catholic Mission, where a priest performed a marriage ceremony. They then went to their new home—a tent pitched in an area called Big Wind, along the Wind River near Arapahoe. Their marriage lasted until Raphael Dewey's death forty-six years later.

Flora and Raphael lived the rest of their lives in the Big Wind area, first in the tent and then in a small log house that Raphael built, where all ten of their children were born. Life was hard in the early days of their marriage. Flora would cut up flour sacks to make shirts for Raphael, dresses for herself, and clothes for her children, and she washed everything by hand—they couldn't even afford a washboard. Water and wood were hauled from the river, a mile or so away, and the children would bathe in the river. Their only transportation was by horse and wagon—neither Flora nor Raphael ever owned or learned to drive a car. To get by, they raised a few cattle and horses, and Raphael would occasionally do wage work such as riding the irrigation ditches. It was "a strugglin' life, but a good one," according to their twin daughters, Frances Dewey and JoAnn Dewey Birdshead, who said their parents always tried to find ways to make their lives comfortable.

Flora stayed home most of the time to care for her family. "Don't be leavin' home—take care of your kids," she would tell her daughters. But she also retained a lifelong commitment to St. Stephen's Mission, where she had attended boarding school. For many years, she and other women belonging to St. Anne's Sodality would help make quilts, baskets, and blankets to give to the poor at Christmas, and they would sponsor a feast and activities day at the mission on Memorial Day. Later, she participated in Native American Church as well as traditional Arapaho ceremonies.

In 1958, the family moved into a larger home, also built by Raphael, a short distance from the first. Until she died, she lived in that house, which was eventually surrounded by newer homes belonging to children and grandchildren. A grove of towering cottonwood trees surrounded the houses, and Flora liked to spend her time under the trees—cooking, beading, sewing, and entertaining visitors with stories. Frances liked to watch Flora entertain visitors there. "She was really

> **Flora Dewey and her daughter JoAnn Birdshead at Flora's home in 1994.**

94

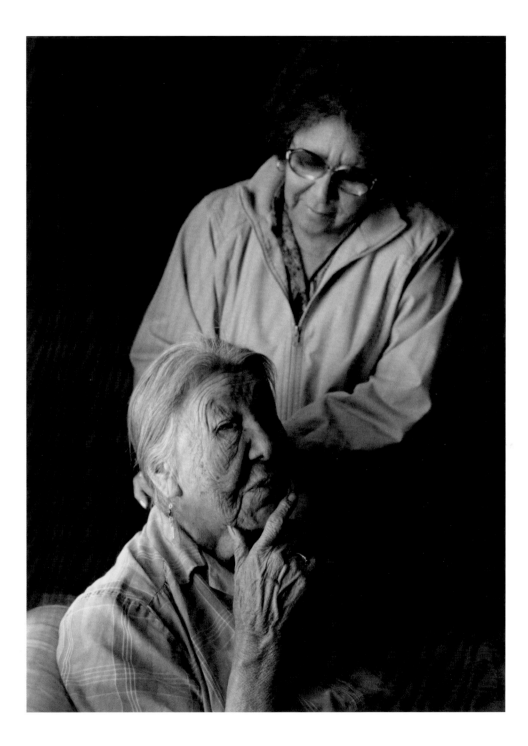

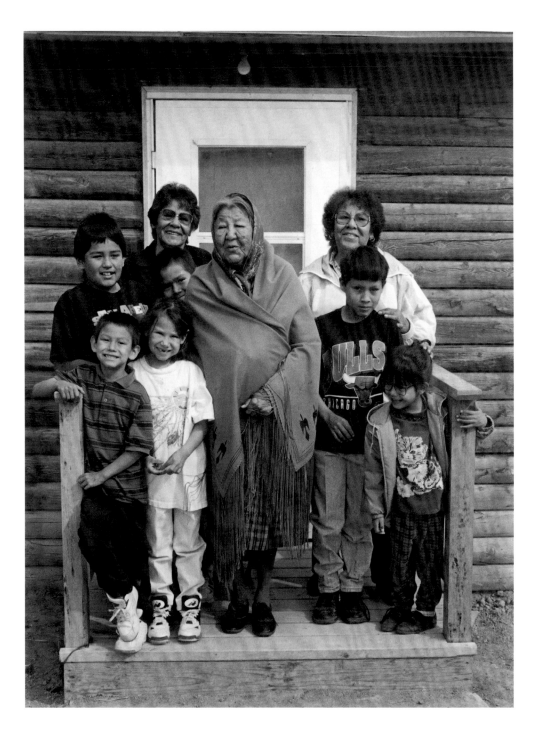

good to them," Frances said. Flora knew the old language and told the old stories but never allowed her words to be recorded. "What I know, I want to take it with me," she often told her daughters. She was an excellent craftsperson and like many other women of her generation made her own dresses. She always used a lined or plaid fabric, not the flowered fabrics that many other Arapaho women preferred.

Frances and JoAnn think Flora knew she was going to die. When the youngest of the grandchildren she was raising graduated from high school in May 1994, she told them, "My work is done." Although in apparently good health, she died suddenly a month later of a massive stroke. She had no Arapaho name at the time of her death. Several years before, she had given her lifelong name Noobesei, Southern (or Oklahoma) Woman, to a granddaughter.

When JoAnn and Frances were born in 1940, no one knew Flora was going to have twins. Like their siblings, they were raised at the family's Big Wind home. But while Frances and the others stayed on the reservation, JoAnn married a Southern Arapaho man and lived away for many years. Like her mother, she too struggled to raise her children but in a very different way. Her children were born "one right after another." It was hard for her—she was away from home for the first time and had no help from her extended family. She stayed home with her children and washed a lot of diapers. "There were no Pampers then," she said. Later she and her husband moved back to Big Wind, but their marriage didn't last.

Struggling to raise her children by herself, JoAnn asked for and received a job at St. Stephen's Indian School. At first she worked with the school nurse, then became a teacher's aide, and finally became an Arapaho culture and language teacher for kindergarten through eighth grade. She found teaching difficult because "the kids have no respect for teachers." So she taught students about respect and asked that they call her *neiwoo,* or grandmother. For three of the five years she taught, Frances was her assistant; they both retired at the age of sixty. JoAnn died a few years later, in 2006. Her Indian name was Heni'ei, or Long Hair. Frances continues to teach Arapaho language and culture for tribal programs.

<
Flora Dewey on the porch of her daughter's house in 1994 with her twin daughters JoAnn *(left)* **and Frances** *(right)* **and several of her many great-grandchildren.** *From left:* **Jordan Barraza, Philip Whiteplume, Amber Whiteplume, Andrew Whiteplume, Alvin Talks Different, and Rachael Dewey.**

Eugene Ridgely, Sr. **Nebesiiwoo Beni'inen**

When Eugene Ridgely returned from World War II, he became interested in a young lady named Lucille Goggles. When her family refused to let him talk to her, he asked elders to arrange a marriage in the old way. Eugene liked to say that this was the last arranged marriage among the Arapaho people, or "it was almost an arranged marriage," since he already knew who she was. They were married in 1948 and soon moved to the Arapahoe Ranch, a tribally owned ranch located on the northern border of the reservation. First he was a cowboy and then became a manager, and eventually he and Lucille decided to start their own ranch. They bought an old railroad car parked at the railroad station at Arapahoe for forty dollars and paid another hundred dollars to have it moved to land near Ethete that had been given to Eugene by his grandfather. They added a kitchen to the car and remodeled it into a front room with a couch where he and Lucille slept and a back bedroom where their children slept. "It was a very comfortable home," Eugene said. A few years later, they were able to build, with their own labor, a three-bedroom log cabin.

Eugene and Lucille had five children and also raised a foster daughter. They continued ranching successfully for many years, but when Lucille became ill in the late 1970s, Eugene gradually sold out—first to pay Lucille's medical bills and later, after her death, because he didn't have the heart to keep on ranching.

Eugene had started elementary school at St. Stephen's boarding school, where he was mistreated. The discipline was harsh: if students spoke Arapaho, they would be hit across the legs with a long switch until they cried. If they spoke it a second time, they would be taken to the basement and made to lean against a wall for hours; some children would pass out or fall over. It was a poor school, and for morning, noon, and evening meals they were served thin soup that got thinner as the day went on. After the first year, he refused to go back. The priests said he would go to hell if he didn't go back to school, but when they came to get him, his mother told them to leave and told them it wasn't right to treat children that way. He then attended elementary school through the eighth grade at St. Michael's school in Ethete and from there went to high school in Lander, where "he stuck it out" for three years before joining the army in 1944. He felt that he and the few other Indian students who attended off-reservation public schools were not treated well.

>

Eugene Ridgely, Sr., painted a buffalo motif on a rawhide drum at his home near Ethete in 1994. Artwork by himself and others decorated his walls, including a poster of his Sand Creek Massacre hide painting visible just over his left shoulder.

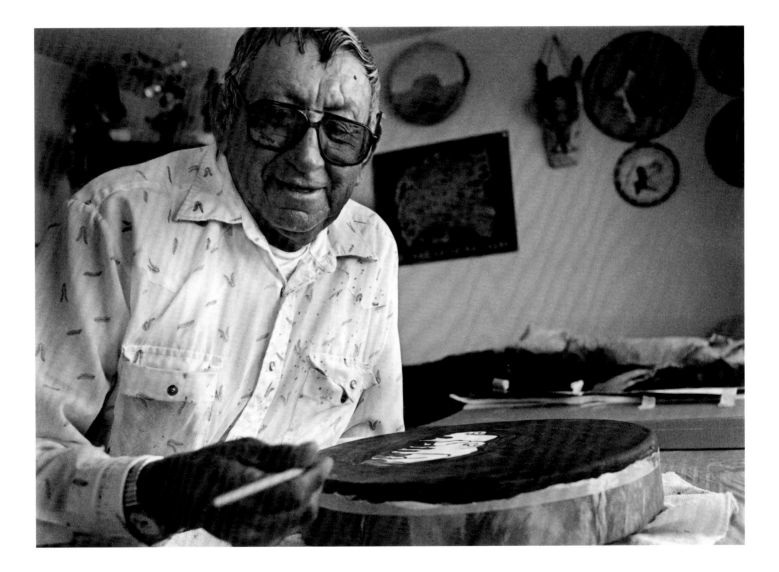

Eugene had always liked to draw or paint Indian scenes and give them away. One of his high school teachers had saved his art; when he returned from the army, she showed him her collection of his work. While he was in the army, an officer recognized Eugene's talent and arranged for him to attend the Art Institute of Chicago on a full scholarship. Instead, he returned home, married, started his life as a cowboy and rancher, and continued to draw Indian scenes and give them away.

After Lucille's death, he devoted his life to art. Within a few years, he and his son had established an art gallery in Riverton and were attending Indian art fairs and markets around the country. He received two Best of Class awards at the Scottsdale All-Indian Fine Arts Festival and two first place awards at the Northern Plains Tribal Arts Festival in Sioux Falls, South Dakota. His work was purchased for museums and private collections throughout the West and was included in a book of Indian art published by the Minneapolis Institute of Art.

In 1994 he painted, on a hand-tanned elk hide, a depiction of the 1864 Sand Creek Massacre of Cheyenne and Arapaho Indians based on an oral account that had been handed down through his family. The hide painting was exhibited in Colorado, and a photograph of it was used on a historical marker in that state. The painting's display coincided with several studies of the massacre site and the effort, led by Colorado senator Ben Nighthorse Campbell, to create a national historic site at Sand Creek in southeastern Colorado. Eugene devoted himself to this effort by participating in the studies and working with the National Park Service to obtain oral histories. He was one of several representatives of the Northern Arapaho Tribe in all negotiations and on-site investigations, and he encouraged and supported memorial runs to honor the victims of the massacre.

While Eugene would probably define his life as that of a rancher and an artist, he was also active in many other aspects of life on the Wind River Reservation. He was a member and commander of the Ethete legion post; he served on many tribal committees, including the Christmas Committee, the Credit Committee, the Arapahoe Ranch Board, and, for twelve years, the Northern Arapaho Business Council; he was a 4-H leader and a member of school boards. His military record continues to be recognized: a Combat Infantry Badge, a Philippine Liberation Ribbon, and a Bronze Star received when he was a member of the Thirty-seventh Infantry Division fighting on Luzon in the Philippines.

Eugene gave his name Nii'eihii Hiitouwut, or Eagle Robe, to a grandson two or three years before he died in 2005. At the time of his death, his children and grandchildren didn't want him to "go home" without a name, so they asked a traditional elder to give him one. He will now be remembered as Nebesiiwoo Beni'inen, or Grandfather Soldier. The runners who had participated in the Sand Creek Memorial Runs led the funeral procession to the small family cemetery across the fields and slightly uphill from his home on Ethete Road. The only other grave there is that of his wife. When Lucille died in 1980, Eugene said, "I didn't want to go on, but she told me I would live a long time."

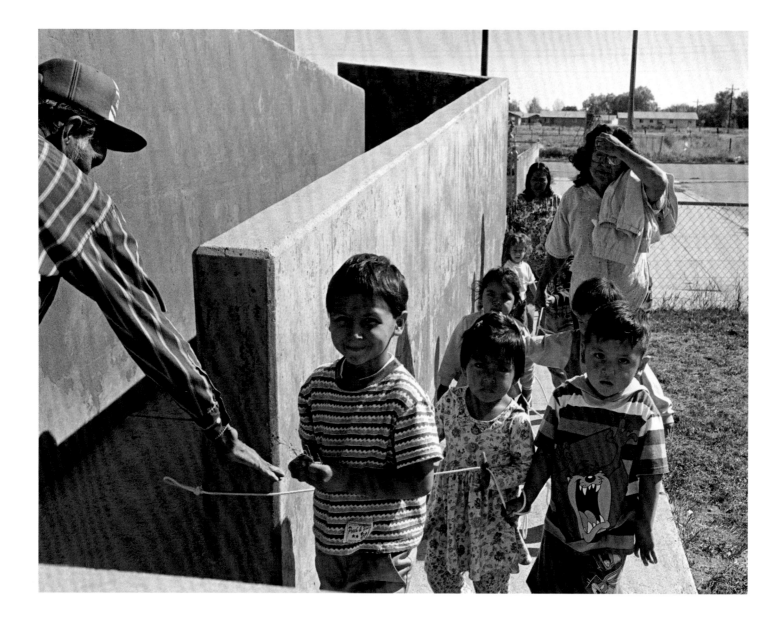

The Arapaho Language Preschool
Hinono'eitiino'oowu'

Typically, the pattern of language loss usually begins with young adults becoming bilingual, speaking both their indigenous language and the language of the majority population. Their children then become monolingual, speaking only the language of the majority population, until eventually only the older people are left as speakers of an Indigenous language that has become a minority language. Left unattended or neglected, the process of language loss continues until the last indigenous speaker dies.

One of the objectives of the preschool immersion project was to demonstrate how children could be guided toward achieving a speaking ability that would allow them to interact with instructors and each other in Arapaho. Underlying the implementation of the immersion class was the idea that if children could gain fluency before reaching elementary school then the task of language instructors would shift to focusing on maintaining fluency rather than trying to create fluency under almost impossible conditions.

Dr. Steve Greymorning, 1997

Arapaho language instruction in reservation schools, despite the desire of board members and parents to implement successful programs, has failed to produce fluent Arapaho speakers. Though taught by elders fluent in Arapaho, classes are usually limited to less than an hour a day, two or three days a week at most—not nearly enough exposure to produce fluency. Anthropologist Steve Greymorning, who worked as director of language and culture programs for Wyoming Indian Schools for several years during the 1990s, recognized the need for more-intensive language instruction for all students, especially the very young. In 1994, he founded the Arapaho Language Preschool Immersion Program, also referred to as Hinono'eitiino'oowu', or the Arapaho Language Lodge. Over two hundred students between the ages of three and five have attended the program.

On first observation, it seems like any other preschool: children play with Legos and dolls and action figures, go to the playground, eat a small lunch, take a nap. But their instructors talk to them only in Hinono'eitiit—the Arapaho language. Recorded Arapaho music, videos, and stories are used frequently, and pictures with Arapaho captions adorn the walls. However, verbal interaction between

<

In 1994, instructor Danny Goggles led a procession of Arapaho Language Preschool students from the playground back to their classroom, each holding a loop tied into a rope. Students in the front are Marcus White, Elisa Armour, and Mylan Glenmore, Jr. Behind Elisa is Ashley Dewey, and behind Ashley is Amber Greymorning. Instructor Ruth Goggles is behind Mylan, and bringing up the rear is instructor Myrtle Oldman.

the children is mostly in English, and when they leave they return to mostly English-speaking homes.

Although Greymorning is now on the faculty of the University of Montana, he continues to make the eleven-hour journey to Wind River to supervise Hinono'eitiino'oowu'. He and his staff continually work to improve the quality of language instruction. Based on his work at Hinono'eitiino'oowu', he has developed an innovative program—Accelerated Second Language Acquisition—that helps create what he calls "maps" of language knowledge. Teachers in the preschool as well as public schools attend his workshops to learn these new teaching techniques and to develop age-appropriate educational materials.

Marcus White attended the Arapaho Language Preschool Immersion Program for two years in the 1990s. He doesn't remember too much about it, just that his instructor, Danny Goggles (who was his uncle), was an inspiring teacher who made them mayonnaise-and-potato-chip sandwiches. Later, at Wyoming Indian Elementary School, he attended mandatory language classes but felt the classes didn't accomplish much. According to Marcus, "The kids just didn't want to learn the language." Now, like most of his fellow Hinono'eitiino'oowu' students, he has lost most of his ability to speak the Arapaho he learned at an early age.

Linguist Andrew Cowell, director of the Center for the Study of Indigenous Languages of the West at the University of Colorado–Boulder, has also worked extensively with the Arapaho language revitalization effort. He agrees with Marcus. "There are plenty of successful methods for teaching foreign languages, including Native American languages. But that is not the fundamental obstacle. The bigger problem is that young people may want to learn the language but there aren't enough social incentives and rewards to really make it seem worthwhile for them to keep at it and use it. After all, they don't really 'need' to learn it anymore. Linguists, as far as I've seen, haven't figured out good ways to motivate communities to learn indigenous languages. That's probably not their job anyway—the motivation has to come from within the community."

As community awareness of the need for more language classes for students and adults grows, Hinono'eitiino'oowu' is viewed by many Arapahos as one step in the language revitalization process. "To build a language it takes a whole community," Greymorning said.

>

Malia Means played with toys, including Easter baskets, at the Arapaho Language Preschool in 1996.

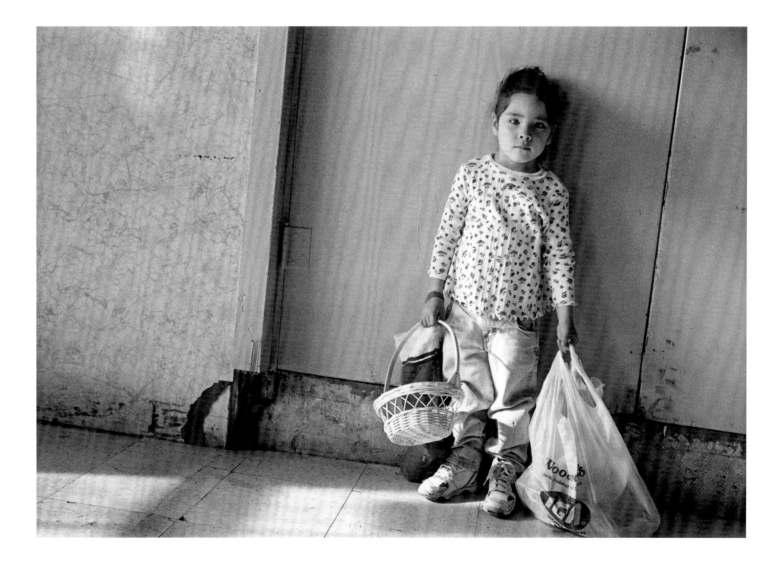

Jessie Swallow **Hicei**

She depended on me for a lot of things. I depended on her, too, for advice. If I hurt or was sad, she helped. If my body ached, she would press me and talk to me about what to do. . . . She was a real little old lady—you couldn't change her mind. . . . She was a simple woman, you had lots of fun with her. . . . I miss her because she was always doing crazy, funny things that made you laugh. Then my sister Florine was there to do that, but now she is gone, too.

Gloria St. Clair, 2004

Gloria St. Clair's husband, Ed, is an enrolled Shoshone. Always a hardworking man, over the years he worked several construction projects and later worked for the Eastern Shoshone Tribe and reservation schools. Gloria's mother, Jessie Swallow, liked Ed because he provided a good home for his family and took good care of his children. But out of respect, Jessie never went to their home. Out of respect, she never talked to him.

Respect—*heeteenebetiit*—is an important concept for traditional Arapaho people. It refers in a general way to a person's relationship to the world, including the human, natural, and spiritual environments. Arapaho kinship, which differs greatly from the Anglo-American variety, offers specific guidelines for how respect between relatives is to be shown. Respect between mothers-in-law and their sons-in-law requires almost complete avoidance. They do not speak directly to each other; if communication is necessary, it is done through an intermediary. In the strictest interpretation, they are not to be in the same room or to even look at each other. Jessie's generation of women, the second generation to be born on the reservation, closely practiced this kind of respect, though subsequent generations have followed the custom less closely.

The records of Jessie Wallowing Bull's birth were destroyed in a fire, so she took the date of her baptism at St. Michael's Mission as the date of her birth—February 14, 1914. She married young, to John Swallow, a Southern Cheyenne, and gave birth to her first child at a very young age. Ten more children followed, five of whom died at birth or in their first few years. Jessie and John were married for sixty years and for most of their lives lived in a small house down by the Little Wind River near Ethete. By the time she died in 1997, she had over thirty grandchildren and many great-grandchildren. John had preceded her in death by a few years.

>
Jessie Swallow, wearing a traditional hand-sewn dress made by her niece, was photographed at her daughter's home in 1995.

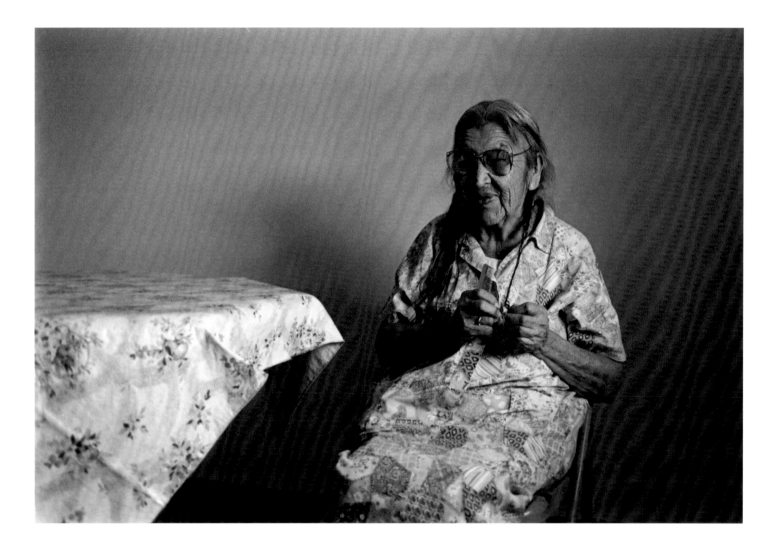

"I always felt nothing was hard," said Gloria, talking about growing up in the little house by the river. "We had a one-room house with one bed, and everybody slept in the bed. We hauled wood and water. But everything was simple—there was nothing to worry about. We went to Lander maybe once a month. A quarter was a lot of money. It didn't bother me to be broke. Mother always said 'Let it go, something's gonna work out, as long as you have food—coffee, tea, and bread.'"

"She was a real traditional woman," Gloria said of her mother. Jessie was never involved in tribal politics and did not attend General Council (a meeting of all enrolled tribal members) because she thought it encouraged people to fight each other. If her children were involved in a conflict, she would tell them to "let it go." She prepared food in the old ways, slicing meat from wild game and drying berries. She knew how to give massages called *teebeinoot,* or pressing—a gentle discontinuous kneading of muscles, used both casually and for healing purposes. She spoke Arapaho almost exclusively and was ashamed of her broken English, yet she questioned whether the Arapaho language should be taught in the schools because she had been punished for speaking it at St. Michael's boarding school.

Jessie made her dresses by hand. She also made slips—sleeveless shifts made of muslin worn under her dresses. As she grew older and her eyes got bad, she would have her niece make them for her, or she occasionally bought dresses at Baldwin's store in Lander, which stocked the dresses that Indian women liked.

During Jessie's last years, her children and grandchildren would take turns caring for her and taking her places. She would always be ready to go. Gloria remembered, "When we took her someplace she would say, 'Behave, don't say anything' because she knew we liked to tease. 'Don't tease if I'm coming with you,' she said."

Her lifelong name was Hicei, but the story and meaning of her name have been lost.

>

**Jessie and her daughter Gloria
St. Clair at a family feast in 1990.**

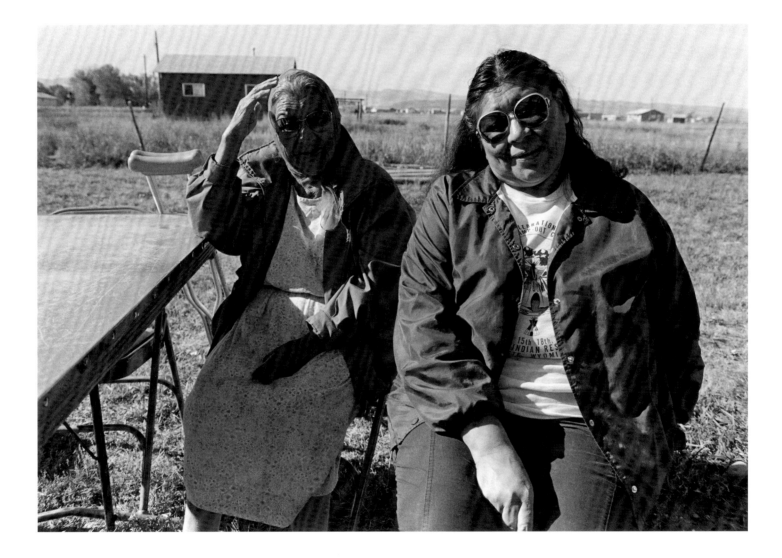

The Butchering **Ceniihooot**

In the spring of 1995, Ardeline Spotted Elk's nephew brought her five skinned and quartered elk he had shot during a special-permit spring hunting season that allows families to obtain meat for summer ceremonials. Ardeline and other women of her family gathered in her yard for *ceniihooot*—the butchering. She later explained about preparing traditional foods:

That's what they would do, these old ladies. The men, the boys, would spread out the game on canvas and quarter it, then the ladies would butcher. There would be quite a bit of meat—maybe fifteen elk or deer. No license was required for hunting, then. The old ladies would bring their own knives, dishtowels, and containers for the meat. Anybody would come and cut their own meat and have it for themselves. The ladies would spread out on the canvas and start slicing meat. They would have lots of fun—joke, tease, tell stories. The daughters would cook lunch and supper, and the old ladies would stay there all day slicing meat. They would quit at dark.

To learn to slice meat, se'soonoot, you sit down and watch. First you cut it in half and feel underneath for the knife. Watch hard. Then cut the other way—to the side. If it is too thick, it will never dry. You dry meat either inside or outside. If it's outside, put a sheet over it or the magpies will drop in and steal it. When you hang it, you don't just forget about it. Turn it over every morning and evening until it's completely dry. If you put it in a sack when it is not completely dry, it will mold. It might take a week and a half to get dry, shorter if it is really hot. In winter, dry it inside. The dried meat, ho'uuw, is stored for sweats and ceremonies, and it lasts a long time.

To make pounded meat, 3o'ohcoo, put the dry meat in the oven until it turns white on one side, then turn it over. Soak the dried meat in cold water or boil it, wrap it up in a canvas, and start pounding with a rock or hatchet until it is broken up. My niece took completely dried meat and put it into a blender to break it up. "It's not pounded meat," I told her. "It's too powdery. You do your white man way," I told her. To make patties, you grind up the chokecherries and mix the chokecherries and pounded meat in a bowl with lard and sugar. Mix all in one bowl, then make your balls. You can freeze the balls or just eat them. Or you can make patties, ceb. Put them outside on a canvas and dry them, keep turning them over like

<
Left to right: **LeAndra Armour, Ian Armour, Kristalyn Spotted Elk, and Elisa Armour took elk ribs to a neighbor's home in their wagon after the butchering in 1995.**

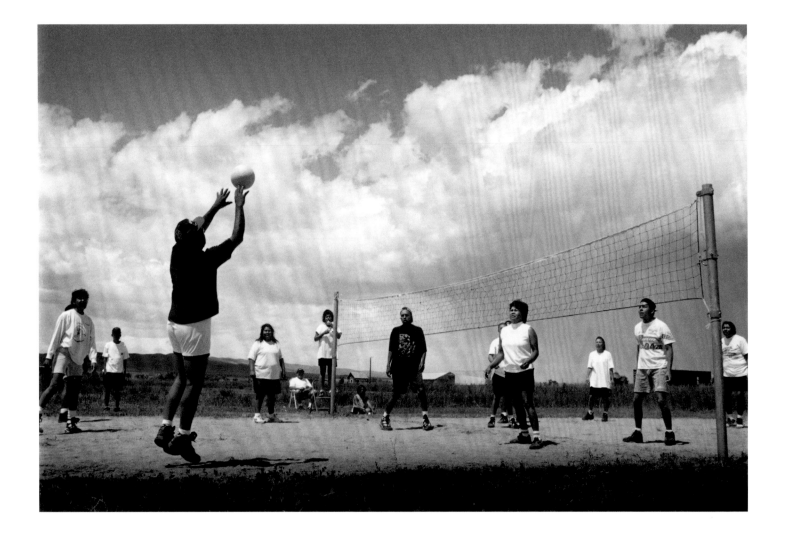

The Volleyball Game
Just to Be Having Fun

Powwows are characterized by performance. Dancers in beautifully beaded and feathered outfits perform elegant and exciting dances. Singers, seated with their drum groups, perform both old songs and new ones they have learned on the powwow circuit. Even the Arapaho word for powwow, *betooot,* refers to dance. But for the community at the center of powwow activities, it is much more. The powwow arena is the site of honoring activities such as giveaways, feasts, and honor dances. The powwow weekend is a time of reunion for families, with relatives often coming from other communities or reservations. It is a time of parades, sporting events, and games.

For the 1995 Ethete Celebration Powwow, Darren Willow organized a volleyball tournament. It was a little tournament, he said, "just to be having fun." He has organized a lot of volleyball tournaments, sometimes advertising through flyers, sometimes just by word-of-mouth. There were four or five teams at this one. He charged a $50 entry fee and gave T-shirts for first, second, and third places.

Darren and the other members of his extended family were encouraged by their grandmother, Clina Willow, to hold tournaments. They had their own family teams and played volleyball every evening near Clina's home. They would play in the rain and in thunder and lightning, too. They would get muddy and drag mud into their houses. Their grandmother used to joke, "What kind of game are you guys playing?"

The volleyball tournament that Darren organized in 1995 was held at a court next to the community hall, right across Ethete Road from the powwow grounds. Just to the west was a ball diamond where a softball tournament was also being held, and next to that was a horseshoe tournament. At the community hall, members of the Yellow Calf Memorial Club were busy cooking a feast they would serve later that afternoon at the powwow arbor. And in the center of all this activity was Clina Willow, who, with the help of her daughters, had set up a small shelter made of plastic tarps and wooden poles that she used as a concession stand. Here, she visited with her customers as she sold them cold drinks and fry bread.

In an arranged marriage when she was fourteen years old, Clina Brown had married Albert Willow. For over fifty years they lived with their eight children near the Little Wind River, surrounded by several generations of their extended families. Her niece (or daughter in the Arapaho way) Rubena

<

A volleyball game during the 1995 Ethete Celebration Powwow weekend included the following players *(from left):* Lisa Hill, unidentified, Leland Hill, Verdonna Valdez, Juan Valdez (seated in chair), Kirsten Martel (standing on chair), Calley Valdez (seated in back), Robert C'Bearing, unidentified, Georgia Willow, Ellie M. Shoyo, Wesley Medicinehorse, and Dominic Medicinehorse.

Felter describes it as a separate little community, on the edge of Ethete, with all their own activities—hand games, volleyball games, feasts. Darren remembers the Memorial Day picnics the family would have in the trees by the river where they would hold hand games and egg-in-the-spoon races.

Clina, who died in 2003 at the age of eighty-four, outlived her husband by ten years. Because of diabetes, she became blind during the last years of her life. The blindness really bothered her, because she had always been busy providing for her family: making donuts or frybread that she would sell in concession stands at various locations in the community or out of her home; making and selling quilts, tent stakes, and other items used during powwows and ceremonies. Her lifelong Arapaho name was Hiisiis Neniibeit, or Sun Singer.

The Willow family continues to carry on the traditions of Clina and Albert Willow: they still have family feasts, volleyball games, hand games, and the sweat lodge ceremonies that Clina especially enjoyed; they still perform the old music; they still gather and use medicinal native plants. Occasionally, Clina's daughters will set up a concession stand somewhere and sell frybread to the community.

>
Clina Willow and her daughter Cora constructed a shade of poles and plastic tarps, where Clina sold frybread and cold drinks during the 1995 volleyball tournament.

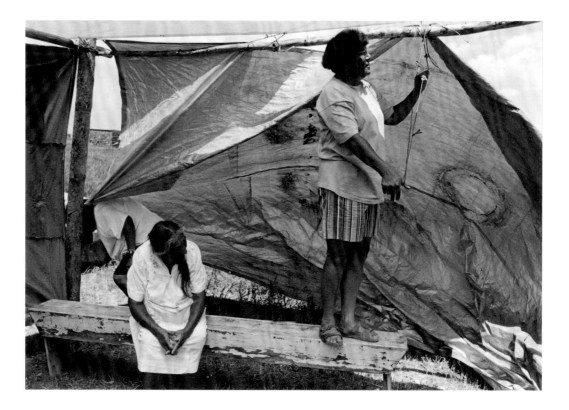

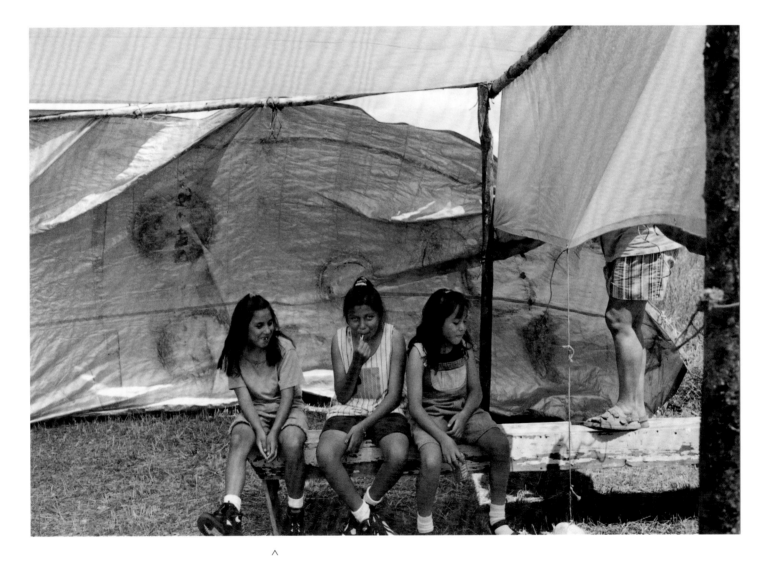

∧

Chanice Glenmore, Tonya Brown, and Candace Brown *(left to right)* visited in the shade being constructed by Cora Willow during the volleyball tournament.

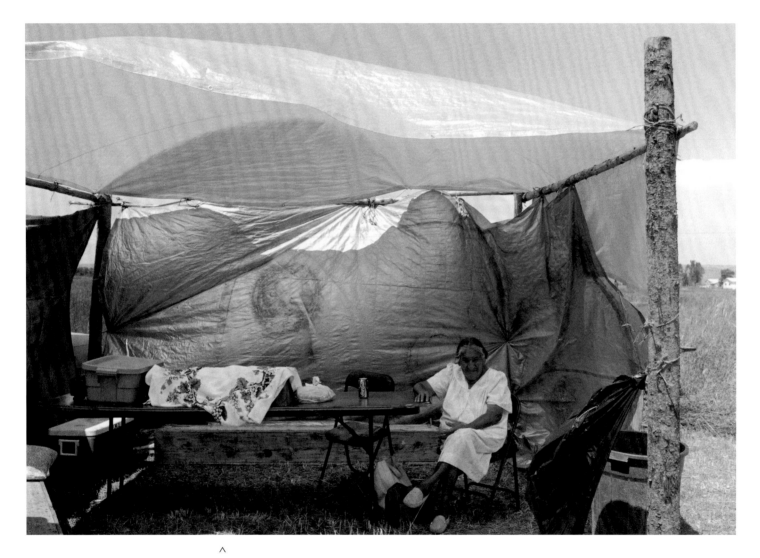

∧

Clina Willow waited for customers in her shade during the
volleyball tournament.

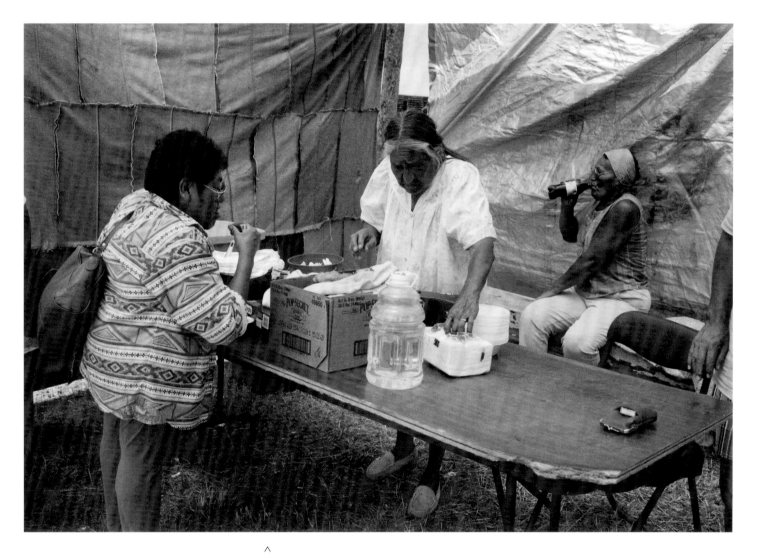

⋀

Marilyn Goggles purchased frybread from Clina Willow in

her shade.

The Native American Church　**Hoho'yoox**

The purposes for which this corporation is organized are to foster and promote religious belief in Almighty God and the customs of several Tribes of Indians in Wyoming in the worship of a Heavenly Father; to promote morality, sobriety, industry, charity, and right living; and to cultivate a spirit of self-respect and brotherly love and union among the members of these Tribes. . . .

　　We, as people place explicit faith, hope and belief in Almighty God and declare full, confident and everlasting faith in our Church, through which and by which we worship God. We further pledge ourselves to work for unity with the sacramental use of peyote and its religious use.

Certificate of Incorporation, 1967

In 1995, members of the Native American Church (NAC) of Wyoming gathered at the Ethete powwow grounds to celebrate the one hundredth anniversary of the introduction of the peyote ceremony to the Wind River Reservation. Speakers had also been invited to discuss the passage, in 1994, of amendments to the Native American Religious Freedom Act of 1978 that allowed them to continue to practice their religion. But participants came primarily to pray in one of three tipis that had been erected for the all-night prayer services, called peyote meetings, that are the hallmarks of the NAC.

　　The ritualistic use of the hallucinogenic peyote cactus has been dated to pre-Columbian times in Mexico and the American Southwest, and by the late nineteenth century the use of peyote had become formalized and was common in Indian Territory (now Oklahoma). According to one account, the peyote ceremony was introduced to the Northern Arapahos in 1895 by William Shakespeare, a young Arapaho man who journeyed to Oklahoma in search of a cure for illness, learned the ceremony, and brought it back to Wind River. Despite some resistance, the peyote ceremony was eventually accepted as a new "way" of prayer that has since coexisted with, but never surpassed, other forms of worship. In Arapaho it is called *hoho'yoox,* the name of the peyote cactus that is at the center of the ceremony.

　　In 1914, at the urging of anthropologist James Mooney of the Smithsonian Institution, who felt it might offer legal protection, peyote ceremony adherents in Oklahoma incorporated as the Native American Church. In 1967, the "Native American Church of Wyoming for Arapahoes and Other Tribes"

>
Hiram Armajo, Sr., and Theresa White relaxed at breakfast following the all-night Native American Church (or peyote) meeting conducted by Hiram in 1995.

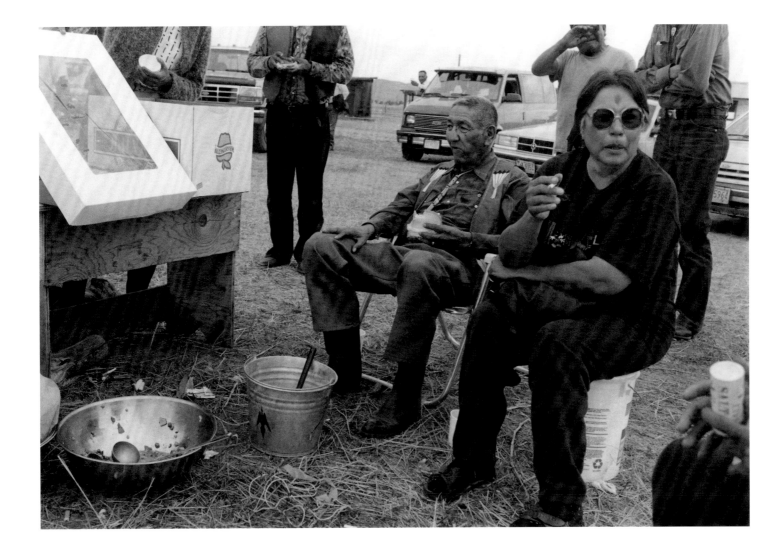

was incorporated. For many years, Indian agents and missionaries tried unsuccessfully to pass federal legislation to ban the use of peyote, but Oklahoma, Wyoming, and other states took a more tolerant view and passed legislation allowing peyote use as a sacrament in NAC ceremonies by members of Indian tribes. In 1978, the Native American Religious Freedom Act was passed to protect the freedom of Native Americans to believe in, express, and practice their traditional religions, but a 1990 Supreme Court ruling denied protection for the use of peyote. In 1994, President Bill Clinton signed into law the American Indian Religious Freedom Act amendments that specifically protected the use of peyote in ceremonies attended by Native Americans.

Among those attending the gathering at the Ethete powwow grounds was Hiram F. Armajo, Sr., who had been one of the original signers of the certificate of incorporation in 1967. Hiram was active not only in the NAC but also in many aspects of Arapaho spiritual and political life. "Hiram very rarely refused to assist anyone in need," his family said. "He was best known for finding time to help relatives, far and near. Hiram believed he couldn't say no, because of his position as a healer, ceremonial leader, one of the Four Old Men, and his own personal philosophy." Hiram, who died in 1998 at the age of seventy-three, had also served ten years on the Northern Arapaho Business Council and worked various jobs on the reservation, including teaching culture and language classes at Wyoming Indian Schools. He and his wife, Mary Belle, were married for fifty-one years and had many children; before her death, she had often assisted him in peyote meetings.

After the death of Hiram's wife, Theresa Hanway White occasionally assisted him in the meetings. Theresa had started participating in peyote ceremonies while attending college and working for different agencies away from the reservation. Finally, a close friend told her, "You need to be home. Go back." She went back to the reservation in 1978, married, raised a family, and took care of her parents and siblings. She has worked in various jobs, continued to take classes at Central Wyoming College in Riverton, and continued to participate in NAC ceremonies.

At the 1995 gathering, Hiram conducted a meeting in one of three tipis that had been erected at the Ethete powwow grounds; other experienced men conducted ceremonies in the other tipis. These meetings, like all others, were conducted at the request of someone who sponsored or "put up" the meeting to fulfill a vow made for a specific reason, such as the health of a loved one. The all-night ceremony, consisting of symbolic rituals, prayer, and music, was followed by a breakfast just outside the tipi. As Hiram and Theresa relaxed and enjoyed breakfast with their fellow worshipers, symbols of the Native American Church could be seen on the water bucket (the water bird) and on Hiram's vest (the peyote fan).

>

Three tipis were set up at the powwow grounds for the 1995 NAC gathering.

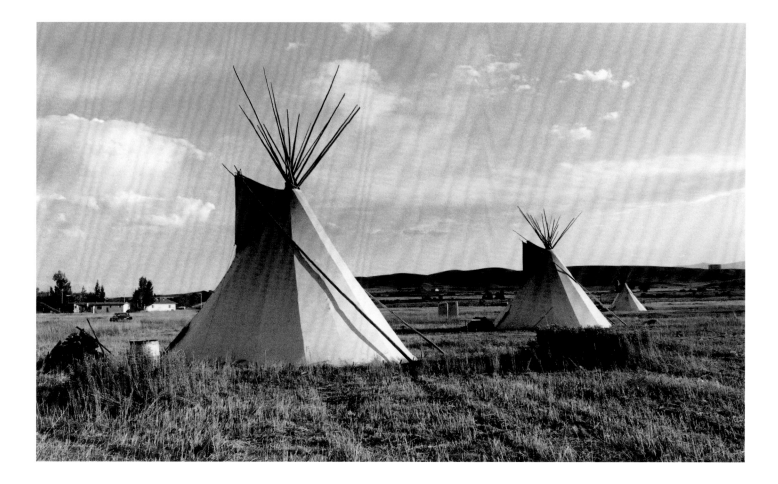

Royce Lone Bear **Ce'eiino3ei**

I was fortunate to grow up in that time when people were maybe—how would I say it—well, they had their own era, their own times. A time when they still had their ceremonies. Kids helped with family life—hauling water, getting wood, around the house—and were well behaved. They grew up close to the family, they were taught respect, taught to help, were well trained. They learned the good life, though we didn't have much. There were times when food was not available. I don't know how my parents fed twelve children. And the transportation was poor—we had to walk a lot. But it was really something to me. In those days, kids helped the father feed the animals. This younger generation has no chores. On the weekend, we would work around, clean the chicken coop, clean the houses. My grandson doesn't know what I knew at that age. He didn't even know how to use a can opener until I showed him the other day. At that age, I already knew horses, cooking, swimming. Today there is education but no skills.

Myself, I had a good time growing up—riding horses, staying overnight way out, fishing, swimming. The rivers were clear—nice blue cold water. You could drink it and swim in it. It was really good [in] them days. Now the water is dirty and polluted, and it is pulled out for the LeClair ditch.

I am glad we still have our spirituality. If you have spirituality, it teaches you respect, love, your ceremonies.

Everything is changing, even in other countries—changing so rapidly. I hate to see the culture decline—it was good for kids. They should experience staying out, horses. That would make our kids better kids, too.

Royce Lone Bear, 2004

>
Royce Lone Bear at Arapahoe School, where he was a language and culture teacher, in 1995.

Royce Lone Bear still lives where he was born in 1941, a few miles from St. Stephen's Mission. On eighty acres of land the family owned, his father and uncles had built the small log home where he and several of his siblings were born. He lived a little ways up the road for a few years while he was married but later, after his divorce, he moved back to be with his mother, who was alone. He cared for her for the last years of her life, until her death in 2001 at the age of eighty-six. Today, Royce lives next door to the old log cabin in a newer, more modern house that was built many years later; there

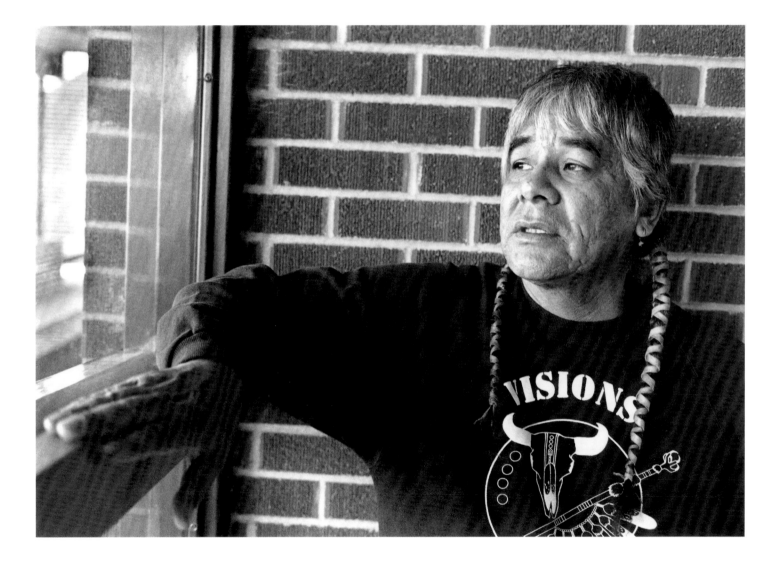

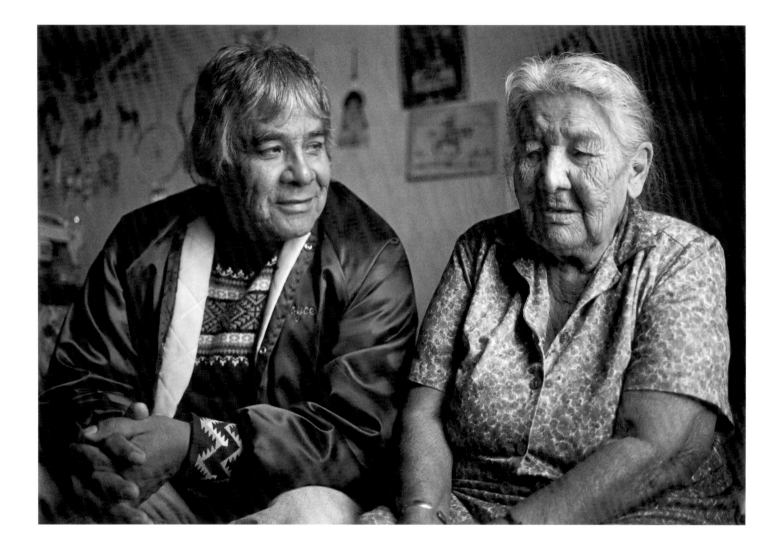

he is raising his grandchildren. He still owns twelve acres of land, the rest having been divided among family members or sold. Only Royce and one sister still live on the reservation—other siblings are living in other parts of the country or have passed away.

Growing up, Royce's mother, Anna Brown, taught him to do beadwork, and he learned feather work from his father, Richard Brown. Traditionally, Royce explained, both men and women did beadwork, but only men worked with feathers. "It was a necessity that I learn," he said, referring to the importance his family placed on artwork for both cultural and economic reasons. He later received training in meat cutting and worked in the profession for many years, continuing to make things to sell on his own or through one of the craft cooperatives that have come and gone on the reservation. For the past thirty-five years, he has been teaching traditional arts to students in schools and camps. "The artwork has been lost, and we want to teach our kids to revive the old arts and crafts. It's important for our kids to keep our culture and heritage alive and going," he said. Using traditional materials such as beads, feathers, paint, rawhide and buckskin, he teaches students to make many things: drums, staffs, warbonnets, fans, and the rawhide containers called parfleches.

When Royce was growing up, it was still legal to trap golden eagles, a bird sacred to Arapahos, and to use feathers and other body parts in ceremonies and regalia. Today, the killing of eagles is illegal and the buying and selling of eagle parts by American Indians is federally controlled, making these items difficult if not impossible to obtain. Royce still uses eagle feathers when he can obtain them from the U.S. Fish and Wildlife Service through a long and complicated application process or when he is given feathers that have been handed down through his family. Using dyed turkey feathers, he teaches students to make warbonnets and dancing fans. Using dyed turkey feathers, he makes items to sell to collectors and museums around the world.

When he was one or two years old, his uncle asked his parents, "Did you give my nephew a name? Well, I'm giving him mine." His uncle took a new name and gave Royce his old one, Ce'eiino3ei, which he translates as He Who Carries His Pack on His Back. In the 1970s, Royce changed his last name from Brown to Lone Bear, the original name of his great-grandfather, who was an important chief during early reservation days. The name of Lone Bear (a translation of his great-grandfather's Arapaho name, Wox Niiseih) had been changed to Lon Brown in the early twentieth century. Several other descendants of Lone Bear have done the same.

<
Royce with his mother, Anna Brown, at their home near St. Stephen's in 1995.

Mary Ann Whiteman **Hinooko3onesei**

My mother would want to be known as a good person—and that speaks a lot about what it means in Arapaho culture. You define good in the Arapaho way of doing things. You are kind, you forgive and forget and move on. She endured a lot to get where she wanted to be. A lot of her values wouldn't fit in today's culture. She strived to be a good person, to live a life without hurting people. Values like alcohol, greed, obtaining things and being successful weren't her way. . . .

She always carried herself in a respectful manner. She was unconventional in her level of education and because when Dad became sick, she went to work. She was a role model for her children. . . .

We endured a lot from alcohol. We endured a lot to keep our family together. Some families were worse than ours—we were still functional.

Valaira Whiteman Cardenas, 2005

My father's alcoholism taught me how strong my mother was—how she always held things together. . . . I could see how a family could make it work, regardless. . . . And it taught us about a place we didn't want to go.

Forrest Whiteman, 2005

>

**Mary Ann Whiteman
at her home in 1995.**

The two older girls who took care of Mary Ann Welsh when she was a very young student at the boarding school at St. Stephen's Mission, who came to help her get dressed every morning, called her "sister." She didn't think too much about it at the time—the inclusiveness of Arapaho kinship allowed many distantly related girls to call each other "sister." And in the harsh atmosphere of the boarding school, the older children often looked out for and took care of the younger ones. Many years later, she found out that they were in fact her biological sisters. Her mother had died at birth, and her biological father had allowed a childless Arapaho couple to adopt her, while he raised her older siblings. After she found out, when her biological father died, she considered herself lucky to have two families, including a brother and several sisters.

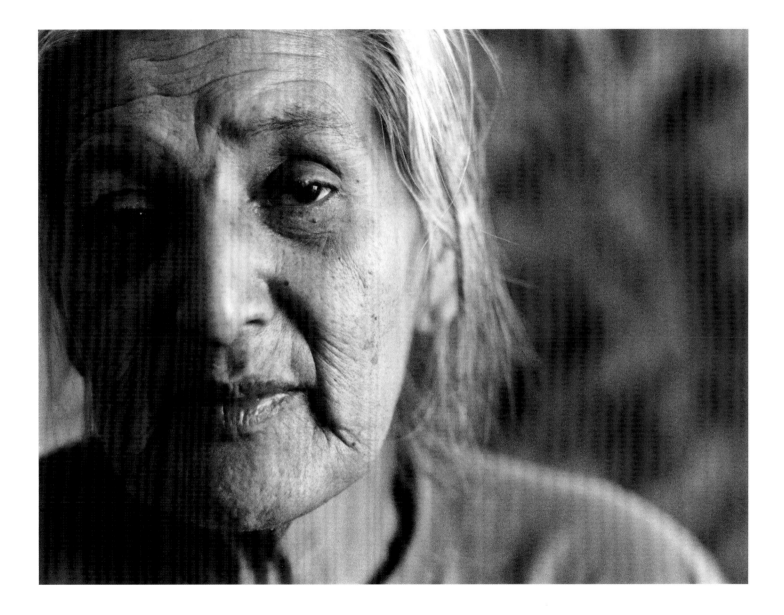

Mary Ann was born in 1934, and according to her daughter Valaira, she grew up "nomadic"—her family moved to different places, establishing temporary camps here and there. For part of the year, they followed the potato harvest through Idaho, along with many other Arapaho families. They worked for the Episcopal missions and later became involved in the peyote religion. Her father, Sherman Welsh, gave Mary Ann the Arapaho name Bo'oobesei—a reference to the crescent-shaped red clay altar or "way" of the peyote ceremony. He translated the name as Red Clay Woman.

She attended boarding school and then the fledgling high school at St. Stephen's, graduating at the top of her class. After high school, many suitors came to her house, but she would tell her mother to tell them she wasn't home and hide under the kitchen table. Instead of dating, at the age of nineteen she moved to Denver to attend Parks Business College. Working as a nanny to pay her expenses, she completed a two-year course and received an associate business degree in secretarial sciences—an educational and cultural leap for an Arapaho woman in the early 1950s.

Also in the early 1950s, she twice participated in the Miss Indian America Pageant in Sheridan, Wyoming, and when the first Northern Arapaho Powwows were held, she was chosen queen. Her attendant, assigned to help her with the horse she would ride in the powwow parade, was Ernest Whiteman. Ten years older than Mary Ann, he was considered "quite a catch"—all the girls chased after him. Mary Ann was "sweet on him," and when she heard that he married another woman, she told herself, "Well, I guess I'm not gonna get married" and considered joining a holy order. Several years later, after he was divorced from his first wife, he asked Mary Ann to marry him. A good Catholic, she insisted on a year's engagement; they were married in 1959. Despite some difficult pregnancies and two stillbirths, they had eight children.

Ernest and Mary Ann held several different jobs to help support their family. But Ernest had returned from the intense fighting of the Korean War physically wounded and emotionally changed, and the rest of his life was spent in what his daughter Valaira refers to as "waves" of alcoholism. Once, after he beat her, Mary Ann left and took the children back to her parent's home. She stayed six months, but her father told her, "He's your husband, it is a decision you made. A woman has to be the center and the strength of the family." So she returned and, with the help of her older children, spent the rest of her life keeping her family together. When he was dying of cancer, Ernest told Mary Ann, "You know what, Mary Ann, I can't do nothing. Everything I put you through, another woman would have left." He apologized to Mary Ann and told her he loved her. Crying, she told him that he was a good man, that she was blessed with many children, and that she would have married no one else.

Mary Ann died in 1998, ten years after Ernest, of complications of diabetes. "After Dad died, she started standing up for herself," Valaira said. "She became more independent." She became active in the Arapaho revitalization efforts and was a language and culture teacher at schools and camps. Shortly before Mary Ann's death, Valaira gave birth to a daughter. Mary Ann told her, "I am glad you gave me the opportunity to watch your baby, to keep your baby. Since my babies died, I haven't healed. Your daughter has healed part of me that was missing. I feel whole again."

Naming was informal at the Whiteman home. Ernest, who had several names during his life, gave his sons names that had belonged to himself and his father. Mary Ann and Ernest gave Mary Ann's name Bo'oobesei to Valaira, and Mary Ann took the name of her mother, Monica Welsh—Hinooko3onesei, or Golden Eagle Woman.

Byron Makeshine
To Provide for Others

I am a happy-go-lucky, hardworking guy who is easy to get along with, very personable, well educated and handsome, and very humble. I am able to take licks with a grain of salt.

Byron Makeshine, 2004

Byron Makeshine grew up on the reservation when there were few restrictions on hunting. His dad and uncles went hunting frequently, and he always wanted to go along, but he was too little. Then, when he was fourteen, he was given his first rifle and became a hunter. His family needed the meat: it was an important part of their daily diet, and they would save some for ceremonies. Hunting was one of those things that a lot of young boys aspired to, Byron said, because it is one thing that men can do to provide for their families and community. He learned from the elders that with hunting, as with other things, you don't take without giving back and never take more than you need.

Despite traditional attitudes toward overharvesting, by the early 1980s it had become obvious that the wild game on the reservation was becoming scarce. In 1984, following a lot of bad publicity, a lawsuit, and resistance on the part of some tribal members, the Shoshone and Arapaho tribes instituted a game code that ended unlimited year-around hunting. The code was not widely accepted for quite a while, and even today a few tribal members oppose it; but most view the code, administered by the Shoshone and Arapaho Tribal Game and Fish Department, as an overwhelming success. According to the U.S. Fish and Wildlife Service (which has worked with the tribes to conduct population studies), elk, deer, and antelope populations have increased by over 200 percent. In cooperation with the Wyoming Game and Fish Department, the tribes transplanted bighorn sheep and other species onto the reservation from other areas of the state, and that has helped to increase their numbers significantly. Most hunters think the hunting is easier than it used to be because the animals are plentiful, and studies indicate that more animals are now being harvested.

Two special sections of the code have allowed tribal members to continue to use wild game in traditional ways: a late-spring/early-summer season allows hunting prior to tribal ceremonies, and elders who are no longer able to hunt may designate a younger hunter to take their place.

In November 1996, Byron acted as designated hunter for elder Richard Moss, an uncle who had often taken him hunting when he was younger. He and his fellow hunters, *hinoo'eineno'*, brought

> In 1996, Byron Makeshine held the leg of an elk while fellow hunter Melvin Oldman butchered the elk. Standing behind them were members of the extended family of Richard Moss, for whom the elk was shot: Dylan Armour in the arms of his father, William Armour, and Alonzo Moss, Jr.

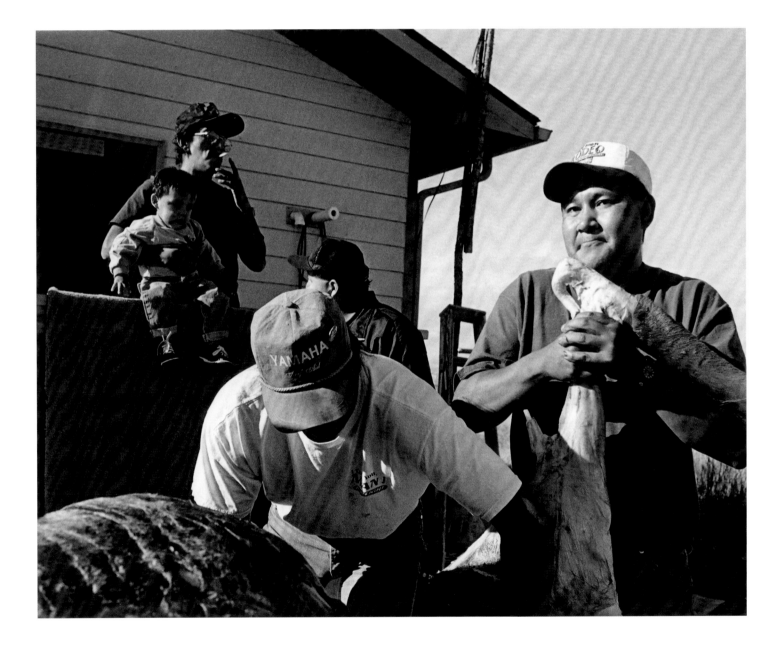

Richard a large elk that they quartered and partially butchered for him in his yard. Members of Richard's household completed the butchering; while most of the meat was dried for ceremonies, they couldn't resist cooking up a few fresh elk steaks. Byron was the designated hunter for Richard for many years before Richard's death. He hunted mostly for big game such as elk and deer and occasionally small game such as rabbits and sage grouse, Richard's favorite. "It feels good to provide for others, especially the elders. They really appreciate it," Byron said.

Until he was seven, Byron's family lived in Alaska, where his mother, a member of the Tlingit tribe, grew up. Since then he has lived at Wind River. He received an associate degree from Central Wyoming College in Riverton and has worked many jobs. He learned carpentry from the "school of hard knocks" and for several years was foreman for Sun Dance properties, a Lander construction firm, where he hired and trained other Indians to work under him. He now works for the Northern Arapaho Tribal Assistance and Construction program, helping his people renovate their homes. But his love is for the outdoors—at every opportunity, every evening after work, he heads for the mountains, where he fishes, hikes, and, in season, hunts. Often, he takes one of his six children, all of whom he is bringing up to love the natural world.

>
William Armour held his son, Dylan, as they watched the butchering at the home of his father-in-law, Richard Moss.

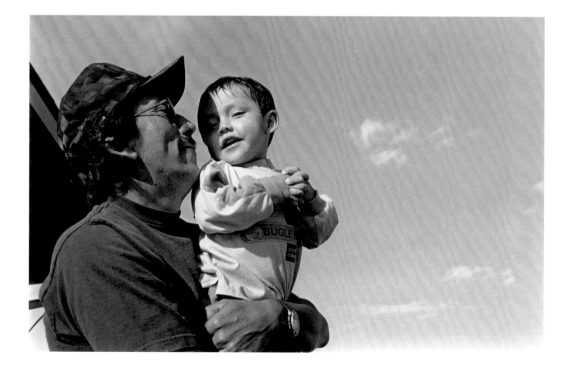

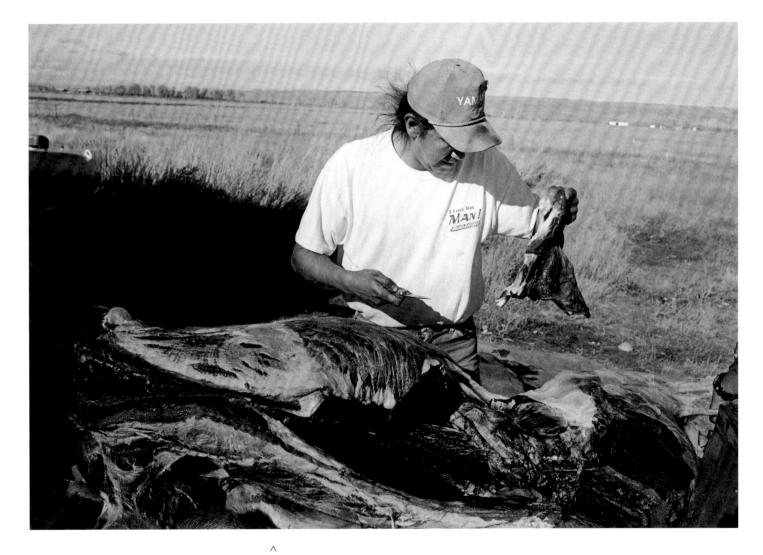

Λ

**Melvin Oldman continued butchering the elk obtained for
elder Richard Moss.**

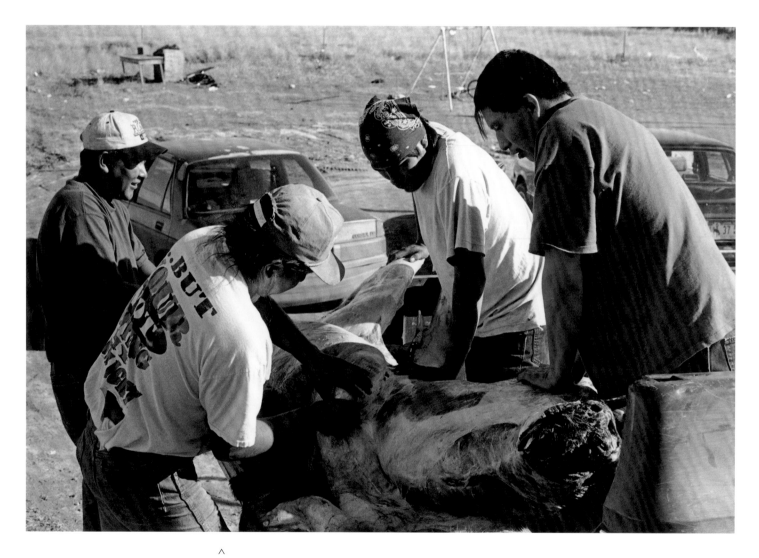

^

Byron Makeshine, Melvin Oldman, Otto Oldman, and

D. J. Gardner *(left to right)* helped with the butchering process.

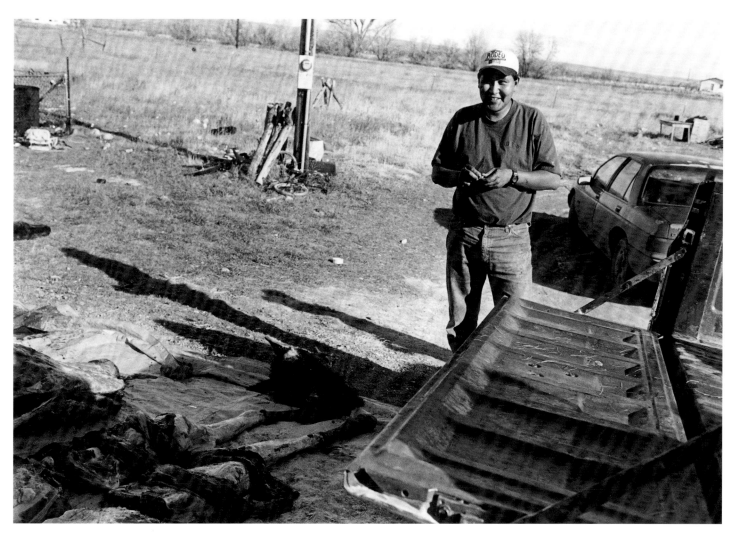

∧

Byron relaxed after the 1996 elk butchering was complete.

Burton Hutchinson, Sr. **Neecee Wo'teeneih**

The Arapaho elderly are the backbone of the Arapaho Tribe. We must never forget that the strength of our tribe today comes from our parents and grandparents. But when you look around, you often see the elderly suffering and forgotten by their children and grandchildren. That is not the Arapaho way. It has always been the way of our people to care for our parents and our grandparents. Today, because the changing economic base of life, the old ways are changing. . . . I believe that tradition is the foundation of progress, and it is the traditional background and knowledge of our grandparents that we must respect and honor today.

Burton Hutchinson, 1981

In 1978, Burton Hutchinson "became political." First, he was appointed to fill a vacancy on the Northern Arapaho Business Council. Then, he said, he was encouraged by the old people to run for the business council—they told him they needed his leadership. They would say to him, "To be a leader, prove it to yourself. You need to have a family, a companion, children, a home and grandchildren behind you." So he ran for office and was reelected to seven two-year terms. He then took a break and worked for the Arapaho Oil and Gas Commission for six years. In 1998 he ran again and served three more terms. For many of those years, he served as chairman. He retired from the business council in 2004 for health reasons, at the age of seventy-five. Burton's philosophy of leadership was always to uphold traditional Arapaho values and to use those values as the foundation for his decisions. He frequently spoke of the elders, the importance of honoring and respecting their wisdom, and providing for them in their old age.

As a small boy, Burton had been given the name Woxuusesei, a child's name that refers to a playful young bear, by his great-uncle. At the age of nineteen or twenty, while he was serving in the army in Korea, his mother and grandmother thought that because the boy had become a warrior who was enduring hardship, he should have a new name, a strong name. During the Christmas dances in 1951, in the old community hall next to the bridge over the Little Wind River near Ethete, his mother and grandmother cooked for the community. They announced to the people that Burton would be given his grandfather's name, and then Old Man Morris

>
Burton Hutchinson, Sr., talked and gestured in the formal manner of Arapaho elders when he spoke to people attending a Native American Church feast in 1996. Seated to his right are Sarah and Herman Walker *(in back)* **and Alyson White Eagle** *(in front).*

Whiteplume performed the ceremony. The people there accepted the name, and they prayed for him to be safe in Korea. He was known and recognized as Neecee Wo'teeneih, or Black Chief, when he returned. He still carries the name but thinks that one of his grandsons might take it some day.

During his tour of duty in Korea, Burton needed all the help a strong name and prayers could give him. He was an army infantryman who saw four months of front-line duty during some of the worst fighting of the war, and he was frequently assigned to patrol. Of this period of his life, Burton will only say, "There was no rest, and it took its toll." Later he was assigned to the Tenth Mountain Division Infantry, based in Fort Carson, Colorado, then sent by ship from San Francisco through the Panama Canal to France, where he worked as a truck driver and deliveryman.

After returning from the service in 1953, Burton married and raised a family of three children. He became active in the American Legion post at Ethete and eventually served many years as post commander. He worked for the Bureau of Indian Affairs for eighteen years and then for the Indian Public Health Service as a community health worker for ten years before becoming political. Along the way, he became more involved in the spiritual ways of the community: at St. Michael's Mission (where he had earlier attended boarding school), in Arapaho ceremonies, and in the Native American Church. He had first started attending Native American Church, or peyote meetings, when he was eleven or twelve years old. At first he would sit and watch. But he became more and more involved, and after participating for fifty years he started conducting the meetings himself or, as he says, "taking care of the vows" for those who "put up" or sponsor a meeting to pray for a family member.

He also gives many Arapaho names. "They come and ask you ahead of time to get ready," Burton said about the giving of names. Sometimes the names are taken from a family member, and Burton performs the ceremony for the family. Usually, he prays early in the morning, looks around, and thinks about what name to give. Sometimes he will think of two or three names, so the individual or the family of a child has a choice. At the ceremony, he will "smudge," or cover the recipient and his family with cedar incense, and pray for them all to have a good life. They, in exchange, will cook for him and perhaps give him a few gifts.

1997 | 2005

<

Tessa Bell and her daughter,
Patricia Wallowing Bull, at their
home in 2000.

Marjorie Shotgun Pizarro **Seibe'eih**

"Look, the sagebrush is growing back," Marjorie Shotgun Pizarro said as she looked over her family land, just across Blue Sky Highway from Wyoming Indian High School. Time was also showing on the old family cabin, delicately perched on a small knoll overlooking the new digital sign announcing high school events. Her family had lived in this cabin many years ago, but now the cabin is derelict, used only by "winos" seeking shelter and a place to bed down.

These eighty acres were once owned, irrigated, and farmed by her parents and brothers. They had a large vegetable garden that provided food for their family, and they grew alfalfa, oats, wheat, and hay. Their forty head of horses had grazed here, and a few cows, too. With money they received from a land payment, the family bought farm equipment: a flatbed truck and two tractors. Margie's mother, Winnie, controlled the money—she would put money in the bank in the fall, and they would start all over again in the spring. "She was the boss of everything," Margie said. Today, the fields are deserted except for occasional grazing by neighbors' livestock and are slowly being reclaimed by greasewood and sagebrush. Once there were several homes here belonging to members of Margie's extended family, but now only the derelict cabin remains.

Margie has moved around a lot in her life. She was born July 17, 1937, near Seventeen Mile Crossing (between Ethete and Arapahoe), where her family was camped with friends during summer ceremonies. The family lived at one place or another while her father worked "here and there." He built the log house when they lived near the Ethete intersection; that house was eventually moved a half-mile south to their eighty acres. Margie attended several boarding schools on and off the reservation.

Around 1967, Margie and a friend caught a ride to California. She remembered sleeping by a police station in Livermore and being very cold. On this trip she met her future husband, Regis Pizarro, a farmworker originally from the San Carlos Apache Reservation in Arizona. Margie's mother insisted that they return to Wyoming to be married. "I don't like him being sneaky—tell him to come here himself," she told Margie. At first she liked him, but she cautioned Margie, "If he is trying to make a fool of you, I'll throw you both in jail." They were married in Lander in 1968 and continued to move back and forth between Wyoming and California for many years, staying "here and there." Sometimes they lived in a shelter by the willows on her family's land.

According to family tradition, the Cheyenne chief Black Kettle, whose camp at Sand Creek was attacked by the Colorado Cavalry in 1864, was Margie's ancestor. Black Kettle had two names—

>

Margie Pizarro at her home near Ethete in 1997.

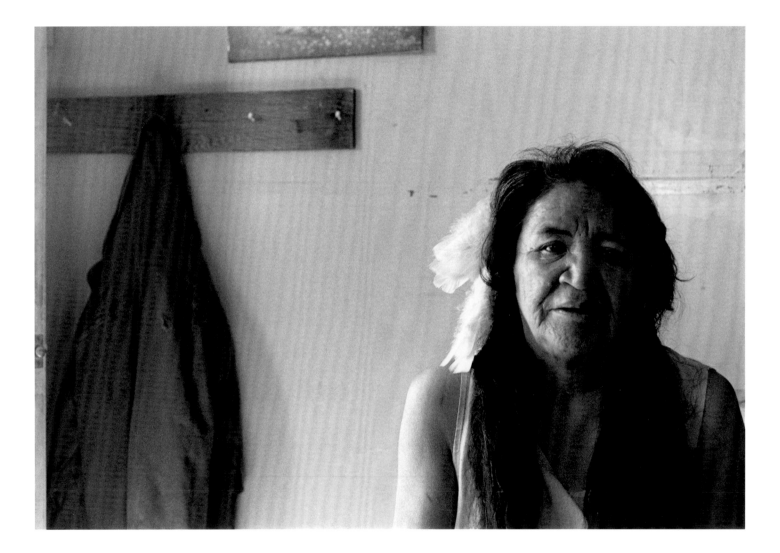

Wo'teeno'o, which Margie translates as Black Bucket, and Niicii Cowo'oo, or Runs the River, names that have been passed on to her sons. Her grandfather Shotgun, or Ceebouu, was a noted warrior, scout, buffalo hunter, ceremonial elder, and early tribal councilman; he was photographed by noted photographer Edward S. Curtis in 1910.

Margie moved permanently back to the reservation in 1994, a few years after the death of her husband. The house she lives in now was an old sheep-camp cabin that her father had built on a ranch where he had sheared sheep; it was later moved onto forty acres of land that her grandmother owned, adjacent to the eighty acres where Margie grew up. Her parents grew old in the house. She lives alone now—her siblings have moved away or died, and her many children are scattered around the country. Often she is without utilities, and in winter she sometimes has no heat. She eats meals at the Ethete Senior Center, participates in community activities, and does craft work.

Shortly after her birth, she was given her mother's name, Scibc'cih, or Red Woman, and she has been known by this name throughout her life. She was given another name (Nookuu3onesei, or Feather Woman) by her grandparents during a peyote meeting, but they were the only ones who used it.

<

The man in "A Smoke" by Edward S. Curtis, 1910, was identified as Ceebouu, or Old Man Samuel Shotgun, a noted Arapaho leader of the first half of the twentieth century and Marjorie Pizarro's grandfather. (Courtesy McCormick Library of Special Collections, Northwestern University Library)

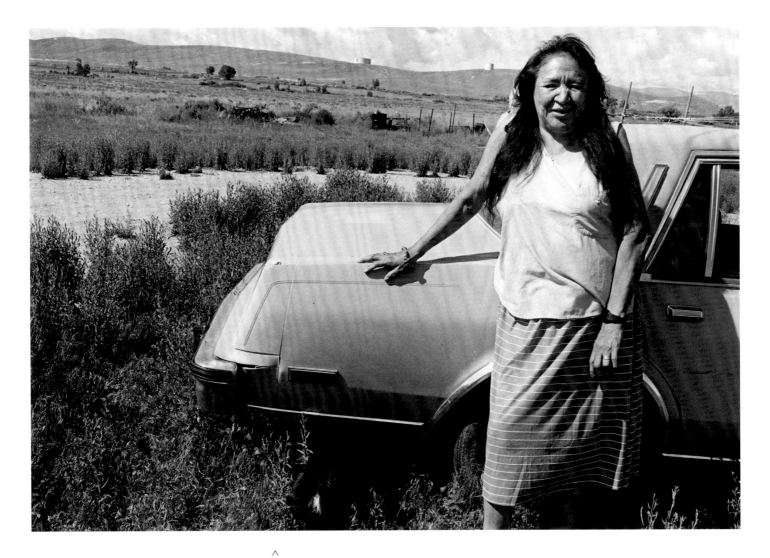

^

**Margie Pizarro at her home with a view of her family's
land in 1997.**

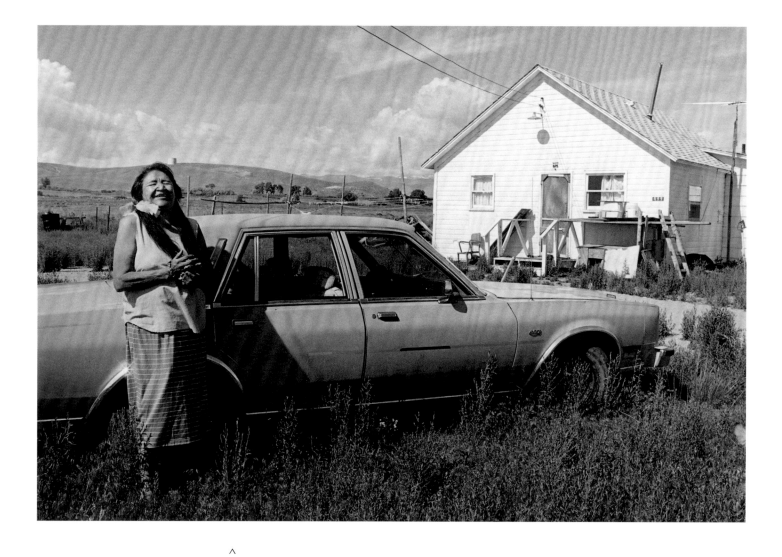

∧
Margie Pizarro outside her home.

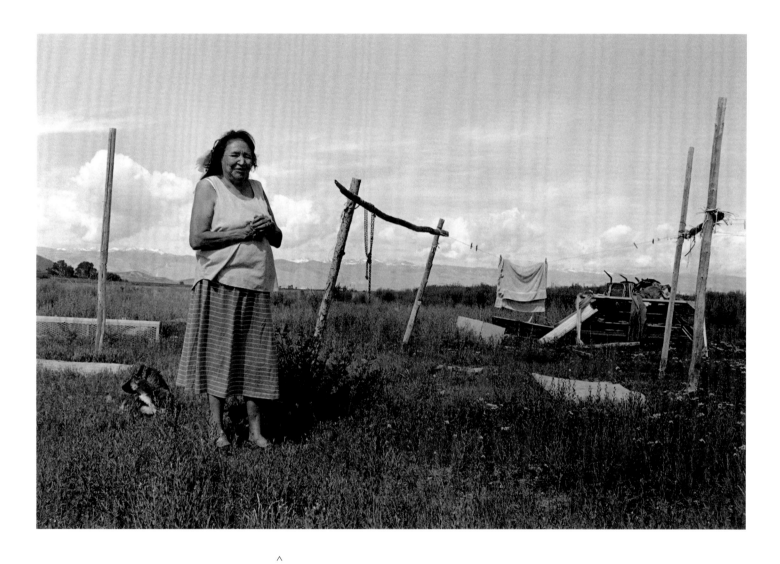

∧

Margie Pizarro by the clothesline near her house.

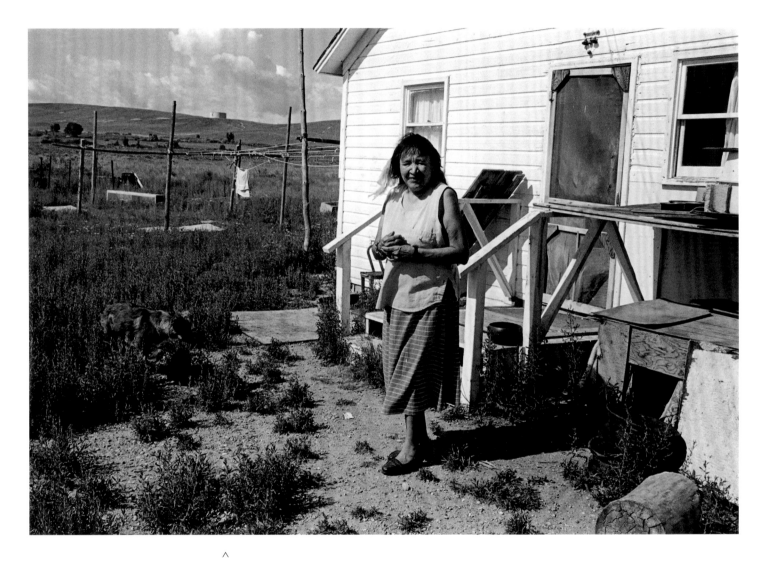

^
Margie Pizarro by the porch of her home.

Flossie Brown
Making Flowers

I learned from my mother—she showed me how to make them. She was a tough old lady.

It is pretty hard, I tell you that. You start in the morning, then you're tired in the butt, then through your legs, then you found at night you got cramps in your fingers. I know I do. Others, maybe it don't bother. Wreaths, too. I knew how to make them, too. When you start, it's easy; all day long you get tired. I buy the crepe paper in Lander—had to go way up there to get some. But the wires—you get the wires in town [Riverton]. You get the soft wires from the lumberyard. Sometimes my brother stayed with me; he'd cut the wires. You soak the flowers. Get a can, put the wax in, let it melt, put it on low. Stir the flower—stir it up. Then go like that till that wax comes out. You drain it. Then you put them over there till they get hard. Get through with one, then another, going back and forth, back and forth making flowers.

A couple of years ago, I used to have a lot. People used to stop by, want to buy flowers from me. "It's hard. Can't you make your own?" So I have to sell them. I made a lot of wreaths, too.

I would always make red, white, and blue. My dad was in the service. Mother makes all different colors. Me, I always make flowers for my dad—red, white, and blue. My brother was in the service, too. Then I got another brother-in-law, in World War II—he come back dead. When Memorial Day come I always walk down, decorate the graves.

This year, I don't even mess around with them—I just went and bought me some flowers.

Flossie Brown, 2005

Every spring since the 1930s, or perhaps earlier, Arapaho women have made crepe-paper flowers, *cee'ese'einou'u'*, to decorate graves on Memorial Day. According to elders, the custom "came through the whites doing that for theirs." The women of a family would make them for their own relatives, and the tradition was passed down through generations of women, from mothers to daughters. On Memorial Day, they would walk or drive to the small family cemeteries in their communities, where they would place a few flowers on each grave. Flossie Brown learned to make flowers from her mother, Myra Dorothy Brown, but Flossie's generation may be the last to practice this tradition. Supplies are harder and harder to find now, and only a few (mostly older) women still make them. Graves are still decorated on Memorial Day, but the flowers and wreaths are purchased at Walmart.

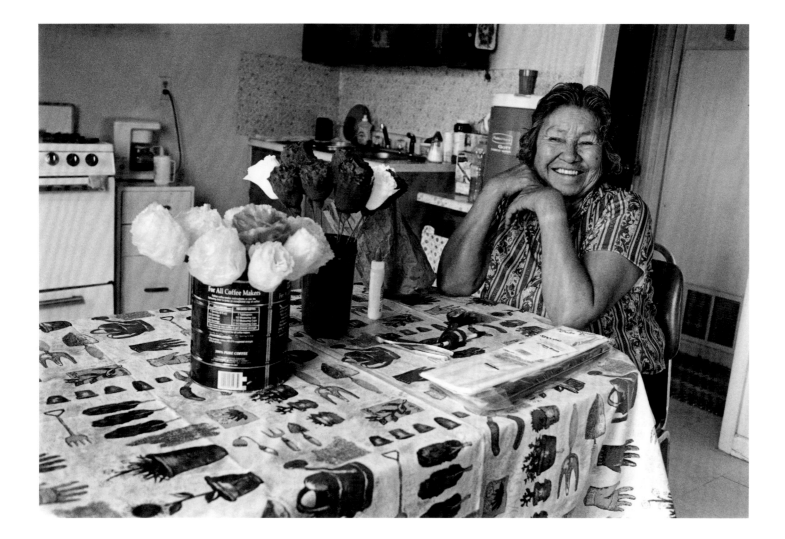

Back in the old days, when everybody made flowers, you could buy crepe paper just about anywhere and there were many different colors to choose from: shades of blue, red, yellow, and pink, as well as green for the leaves that were added to the base of each flower and for covering the wire stem. Some women cut the flowers from patterns, but most folded the crepe paper into shape. Sometimes the flowers were dipped in wax to make them last longer. Arapaho women made them not only for their own families, but also occasionally to sell to others—by the dozen, placed in a coffee can.

In the Arapahoe and St. Stephen's areas, flowers were made by individual women such as Flossie and her mother. At Ethete, flowers were made primarily by members of the Chief Yellow Calf Memorial Club as a community service. Their founder, Chief Yellow Calf, told the members to always honor the elders and those who had died, and one of the things they did from the very beginning was to make flowers to decorate graves on Memorial Day.

Back in the 1930s, when the Memorial Club was founded, money was hard to come by. Members had asked a white woman, a teacher, to show them how to make flowers. They would ask neighboring white farmers and ranchers for spare baling wire, which they would cut into stems. They would raise money for other supplies by selling box lunches or by having games or dances, or sometimes someone would make a donation. They would start early in the spring, pick a day or two a month, and make flowers at someone's home or the community hall. Men would come, too, and play and sing at a drum, which made the occasion festive and fun. The club members would make as many flowers as possible in a day and place them by the dozen in coffee cans; folks would stop by and pick out what they wanted. On Memorial Day, two or three club members would visit the family cemeteries and place flowers on graves that weren't decorated. "That's the way we helped," said Helen Cedartree, one of the original members of the club. Later that day, down by the river, they cooked a feast for the community.

Flossie Brown, the youngest daughter of the thirteen children of Myra Dorothy and Joe Brown, still occasionally makes flowers for herself and her family and a few to sell to others. She was born in 1935 and has lived her entire life in the Arapahoe and St. Stephen's area. She had attended St. Stephen's boarding school for five or six years. "I got in trouble, never went back. Kids fight you— I fight back. I got a spanking by the Father. So I just walk off, never went back. I told my mother and she just said, 'Let it go.' She said I shouldn't fight back, but I did. Didn't want them to bother me."

Four of Flossie's six children have died, and she lives now with her youngest daughter. She has raised her great-granddaughter since she was very young. "All I do all day is taking my [great] granddaughter to school, go get her when school is out. Go pick her up. I go every day—I never miss, ever since I had her. She went to Head Start, kindergarten, first grade, now second grade. She's smarter than me. She reads my papers for me."

<

Flossie Brown worked on crepe-paper flowers in her home near St. Stephen's in 1997.

The Arapaho Language **Hinono'eitiit**

"The Clock is Ticking" and time is running out.

There was once a time when the fluency of the Arapaho language was thriving in the homes and communities on the Wind River Reservation. It was a time when the old people and families spoke to one another in the Arapaho language. It is now in the state of extinction.

The population of the Northern Arapaho is presently nearing 8000 enrolled members. Out of the near 8000 members, less than 1000 are fluent and at a conversational speaking stage. Two generations of Arapahos have lost out on speaking the language. We can no longer place the blame on the government and churches today but on ourselves for not teaching and learning the language in the homes for the past 50 years. We now look to our tribal government, the schools and the last remaining fluent speakers to save the language from extinction; this is not a prediction but a fact.

The Council of Elders, 2004

>
Young students at the Arapaho Language Lodge (Arapaho Language Preschool Immersion Program) at Ethete in 1997. The classroom is decorated with signs using the Arapaho alphabet. *From left:* **Alexandria Winn, Nelson White III, Gregory Longtime Sleeping, John Sounding Sides, Levi Redman, and Skye Willow.**

The Arapaho language, like all others, is a unique, complex expression of human thought and emotion. It is a member of the widespread Algonquian language family that was scattered across North America but concentrated on the eastern seaboard and in the Northeast and upper Midwest of what is now the United States, as well as eastern and central Canada. Algonquian languages that migrated onto the Great Plains include Cheyenne and Blackfoot, but Arapaho is not closely related to these or other Algonquian languages. The Arapaho branch includes Hinono'eitiit, the language spoken by the Northern Arapahos of Wind River and Southern Arapahos of Oklahoma; the language spoken by the Gros Ventre tribe in Montana; and several extinct languages known only from historical documents. Many Algonquian languages are extinct or, as with Arapaho, in danger of extinction; however, some remain vital.

Since the 1970s, Northern Arapaho speakers have been involved in an attempt to revitalize—to bring back—their language. One of the tools used to teach the language to nonspeakers is an Arapaho alphabet initially developed by Zdenek Salzmann in the late 1940s while he was a graduate student in anthropological linguistics. He used the International Phonetic Alphabet (IPA), a linguistic tool that represents each of the wide variety of sounds (or phonemes) used in human languages.

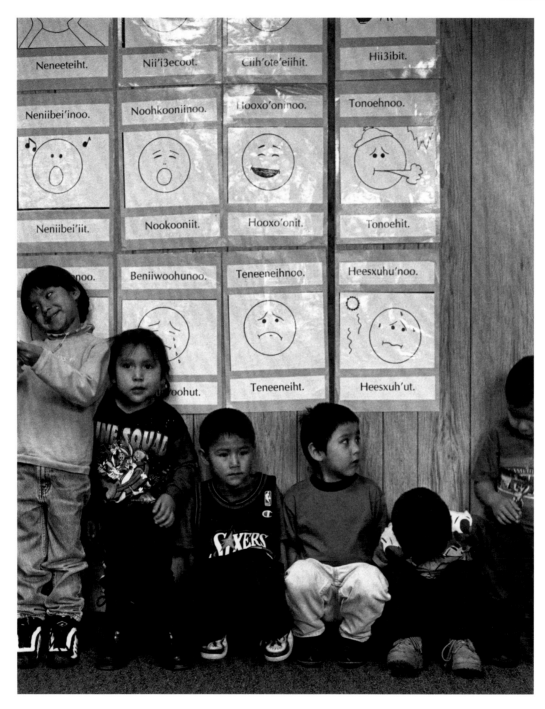

The Arapaho Alphabet—A Pronunciation Guide

Consonants	
B	an English *b* at the beginning of a syllable and a *p* at the end of a word
C	an English *j* at the beginning of a syllable and a *ch* at the end of a word
H	an English *h* breathed at either end of a syllable
K	a sound between the English letters *g* and *k*
N	as in the English word 'noon'
S	as in the English word 'sing'
3	"th," as in the English word 'three'
T	an English *d* at the beginning of a syllable and a *t* at the end of a word
W	as in the English word 'water'
X	a sound not heard in English: start to say "K," but breathe out hard enough to make the back of the throat rattle
Y	as in the English word 'yes'
'	a glottal stop: it does not make a sound but shows that the sound or breath is cut off suddenly

Vowels	
E	as in the English word 'bet'
I	as in the English word 'bit'
O	as in the English word 'got'
U	as in the English word 'put'

Long Vowels	
EE	as in the English word 'bat'
II	as in the English word 'beet'
OO	as in the English word 'caught'
UU	as in the English word 'suit'

Triple Vowels	
EEE, III, OOO, UUU	drawn-out long vowel sounds with rising-then-falling or falling-then-rising tone

Diphthongs	
EI	as in the English word 'day'
OE	as in the English word 'pie'
OU	as in the English word 'glow'

Salzmann reintroduced his work into reservation communities, where he had done fieldwork, in the late 1970s. In adapting the alphabet for daily use, Salzmann substituted common keyboard symbols for the more complicated IPA symbols: the *3* for the "th" sound (represented in the IPA by the Greek symbol theta) and an apostrophe for the glottal stop (a short stoppage of breath). This orthography, or writing system, has been adopted by schools for the production of language teaching materials and as a basis for teaching the language itself. Salzmann's *Dictionary of Contemporary Arapaho Usage* (1983) is still in use and has formed the basis for further word collection efforts.

In recent years, linguists, including Steve Greymorning, have tried to emphasize the oral learning of the language—the way children would naturally acquire a language. He feels that "the weakness of the writing system is that if you are not a fluent speaker, you easily start pronouncing things wrong. Orthographies are only approximate." Many Arapaho elders agree with him, and they have expressed reluctance if not hostility toward the orthography. They think it is complicated and imprecise, and there is also a sense that the act of writing the language will change it. "It's like our language was never meant to be written," many have said. One elder described nonspeakers trying to read the language out loud as *cecii'eiyeeti'*, or hiccupping. But many others say that because the language is not being spoken in the home, the orthography is necessary not only to teach the language but also to save it. Time, they say, is running out.

The elders feel that every culture needs its own language to express its uniqueness and that without the language their culture—its religion, its knowledge, its worldview, its Arapaho-ness—will disappear forever. The "Language Policy for the Northern Arapaho Tribe" declares, "The Arapaho language is a gift from our Creator to our people and shall therefore be treated with respect. Our language is the foundation of our cultural and spiritual heritage; without it we could not exist in the manner that our Creator intended."

Rosaline Addison Neci'3i'ookuu

My mother was my good friend. I could always go over and talk to her, ask her different things. It was always that way. . . . She raised us good. My mom and dad taught us how to get along with others, be respectful of the elders. She would tell a story and it always had a meaning to it. If there was a personal conflict, she would say "Just let it go. Things will work out. It will come back around in a circle."

She always had a good attitude. She would say, "Life is tough. Like running or walking, you're gonna trip and fall. Don't be satisfied with lying there—pick yourself up and brush yourself off. And don't kick others when they are down. Treat people good—it is a circle, it will come back to you."

She had a hard time with all her children and grandchildren. It made you want to go out and do something to help her. . . . It was tough seeing her the way she was when she left us. She couldn't talk. I wanted to hear her when she went home, but she had had the stroke.

Anthony "Al" Addison, 2004

>
Rosaline Addison on the porch of her home near Arapaho in 1998.

Once she loaded a bunch of grandkids into her car—seven or eight of them—and drove to Thermopolis to take a dip in the hot springs. On the way home they ran into a really bad storm. The hail was coming down around them and the thunder and lightning were going strong. She had to pull the car over to the side of the road. The kids were really frightened by the storm, so Rosaline told them to wrap toilet tissue around their heads and the lightning and thunder wouldn't bother them. "The lightning won't hit you," she said. So all the kids wrapped toilet tissue around their heads. They worried about her, so she wrapped tissue around her head, too. She put some on her head to make them feel better. They were all just sitting there with that tissue on their heads.

Polly Addison Redfield, 2005

If my mom was alive, we'd all be at the house. The house would be full of kids.

Ava Addison Headly, 2005

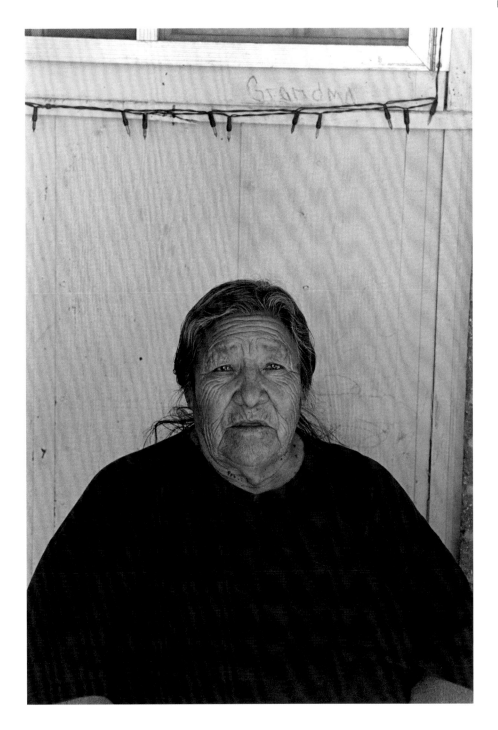

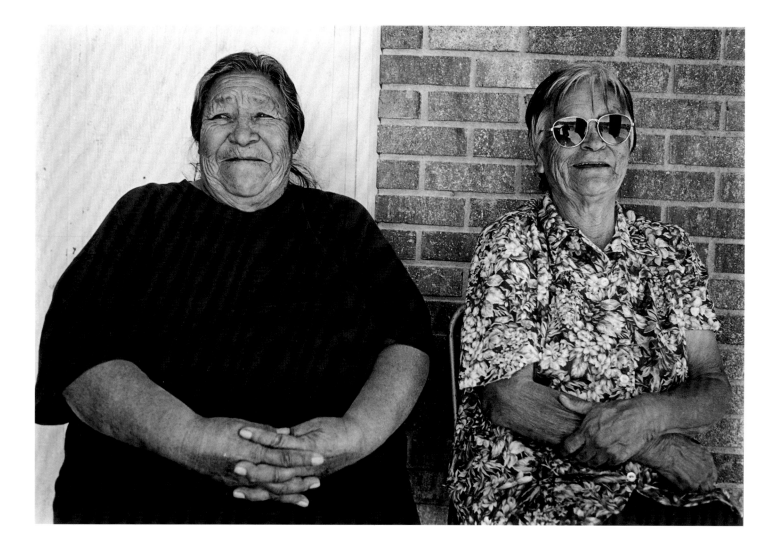

Rosaline Addison spent her life taking care of others—her grandmother, her mother, her brothers and sisters. Even before she was married, she had adopted a sister's children. She had eight children of her own, and because her first husband was often away, she raised them mostly by herself. According to her daughter Polly Redfield, she sat the children down one day and told them that two of them were really her sister's children. It surprised all of them, because she had never made a distinction. Later she raised many of her grandchildren, and other people would bring sick children for her to nurse back to health. She often took temporary jobs such as working in the potato fields or cleaning motel rooms to help support her family. When she married her second husband, she told him, "You married me, you gotta take the whole package."

No one can remember just how long Bernice Jenkins and Rosaline were inseparable best friends. Bernice's son Al C'Bearing said simply, "As far as I can remember, it would have to be way back—at least to the 1950s." Rosaline's daughters thought it might have been even further back, into the 1940s, when they were both students at St. Stephen's boarding school. They were related by marriage, in the inclusive extended Arapaho family way, but no one is sure of precisely how. They would go everywhere together, driving each other around the reservation or to the Country Cove Café in Riverton to have a quiet cup of coffee. Together they cooked for community feasts and dinners of all kinds: Arapaho General Council, powwows, Native American Church meetings, funerals. They coached basketball together at St. Stephen's and played hand games or cards with family members and other friends. Their children were raised together, like brothers and sisters; the children called their mother's friend "aunt." They saw each other through two husbands each, the deaths of spouses and children, and illnesses. When Bernice's eyesight began to fail, Rosaline would pick her up and take her to the senior center or to town. Rosaline was the outgoing one who did most of the talking and made people laugh, while Bernice was her quiet twin. Because of illness and infirmity, they saw each other very little in their last years.

Bernice died in 2000 at the age of seventy-two, a year before Rosaline. Her Indian name, Heebetees, had been given to her as a young child by her dad's aunt, Old Lady Lamareaux. Today, no one is sure of the exact meaning. Many years before she died at the age of seventy-six, Rosaline had given her name Neci'3i'ookuu, or Standing in Water, to two granddaughters. She had given the full name to one, and the other received the shortened form Neci', by which Rosaline was commonly known. It had been given to her by her own grandmother when she was an infant.

<

Rosaline on the porch of her home in 1998, seated beside her lifelong best friend, Bernice Jenkins *(right)*.

Edna Moss **Sooxei**

In a 2001 interview, Marie Willow told about the arranged marriage of her parents, Edna Trumbull Moss and Clarence Moss in the early 1930s.

My dad had been married before, and his wife had died in childbirth. I had an uncle, his name was White O Goggles, you might have heard about him. Well, I guess he approached my dad and told my dad that he knew of a young woman that was kind of like an orphan, you might say. She didn't have no home, she stayed here and there, you know, because her step-dad didn't like her. White O told my dad, you have to go on living, you have to continue to live, and you need a woman. So, he was the one that arranged the meeting, the marriage of my dad and my mother. I think she was fourteen. He was the one that went up and seen my grandmother, my mother's mother, to set up the wedding. Then he had to come down and see my dad's mother, explain to her what he was doing. So, after he got those things done, then it was more or less okay to go on with all the other things that had to follow for arranged marriage.

They never met. 'Cause I asked my mother, I said, "Did you know him before you married him?" She said, "I used to see him at a distance," she said, "but I didn't know him." She said, "I knew who he was," she said, "but I never talked to him or nothing." I said, "God, you went into marriage like that?" She said, "It wasn't up to me," she said, "to say 'no I can't, because I don't love him or because I don't know him.'" She couldn't do that, out of respect for the person that arranged it, she had to go through with it.

I've seen this done once, at somebody else's arranged marriage. Two tents were set up. One tent was smaller than the other one. The bigger tent is where they ate [on] the day of the arranged marriage. Everything was done in front of elders. And what little I remember about it is this young man and this woman sat at the head of the tent—it was always done in the tent, the elders on each side of them, and then family. Food was brought by all the female relatives of this man. So, as my dad had just one sister, he had to get his cousins, his first cousins, to bring food for him. My grandmother had to go out and invite an older man to talk to the bride and the groom about marriage, how hard it is—just from his own experience, you know. After he gave them the talk, the priest over here at the mission

> Edna Moss with her dog, Foo-foo, at her home near St. Stephen's in 1998.

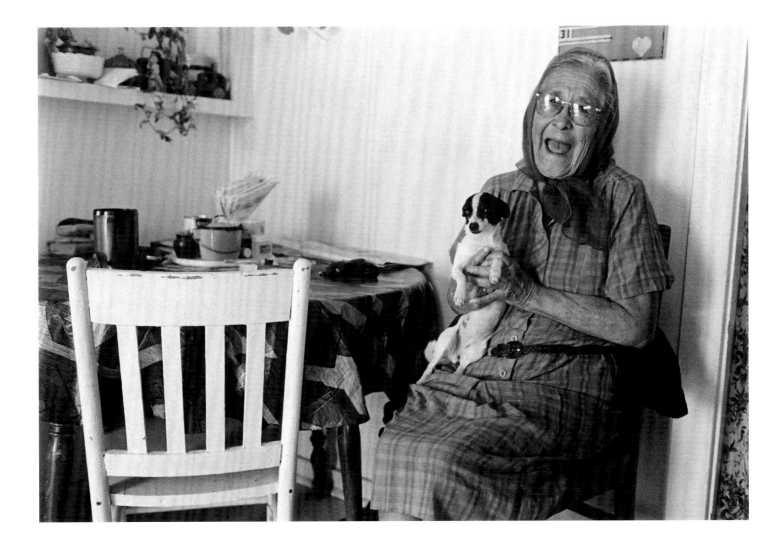

came and did the legal bit. The other tent was a lot smaller. The people that came brought wedding gifts and by the time everybody left, that whole tent would have been furnished. You would have had your bed, you would have had your dishes, you would have had your stove—everything—to start your marriage with.

I did see it once and that's how it was done. The people who used to live across the pasture here, they got married through an arranged marriage and that's how it was done. And my grandmother told me, "See, you look at this," she said. "This is how your dad and your mom got married," she said.

My mother was told when she left her mother's side not to think of running home to momma. The first big fight, my mother decided, "Well, I'm going back home. Heck with this thing, I'm going home." Well, she did go home. My grandmother made her turn around and come right back down. She hired someone to bring her back down. Because my grandmother, her mother, told her when she got married that that was her home, and she wasn't supposed to leave it. That was her husband.

My grandmother on my dad's side didn't even interfere. She heard them when they were arguing, she knew my mother was leaving, but she didn't try to stop her. She said, "It was none of my business." She said, "It was up to them, to iron out things, what they were gonna do." And it wasn't up to her to interfere. That was her explanation of it.

How Mom got to know him and to feel that love for him, she said it didn't happen for about two and a half years. She was married to him two and a half years before she really felt at ease with him, she said. "I used to be just terrified of him," she said. "But there was nothing I could do," she said. She couldn't go back home. And they were married fifty-four years. I told her, "Gosh, Ma, fifty-four years, that's a long time."

In them days, the husband was put first. He ate first, he had everything first. Even after the children came, he was still first, you know. And that's how women were brought up then. That's the way it was done. Gradually Dad lost the power, you might say, he wasn't boss anymore, gradually, as they both got older. They'd go to town together and cash the per capita check—it always came in my dad's name. He'd put it in his billfold, and when they were getting ready to go in the store, she'd say, "Okay, give me your billfold." And he handed it over. He had to ask my mom, you know, for different things, which he never did in the earlier part of their marriage. He used to make us laugh. He'd always say, "When my billfold's empty, that's when I'm allowed to keep it."

Edna Moss died in 1999 at the age of eighty. Her husband of fifty-four years, Clarence, had died in 1990 at the age of eighty-eight. They had three children and many grandchildren and great-grandchildren. Her Arapaho name was Sooxei, a name whose exact meaning has been forgotten. His name was Hiinookuunit, or He Is Wearing a Plume. According to their daughter Marie Willow, "They eventually lost those names. Those names were taken by grandchildren."

The Warrior's Horse Race
Back to the People

We gave away two horses—one to my dad and one to Karl Whiteplume, who won the race. We felt it was more appropriate to have something like this. It was a good way for my little girl to get her Indian name. We told people around here, and they seemed more excited. After everything was done, it made me feel more spiritual, more being Arapaho. The old people said it was special. If I had another kid, I'd do the same thing—put on a horse race. People would always ask if we are going to have races.

Annin Soldier Wolf, 2005

On the last morning of the 1999 Northern Arapaho Powwow weekend at Arapahoe, a parade was held—dancers and other powwow participants walked or rode floats through the arena. But this morning, unlike other powwow parades, a group of riders rode their horses into the powwow arbor, circling and whooping. They were participants in a "warrior's horse race," organized by the Soldier Wolf family to honor three-year-old Echo Soldier Wolf, who was to receive her Arapaho name later that day. They rode bareback and wore Indian regalia. Earlier in the summer, the Soldier Wolf family had published the rules for those wishing to participate: no saddles or stirrups; no curb chains, chinstraps, tie-downs, or other unnatural aids; no jeans, boots, spurs, or other "cowboy crap."

Following the parade, the five riders and many onlookers made their way over rough, muddy roads to the gently rolling sagebrush-covered hills west of the arbor. Annin Soldier Wolf, Echo's father, had staked out a roughly circular three-mile track, with men on horses stationed at the cardinal directions pointing the way. Following the cross-country race, everyone returned to the powwow arbor.

Karl Whiteplume was the winner that day. His horse, William H. Bonney, was named after Billy the Kid, Karl said, "because he was kind of a bandit." The half-Arabian, half-Quarter Horse wasn't supposed to be the color he is, Karl explained. He had been born dark and became lighter as he aged. In preparation for the Soldier Wolf race, Karl had taken him for daily five-mile runs for several weeks. During the race, Karl wore moccasins and a dancing skirt from his powwow-dancing outfit and a feathered hat borrowed from his brother. He painted circles, hands, dots, and zigzag designs on the horse, he said. "Things I've seen people put on horses." After winning the race, he was presented with a two-year-old bay filly that Annin had raised and trained.

>

Karl Whiteplume, a participant in the 1999 Warrior's Horse Race, galloped through the Northern Arapaho Powwow arena and stopped to whoop in front of the announcer's stand. Annin Soldier Wolf, whose family had sponsored the race in honor of his daughter's naming, also rode into the arena. Drawings of chief Black Coal and Sharp Nose, based on nineteenth-century photographs, adorned the powwow sign.

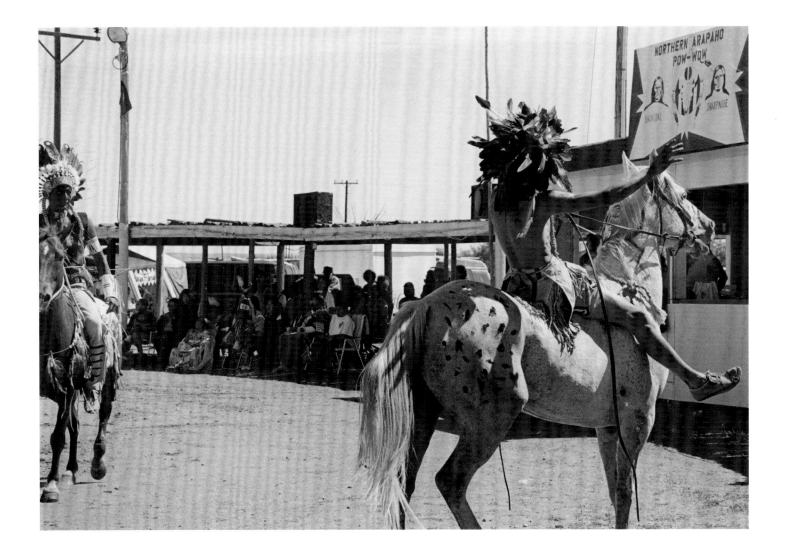

Once, gatherings like this, in which both men and women displayed traditional horsemanship skills, were common. Families living in outlying locations would host one or more days of activities; they would butcher a beef and cook and feed everyone. Sometimes there would be a dance, too. Although you still see lots of horses on the reservation, according to Annin fewer and fewer families seem interested in training and working with horses in more traditional Indian ways. The few families who still ride usually participate in western-style rodeos and teach their children cowboy ways. He and his family, by sponsoring Indian games and races, hope to bring a more traditional Arapaho way to horse events. They attempt to include their culture and religion in the natural world and vice versa, he said, by incorporating horses into powwows. "We need to get this back to the people," Annin told his father, Mark Soldier Wolf.

According to Mark, the warrior's horse races have been handed down. "It was a tribal tradition, but hardly anyone else does it," he said. They were a form of entertainment and also a time to show off your best horses—the best runners or the prettiest. At gatherings, there would also be games and trick riding. "It's a habit, second nature, working with horses. The old people used to say, 'If you don't have horses, you're pitiful.' You have to move camp with your feet. When you moved, you needed ten to fifteen horses to move your tipis and clothes. The horses were marked, then all the horses were herded together into one big herd. When you got where you were going, you got your own marked horse. Some horses even had names—Indian names."

Annin gave another horse he had trained to his father that day, for giving Echo her Indian name, Hooxeihino' Nono'eici3oot, or Leads the Wolves.

>

During the 1999 Warrior's Horse Race, an unidentified man pointed the way for Karl Whiteplume and his white horse, while Mark Soldier Wolf watched from his white pickup.

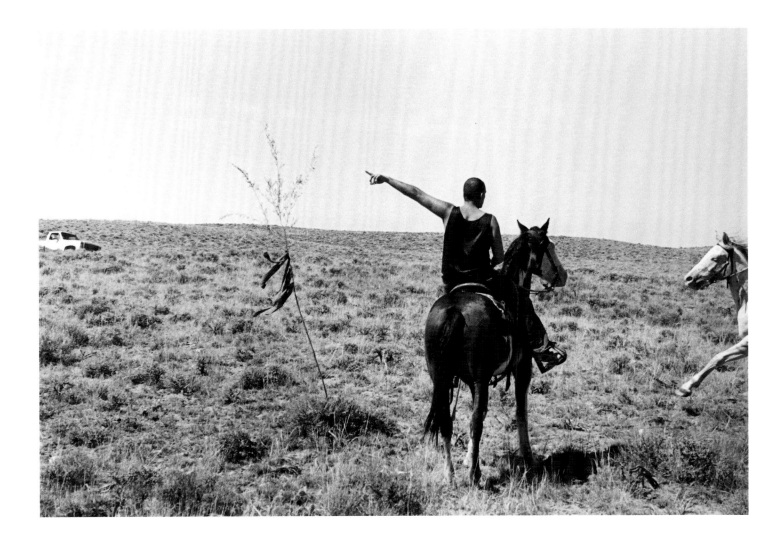

Echo Soldier Wolf Hooxeihino' Nono'eici3oot

"You need to know why we are having a naming ceremony like this," said Florita Soldier Wolf, Echo's grandmother. When Echo was eleven and a half weeks old, just after she had been baptized, she became very ill. At the local hospital, they kept sending her home, saying there was nothing wrong with her. Finally, when she started having seizures, she was life-flighted to Salt Lake City. There, she was diagnosed with spinal meningitis, and it was touch and go for a while. Fortunately, she came out of it with only a slight deafness in one ear. "A miracle she got away with just that," said her mother, Cathi. Cathi had also been quite ill during Echo's first year. Misdiagnosed by the same hospital, she was told she was just imagining her symptoms. Eventually, she also was taken to Salt Lake City—but by an ambulance that broke down on a mountain pass in a February blizzard. They sat there overnight until another ambulance from Salt Lake could get through to pick them up. A life-saving surgery was later performed.

"This is why we are having this ceremony."

Following the warrior's horse race, the Soldier Wolf family prepared a giveaway. They presented awards to the participants, including a two-year-old bay filly trained by Annin Soldier Wolf that was given to the winner. Then the family and friends participated in an honor dance for Echo. Following the dance, Echo's grandfather Mark took Echo's left hand, and her grandmother Florita took her right hand. Each was dressed in buckskin outfits and breastplates made by members of their family. Starting on the south side of the powwow arena, they faced the announcer's booth. Speaking in Arapaho, Mark explained the purpose of the ceremony. Walking around the arena, he repeated his message facing the southwest, the northwest, the northeast, and the southeast: "Look at this little girl here, so all you people who see her dressed as she is for this ceremony, a name to be given to her—so all you people will know her name. And her name is Hooxeihino' Nono'eici3oot—Leads the Wolves."

The name had belonged to her great-great-great-grandmother. The old lady, who was originally named Biito'owu' Cebisei, or Walks the Ground, lived alone. Although she continued to move with the rest of the village, she always camped by herself. She preferred the company of two wolves she had raised from pups to that of other people. These two wolves were always following her, so the people in the village started calling her Hooxeihino' Nono'eici3oot.

> **During Echo Soldier Wolf's naming ceremony in 1999, her grandparents Florita Soldier Wolf *(left)* and Mark Soldier Wolf *(right)* led her around the powwow arena, as Mark announced her new Indian name. In front of them are boxes of giveaway goods.**

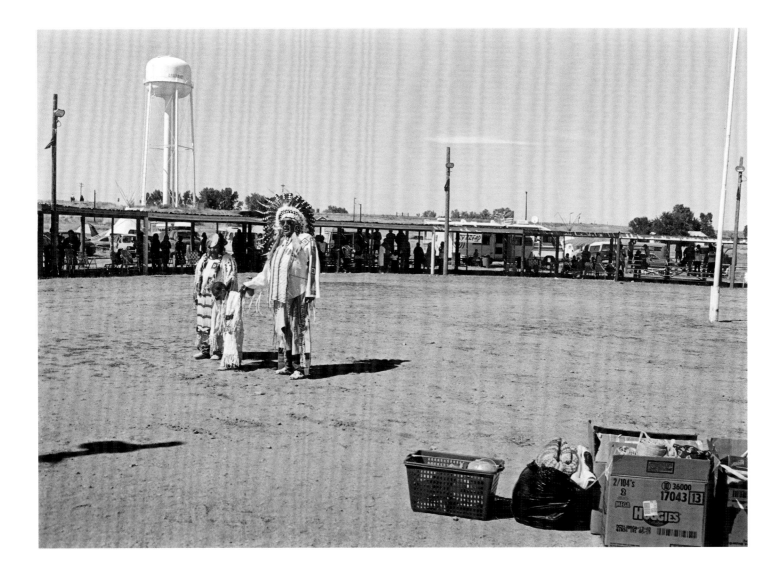

After circling the arena, Florita, Echo, and Mark returned to the announcer's stand and Mark formally asked the announcer to tell the people his granddaughter's new name. Echo's aunt then tied a feather in her hair. Following the ceremony, the giveaway continued, and the community powwow feast prepared by the powwow committee was served.

Mark Soldier Wolf has named all of his grandchildren and many other people as well, most of them in small ceremonies at his home. When people ask him to give a name, they come to him with gifts, in order to be honorable, respectable. "I say, 'Okay, I'll think about it then.' I tell him before he is leaving, 'Give me four or five days, and you be sure to come back at that time.'" Mark explained,

> So while he's gone I have a job to do. I have to think of this family history. Then I think of a lot of names at that time. And I try to think what might suit him. And if I know this man or girl, try to see what kind of personality he or she has. And then I go over the names right for him or her. So I'll choose two names and those two names, in case he doesn't like the first one, he's going to like the second, but I don't tell him what I'm doing. So when he comes back in four or five days, he'll say, "Grandpa, what do you think?"

> Okay, these names, I've decided on for the man or woman. But I don't tell him. When I come up with a thought about that name, I go see one of his relations—an older person there with him or her. And I tell that relation, "Has this name been used or taken?" Then we talk about that name and the person who had it. And they might say, "Yeah, he's long deceased and no one has that name."

> So after that, well, nobody says any more about it. They don't say any more about it until the time of the ceremony. Then everything is complete and official.

>

Annin Soldier Wolf, Mark Soldier Wolf, and Florita Soldier Wolf (*left to right*) **discussed the proper sequence for Echo's naming ceremony held in 1999. They were dressed in beaded buckskin outfits and headdresses made by themselves and members of their family.**

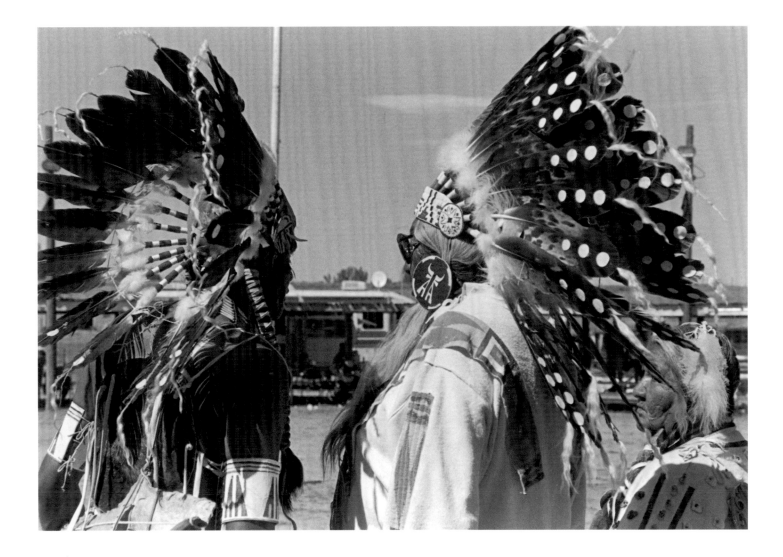

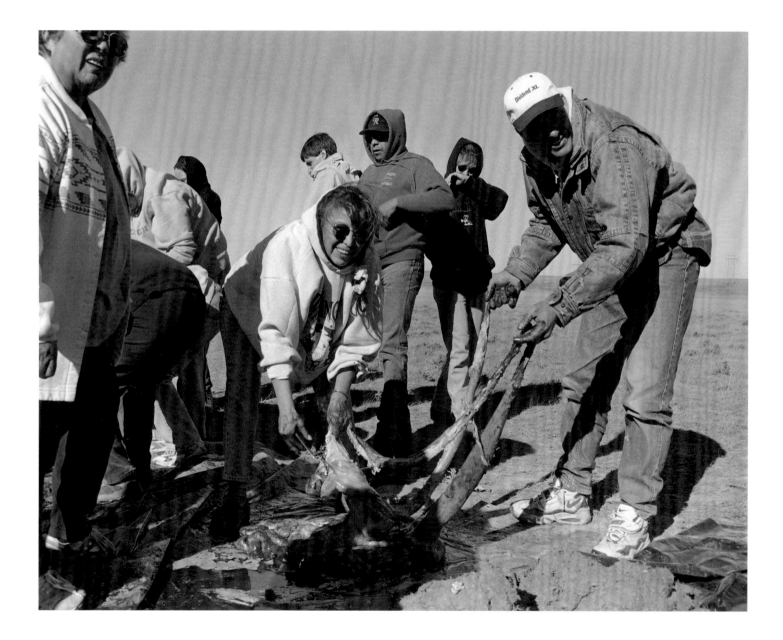

The Buffalo Road Heneeceibo'o

On a cold Saturday in October, students and staff from Wyoming Indian High School (WIHS) journeyed south and east for three hours in school buses and pick-up trucks, to the ranch of Vern and Della Vivion. The Vivions' ranch stretches for miles, from north of Wolcott Junction, a lonely I-80 exit with a convenience store and restaurant, almost as far south as the town of Saratoga, Wyoming. They had been raising buffalo on this vast sagebrush steppe for several years, and this was the second time they had donated a buffalo (along with a lunch of steaming hot chili) to the school's cultural education program. A few students from Saratoga High School came, too, for what Gloria Goggles, a WIHS teacher, called "a cultural sharing."

The students had come to a place their ancestors knew well. It was located west of the bison-rich Laramie Plains and on the seasonal migration route the Arapaho called the Buffalo Road, or Heneeceibo'o. According to information provided in 1914 by Arapaho elders Gun Griswold and Sherman Sage, Arapaho bands traveled from their homeland in central Colorado north along the west side of the central Rockies and into what is now called North Park, Colorado. From there, they followed the North Platte River into what later became Wyoming. They crossed the river at a place called Tecenoo (The Door), in the Saratoga area, just a few miles from where WIHS students stood that cold October day. The bands then crossed the northwestern extension of the Medicine Bow Mountains, Hooksee3oo (The Protection), and eastward onto the Laramie Plains.

Arapaho elder Mark Soldier Wolf provided a slightly different but not contradictory explanation of Heneeceibo'o. Different Arapaho bands, he said, saw things differently. His family's oral tradition tells of the Buffalo Road coming north on the east side of the Rockies. Tecenoo was that point on the trail where you crossed onto the high plains and the buffalo ranges began. The buffalo range to the west, now called the Laramie Plains, was Heneeceinonii (Buffalo Fat). The entire mountainous area at the southern edge of the Laramie Plains, from North Park through Saratoga and over the Medicine Bow Mountains, was called Ni'inone' (Place of Many Lodges). It was a fruitful place, Mark said, full of lodgepole pines, berries, roots, plants, elk, deer, and moose in winter, and buffalo that would wander into the mountains—a perfect place to camp.

The Vivions' buffalo grazed not only along Heneeceibo'o, the Buffalo Road, but also in the ruts of another historic route: the Overland Trail, a southern alternative to the Oregon Trail that was used most extensively during the 1860s by European-American emigrants headed west. The Overland Trail

<

Wyoming Indian High School staff members Phyllis Trosper, Gloria Goggles, and Derek Sandall (left to right, foreground) **finished butchering the buffalo after the school's hunt in southeastern Wyoming in 1999. Standing behind them was another staff member, Bryan Trosper.**

crossed the Laramie Plains to the east, penetrating one of the last of the bison's natural ranges, and then crossed what are now the Vivions' large fenced buffalo pastures. Just a few miles to the north is the Union Pacific Railroad, also built in the 1860s, which was perhaps the final disruption to the bison's seasonal migration. Fort Halleck on the Overland Trail and Fort Steele on the Union Pacific railroad line were built near here in the 1860s to protect mail routes and westward travelers from the nomadic bands of Indians of many tribes, including Arapahos, who attempted to defend their right to use the area's resources.

Within sight of the Ni'inone', a teacher from WIHS named Leo Her Many Horses killed a small bull with a rifle, while students remained a safe distance away. An elder prayed over the animal's body, to indicate respect and to thank the animal for its life. Then, led by their teachers, the students participated in the butchering process. The animal was quartered and the parts loaded in the bed of a pick-up to be taken back to the reservation. All external body parts and internal organs were saved, and students even took turns squeezing the bowels to empty them of their contents. According to Jim Stewart, a staff member who helped organize the trip, "We only left the poop."

Back at Ethete the following week, some meat was given to elders and the rest was served at the school's annual Veterans Day feast. Phyllis Trosper, the head cook, also made tripe soup from the stomach. Just as in the old days, all non-edible parts were used for craft or ceremonial purposes. The skull was boiled to remove the muscle and is now on display at WIHS.

>

**During the 1999 buffalo butchering,
WIHS students Michael Yawakia
and Lonnie Bell, barely managing
to suppress grimaces, stripped the
intestines of their contents.**

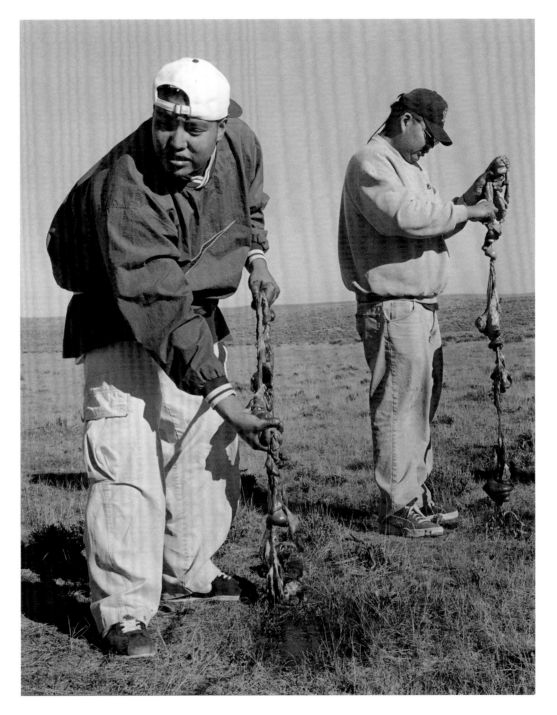

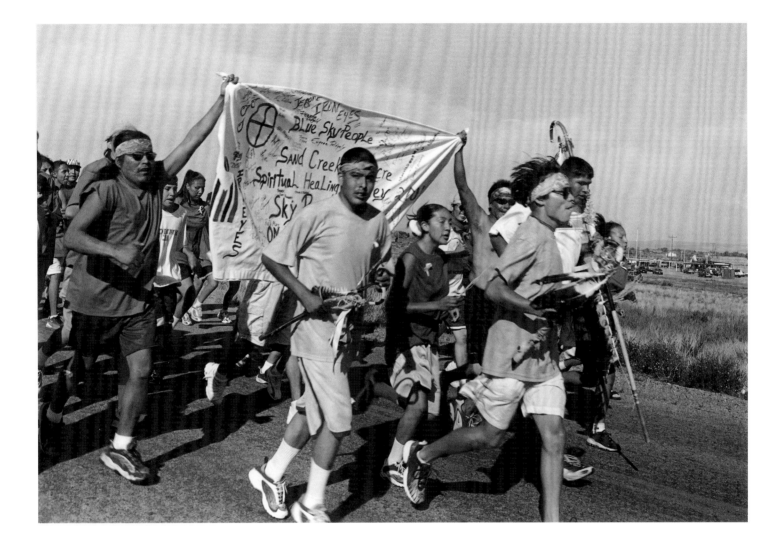

Sand Creek
Why They Run

See'n my father at the entrance of the powwow arbor as we were runnin' into the arbor. My pop was stand'n there. He had his arms raised and give'n some joyful whoops, hollers. That's what the Run was all about. See'n the look on his face, of pride, happiness, all the good. Seems like it was well worth the journey, the miles we put in, trials, tribulations, was well worth it! See'n my pop there at the end of the run, holler'n and shout'n, raise'n his arm canes in the air, made me proud, happy. Feel'ns are hard to explain. All good. "Spiritual Healing Journey."

The headband in the picture I am sport'n was given to me by a brother I got to run with. I ran with the indigenous runners that year!! Met up with them, ran with them until we part'd company, I came home then.

Jerome Goggles, 2007

There's a place that I have visited only twice, but I know, in the future I will return there every year.

Once a year, there is a group of runners of the Northern Arapaho tribe from the Wind River Indian Reservation, who are proudly called the Sand Creek Massacre Runners. We have a variety of Northern and Southern Arapahos and Cheyennes that join our running group. The age of the runners really carries along, for example there are kids as young as four or five years old who join us, and adults, and even elders who participate.

When my Great-Grandmother Regina Arthur was alive, she used to tell me stories of the old times. She told me that both sides of my family trace back to Sand Creek. "That is our heritage, and nobody can take it away, because it is a part of my Arapaho blood," she used to say to me.

People need to realize that we're not running for money, publicity, or to get attention. We run to honor the memories of our ancestors who were killed at Sand Creek. We run to make sure people still remember what happened to innocent women, children, men, and elders in southern Colorado.

During the year 2002 Run, we started in Chivington, Colorado and ran to Ethete, Wyoming. Right by Chivington is the Sand Creek Massacre Site. That is where we always start,

<
At the conclusion of the 2000 Sand Creek Memorial Run from southeastern Colorado to the reservation, runners approached the powwow grounds in the community of Arapahoe holding their handmade banner high. The runners in front *(left to right)* are John Goggles (holding banner), Ernest C'Bearing, Ambrosia Harris, Jerome Goggles (holding banner), Vincent Brown, and Myron Arthur (holding the large staff).

179

and we do our ceremonies there also. That is how I feel about Sand Creek. I feel that people should stop and think of what really happened, and remember how brutal it was. And it's not only that Indians were killed, Sand Creek is similar to what happened to the Jewish people when Adolf Hitler was in command in Germany before and during World War II.

At Sand Creek, soldiers cut open a pregnant woman's womb and took out her unborn baby, and used the babies as target practice. The soldiers had no mercy or remorse for what they were doing to those native people.

I wish that people would stop, think, and remember what happened to those groups of people at Sand Creek. I want people to think from their point-of-view, and then they might get the picture of why we're honoring our ancestors of Sand Creek. I think that people should tell their children, and other generations to come, because this is not something the Arapaho or Cheyenne should be ashamed of, this is something to honor and respect and not just to poke fun at.

Me, personally, I got into the year 2001 Run. At first I wasn't sure of what I was getting myself into. I thought it was just a run, like a marathon. I didn't know that it included the Indian ways, or that we were going to travel down to the massacre site, tour the museums, or learn more of what our purpose for running was.

But now it is 2003, and I still have my first Sand Creek Run memories and shirts. Ever since that run, it has made a difference. It has made me stop and think of where my ancestors were, and who they were. It has made me want to tell everyone in the world that the Indian people are a sovereign nation, and that we could stand out after being ignored all these years. There are people all over the world who still believe that American Indians still live in tipis and wear buckskin clothing. They view us as living fossils, and it is time to stand up and be counted as a civilized people.

Jenna Black, 2003

The Sand Creek Run is important because it continues the healing process—and the young runners are role models for this effort—and brings awareness to the people of Colorado.

Historian Tom Meier, 2000

Sand Creek **Noobeiniicii**

The ground was just red with blood. It hurts your heart to know that. They were our ancestors.

Cleone Thunder, Sand Creek Oral History Project, 1999

On the morning of the massacre I was awakened with the camp crier telling us to wake up; his words were, "Wake up Arapahos, wake up Arapahos, the soldiers are attacking, the soldiers are attacking us. Run, scatter, run, scatter, we will all meet again in two moons where we had our last Sun Dance. We will all meet again where we had our last Sun Dance."

Being a young woman, I sat up from my bed and put on my moccasins, there was an awful lot of noise outside of the teepee. As I went outside of the teepee I saw people running in every direction and I saw people falling down and teepees falling apart. The people falling down were those that were getting killed, the teepees falling apart were those getting hit from the soldiers' big guns.

I started running towards the hills which was north of camp, as I was running near some rocks I heard my name being called "Singing Water, Singing Water." I stopped running and looked around and could not see anyone, I was about to start running again when I heard this voice called my name again. "Singing Water, look up to the rocks, we are behind them. Crawl up here and we will hide you with us." I crawled up to the rocks where this voice came from, when I got to the rocks, the man made an entrance for me. I had to stand up and climb over the rocks; behind the rocks was a man, a woman, and a child. We stayed behind the rocks for two days.

Singing Under Water Moss (Underwood), Sand Creek Oral History Project, 1999

[It is] right and honorable to use any means under God's heaven to kill Indians that would kill women and children, and damn any man that was in sympathy with Indians.

Colonel John M. Chivington, 1864

Sand Creek. The Arapahos call it Noobeiniicii (Sand Creek) or just Noobe' (Sand). Or they might refer to it as *nih'iitbisiitoneihi3i'* (where we were attacked).

An estimated 450 Cheyennes under Chief Black Kettle and a band of perhaps 50 Arapahos under Chief Left Hand were camped along the small creek in southeastern Colorado in November 1864.

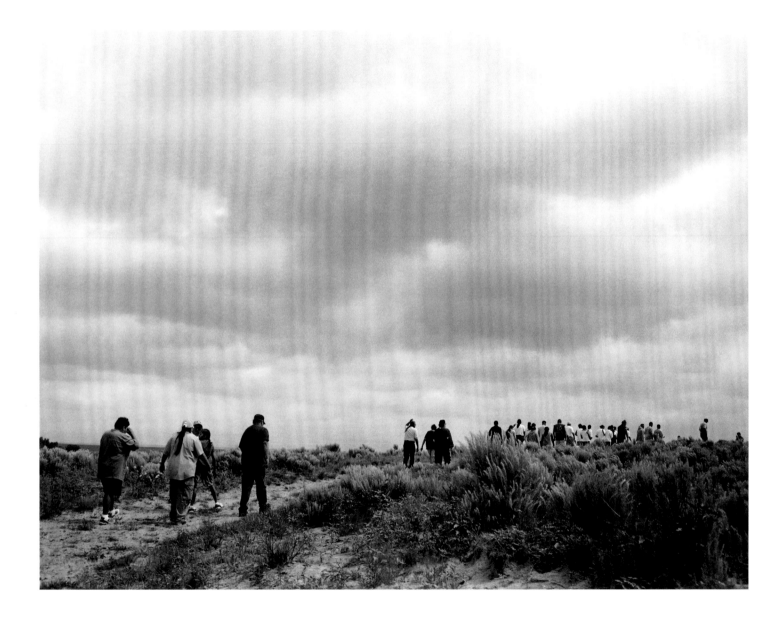

A complex series of events had brought them to that place at that time: Indians, including Arapahos and Cheyennes, had attacked settlers and immigrants intruding into their territory, guaranteed to them by the Treaty of Fort Laramie in 1851. The Colorado Cavalry had attacked Indian villages, and the inflammatory rhetoric and actions of Colorado territorial governor John Evans and Colonel John Chivington, the head of the Military District of Colorado, worsened an already volatile situation. In September, several chiefs met with Evans and military officers at Camp Weld near Denver to discuss the options for peace. Though no agreement was reached, they were told to report to Fort Lyon on the Arkansas River (near present-day Lamar, Colorado). Black Kettle established a camp on Sand Creek and reported to Fort Lyon, forty miles away; Left Hand's band joined him. Sand Creek was the northern and eastern boundary of a smaller reserve that had been guaranteed them in the Treaty of Fort Wise in 1861.

On November 14, Chivington left the Denver area with several companies of the Colorado First Cavalry and the newly formed and little-trained Colorado Third Cavalry, one-hundred-day volunteers meant to protect Colorado during the Civil War while most federal troops were committed elsewhere. They reached Fort Lyon at midday on November 28th. Chivington took control of the fort and stationed pickets around the fort so no one could leave, and after a few hours rest, he and 700 to 800 soldiers set out for the Cheyenne and Arapaho village on Sand Creek. They attacked at dawn on November 29th.

The sleeping camp consisted mostly of women, children, and elders; most adult men were hunting away from camp. As soldiers approached, Black Kettle raised an American flag and a white flag of peace. Many Indians were killed immediately, mostly women and children begging for their lives, and the rest scattered across the prairie or ran up Sand Creek, where they dug pits in the sand and tried to defend themselves. The Colorado Cavalry volunteers had brought with them both hatred and howitzers, and by the end of the day more than 150 Indians had been killed and the rest were scattered and in hiding. Left Hand's Arapahos were almost entirely wiped out, and he was mortally wounded.

Although the leaders of two companies had refused to participate in what they thought was a massacre of peaceful Indians, most soldiers stayed there that night and the next day, committing atrocities on the dead and dying. On December 22nd, they returned to Denver as heroes—the victors of the battle of Sand Creek—proudly displaying body parts.

The Sand Creek Massacre is an important event not only in the history of Cheyenne and Arapaho people but also in the history of the American West. Though there were other incidents of ethnic

<

Arapaho people respectfully approached the bluff overlooking the Sand Creek Massacre Site in Kiowa County, Colorado, for a ceremony honoring their ancestors. The ceremony was also the beginning of the 2001 Sand Creek Memorial Run.

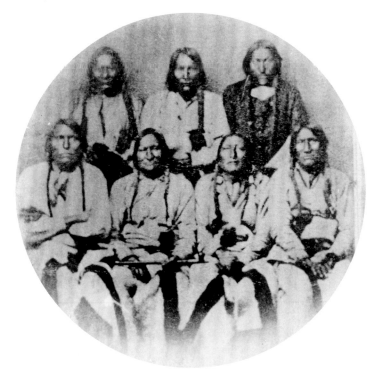

^

A few months before the 1864 Sand Creek Massacre, Arapaho and Cheyenne chiefs were photographed. The inscription reads, "Bosse, Left Hand [Arapaho], White Wolf, Black Kettle [Cheyenne], White Antelope [Cheyenne], Bull Bear, Neva [Arapaho]." Left Hand and White Antelope were killed at Sand Creek; Black Kettle survived only to be killed a year later. (Courtesy of the Denver Public Library)

cleansing, the brutality and inhumanity at Sand Creek sparked a national debate as well as two congressional investigations and one military investigation. It worsened already tense relationships between whites and Indians in Colorado, precipitated a three-year war of retaliation and re-retaliation, and left a legacy of distrust that lasted for decades. It destroyed Chivington's military and political career but made him a folk hero to many; he was never charged with crimes. Evans remained an important citizen of Colorado, and continued to achieve political and financial success. It led eventually to Arapaho and Cheyenne bands being pushed out of Colorado: the Treaty of the Little Arkansas of 1865 moved southern bands of Cheyennes and Arapahos to Indian Territory (which later became Oklahoma). The northern bands that refused to go to Indian Territory were essentially pushed out of Colorado Territory by 1868; they moved north into Wyoming Territory.

In 1998, Senator Ben Nighthorse Campbell of Colorado, a Northern Cheyenne, introduced a bill that quickly passed both the U.S. Senate and the House of Representatives and was signed into law by President Bill Clinton in October of that year. The Sand Creek Massacre National Historic Site Preservation Act allowed for the National Park Service to conduct archaeological and historical research, including the collection of oral histories, to determine the location and extent of the massacre area. The Sand Creek Massacre National Historic Site Establishment Act was authorized by Congress in 2000, after the completion of the site study report. In 2005, President Bush signed the Sand Creek Massacre National Historic Site Trust Act, allowing land to be brought into trust status by the National Park Service. In April 2007, the Sand Creek Massacre National Historic Site was dedicated.

In 1999, members of the Northern Cheyennes of Montana, the Southern Cheyennes and Arapahos of Oklahoma, and the Northern Arapahos of Wyoming began annual ceremonies at the site and memorial runs from there to a variety of locations. In 2000, Northern Arapaho Eagle Staff Runners ran to the Wyoming State Capital in Cheyenne and then on to Wind River; a welcoming ceremony and feast awaited at the Arapahoe powwow grounds. In 2001, they ran to Boulder, Colorado, as part of the Arapaho Nation Cultural Festival and Powwow, called No'eeckoohuut (Coming Home). Sand Creek runs continue to be held annually.

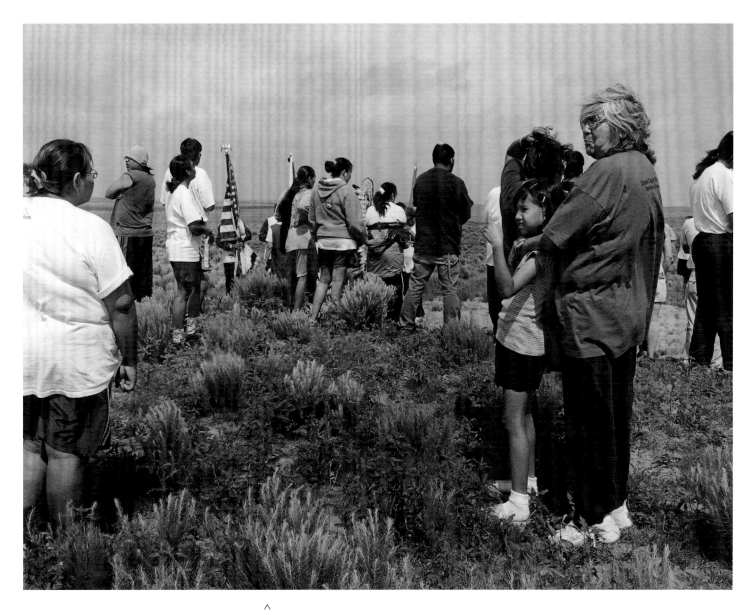

∧

Wilma Rose Moss and her granddaughter Brandi were among
those attending the 2001 ceremony, on a bluff overlooking
Sand Creek.

In 2006, the Wyoming State Legislature passed a resolution to create a Sand Creek Massacre Trail from the Colorado border to the Wind River Indian Reservation.

For American Indians, Sand Creek has become a symbol of atrocity and genocide. For some non-Indians, however, the debate over whether to call it a battle or a massacre is ongoing, and there is still a marker near the site, placed there by residents of Kiowa County, Colorado, in 1950 that identifies the "Sand Creek Battle Ground / Nov. 29th & 30th, 1864." There are still defenders of Chivington's actions who say he was merely defending settlers and immigrants from terrorists. There is still a town a few miles southwest of Sand Creek called Chivington, a distasteful reminder for Arapaho people who believe that to name is to honor.

According to anthropologist Alexa Roberts of the National Park Service, the disbelief that U.S. troops could betray their word and their flag is still vividly embedded in the Northern Arapaho oral histories collected during the Oral History Project of the Sand Creek Massacre Site Study. For many Northern Arapahos, to talk about the massacre is a sign of disrespect of their ancestors, and there is still a sense of shame and a fear of reprisal should it be discussed openly. As Josephine White said during her interview for the Sand Creek Massacre Oral History Project, "Most of them remember if only they will tell. It makes you mad that they were killed even though they had the flag. The flag meant not to do anything but they did anyway."

Leo Cowboy
The Eagle Staff Runners

Leo Cowboy of Ethete made twelve staffs for the 2001 Sand Creek Memorial Run. "You're not supposed to overdo these kinds of things," he said, "never go over four." But because of the special nature of this run and the large number of runners, many of them children, Leo went ahead and made staffs so that each group of runners would have one. Each staff was made from red willow that Leo had collected, soaked, and bent into shape. Eagle feathers were attached to each staff, and they were painted at the top of the crook with the sacred Sioux colors—red, white, black, yellow—representing all the peoples of the earth. At least one of the men's staffs had brown rabbit fur, standing in for buffalo hair, with an antelope foot at the bottom. One staff was a woman's staff that had beading to represent the beauty of woman. Sage was tied to each staff to ward off the bad spirits that are often encountered on runs.

Leo had been a runner since he was a child chasing family horses on the Navajo Reservation near Crown Point, New Mexico. He ran competitively while in high school at Stewart Indian Boarding School in Nevada, but his adult life was devoted to noncompetitive running. He participated in memorial and spiritual runs to honor people or events and runs to raise money for and awareness of important causes such as domestic violence. In 1988, at the age of forty-four, he participated in a run from Hiroshima to Hokkaido in Japan on the forty-third anniversary of the Hiroshima bombing, and he also ran in Germany and Russia and in many locations in the United States. After the Hiroshima run, elders gave him the spiritual authority to lead runs and make staffs, which he did for many years. Referring to this leadership role, Leo said, "The whole thing changed when I became a spiritual leader."

Together, Leo and his wife, Mary, the Arapaho woman he married in 1967, helped organize many runs throughout the West, including the Sand Creek runs held annually since 1999. They called their group of runners the Eagle Staff Runners; the group consisted mostly of Northern Arapahos from Wyoming but included members of other tribes and occasionally non-Indians as well. Leo would meet with the runners several times prior to a run to tell them what they should take with them, including medical supplies and "lots of clean socks." He would demonstrate how to hold the staff out in front, with minimal arm movement, and how to pass the staff on to the next runner like a relay baton. The staff, he told them, doesn't stop. But Leo's most important role was that of spiritual leader. He would talk to the participants about how to prepare mentally and how to pray with the staff. "The staff carries you," he told them.

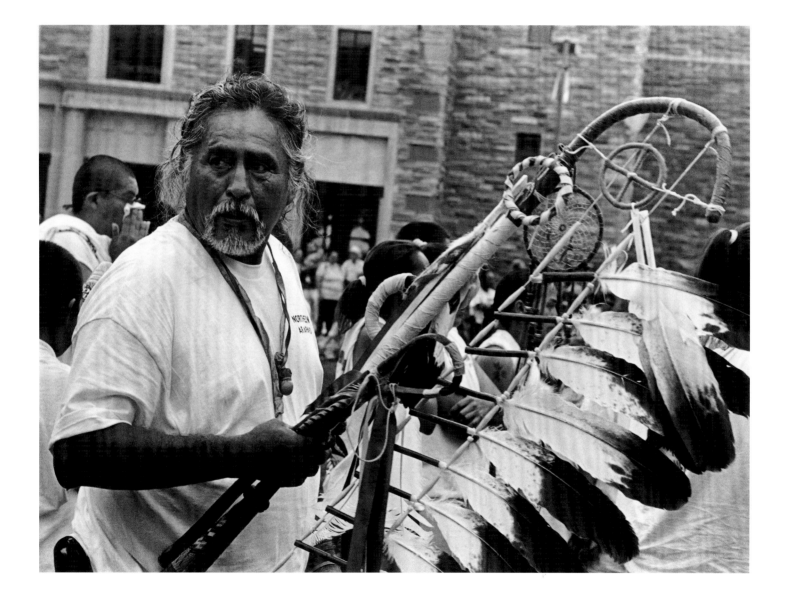

In preparation for the Sand Creek runs, Leo, Mary, and other organizers traveled potential routes well ahead of time to find the most scenic and least congested roads, to plan the route, and to determine mileage and designate sections or "legs." The locations of rest areas, camping areas, motels, and restaurants were noted. Mary obtained clearances from the highway patrol, insurance, and releases from the participants. They collected the equipment that would be needed, such as reflective vests and signs, and found volunteers trained in first aid willing to come along. They arranged to borrow vans from schools and businesses, recruited the drivers, and assigned runners to each van.

In 2001, there were over a hundred Eagle Staff Runners participating in the Sand Creek Memorial Run. Each morning, Leo asked them to form a circle to pray and to be blessed and smudged with cedar. They would then board the vans. There were ten runners in each of ten vans, as well as a van for very young runners who ran very short sections. Each runner ran a mile or so, depending on the terrain, and then passed the staff on to the next runner. When a van's runners had covered their designated ten miles and had arrived where the vans in front of it had started, the van leapfrogged around the other vans to their next designated ten-mile section. It took less than two days to cover the two hundred miles from the Sand Creek Massacre site to Boulder, Colorado.

The Eagle Staff Runners entered Norlin Quadrangle at the University of Colorado in Boulder on midday on June 9, 2001, and were greeted by a large crowd of spectators. Their entry was an important part of the opening ceremony of the Arapaho Nation Cultural Festival and Powwow, sponsored by the University of Colorado and the Boulder Historical Society—an event that had been timed to correspond with the Sand Creek Memorial Run. Residents of Boulder wished to honor the Arapaho people, who had been forced out of central Colorado following the Sand Creek Massacre, with a weekend of dancing, classes, films, and exhibits. They called the festival No'eeckoohuut—Coming Home.

Leo lived at Ethete for over thirty years with Mary and their seven children and was part of the community. Once, Arapaho elders, including the Four Old Men, asked him to bring his principal running staff to a sweat lodge ceremony, the first and only time the staff had been through a sweat. In that sweat, the elders adopted the staff and told Leo he would be Keeper of the Staff and gave him the responsibility for caring for it.

Referring to his participation in the Sand Creek runs, he said that although he is not Arapaho, his family is Arapaho. "I am doing this for my family." Personally, Leo felt he had achieved his life's goal of running in the four directions and always returning to the center—to the Wind River Reservation. "The four directions start here," he said. "The rivers run in all directions from here."

Leo died in 2007. Mary and several of their children continue to live in the Ethete area.

<

At the end of the 2001 Sand Creek Memorial Run at the University of Colorado in Boulder, Leo Cowboy collected staffs from the Eagle Staff Runners. In his right hand, he carried his principal staff, with many attached eagle feathers, and two smaller staffs used by younger runners.

The Arapahoe Ranch **Koonootoo'hoene'**

In the fall of 2001, folks gathered at the headquarters of the Arapahoe Ranch for a horse auction. Old ranch buildings were surrounded by horse trailers of various sizes, and people milled about the maze of corrals and the century-old barn looking for horses they might be interested in buying. Over the years, the ranch has occasionally sold horses at these well-attended auctions to reduce the size of its herd. Arapaho tribal members as well as many non-Indians purchase horses here because of their unique breeding, rearing, and training; tribal members are given discounts.

Arapaho elders still refer to the Arapahoe Ranch as "At the Place Unlocked by a Key," or Koonootoo'hoene'—a reference to its original name of Padlock. Padlock and adjacent ranches in the northeastern corner of the reservation, originally owned by non-Indians, were purchased by the tribe in 1940. The ranch has been run by the Northern Arapaho Business Council and an appointed board of directors since the 1950s. Its headquarters is a two-hour drive from other reservation communities, on the other side of the Owl Creek Mountains, fifteen miles from the town of Thermopolis; it is both a part of the reservation and somehow separate.

Today, the Arapahoe (an older spelling of the tribal name) Ranch is one of the largest ranches in Wyoming, covering nearly 380,000 acres. In a good year, it will run as many as six thousand cattle, although since 2000 drought and major fires have forced a reduction of the herd. There are also two hundred horses of Thoroughbred and Morgan base lineage with later additions of strong Quarter Horse lines. The ranch maintains a cavvy (the string of working horses) of between fifty and one hundred horses.

Colts, born on the range, are brought in during the first year only to be weaned and the second year only to be castrated. They are brought in to start their training at age two or three. "They're the closest thing to wild horses," said Forrest Whiteman, the ranch's horse foreman, who helped organize the horse sale. "They have the social structure of wild horses." This, he feels, creates horses that are strong, smart, and easily trained, because they have learned to follow their instincts. Horses raised in pastures and corrals lose their herd instincts and don't know how to behave. "It's like someone who pays no attention to safety."

Many young Arapaho men have worked at the Arapahoe Ranch for a few years as cowboys, and for some it has been a lifetime employment. In many ways, Forrest Whiteman's story is typical of many Arapaho men (including his grandfather, father, and uncle) who have worked there. When he was fourteen, his dad bought horses for him and his brother, and Forrest started working with them

> **Sheyann Stewart, granddaughter of Arapahoe Ranch Board member Irene Crazythunder, ran through the historic Arapahoe Ranch barn on horse auction day in 2001.**

right away. After graduating from Riverton High School, he studied carpentry and got his first job as a carpenter at the ranch in 1982, but he said, "The cattle and horses kept drawing me." Once he was working on a roof in the early morning, before it got too hot, with another man. When the cowboys headed out on their horses for their day's work, Forrest and his companion stopped to watch. The man told him, "You need to be cowboying. I'd rather be cowboying, too." Forrest brought an old saddle to the ranch, just in case. When three cows—two mean ones and a cripple—needed to be brought in and there was no one else around, someone said, "Hey, he's got a saddle in his room."

He was given a "bronky" horse named Cricket to ride, and though he had never worked with cows before, he brought them in. He noticed that you could apply the same concept to working with cows as with horses, so he slowly pushed the cripple and the other ones followed along. Within three years, he was a full-time cowboy. For fifteen years after that, he cowboyed and worked as cattle foreman and later as horse foreman.

Forrest's Indian name, Bad Horses, came from the Arapahoe Ranch. When his grandfather worked at the ranch, he was given some horses to train that no one else could handle. The next day, he returned to headquarters with these bad horses calmly pulling a wagon, so people started calling him Bad Horses. Forrest's parents passed the name on to him.

Today, Forrest no longer works at the ranch. Since 2003, he has been raising and training horses for himself and others, as well as working as a supervisor for an oil company.

>

Forrest Whiteman worked with a dapple horse in a round pen during the 2001 auction conducted by Worland Livestock auctioneer Richard Venzor. Forrest wore his hat in a way unique to ranch employees.

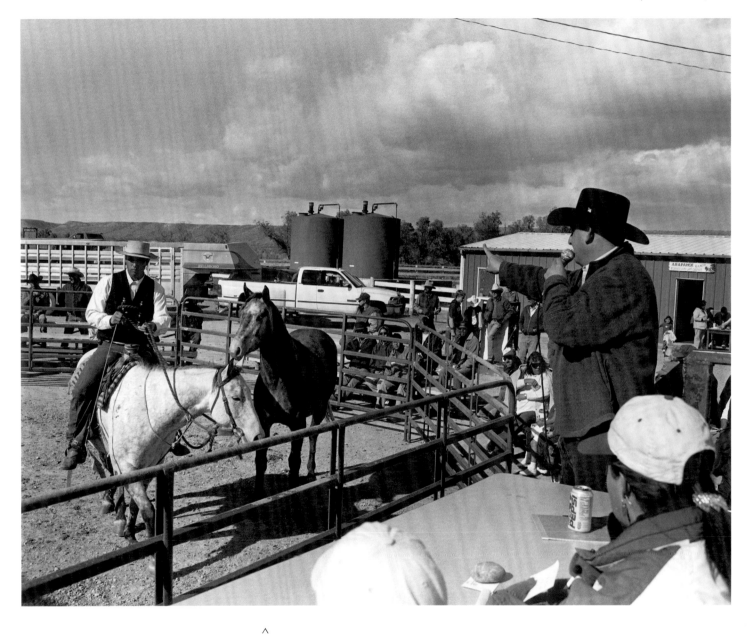

^

**Forrest Whiteman headed off a horse being auctioned by
Richard Venzor.**

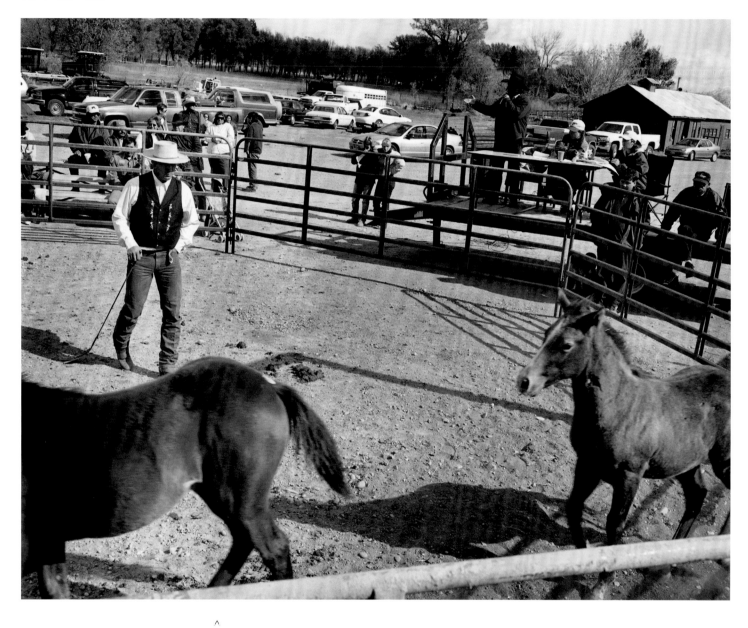

∧

Forrest Whiteman worked colts in a pen during the auction.

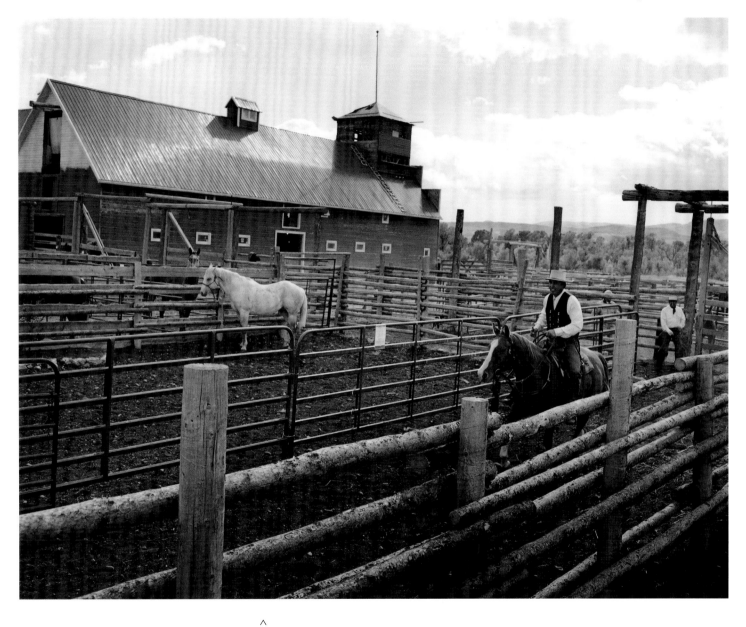

∧

Forrest Whiteman rode between corrals surrounding the

historic Arapahoe Ranch barn.

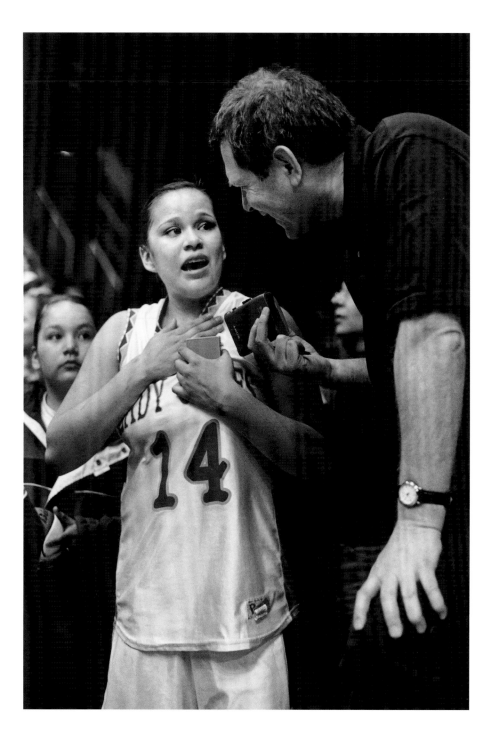

Lady Chiefs
Not Shy Anymore

It was the year 1910, when on one of his hauling trips to Casper, "Joe" Duran drove his wagon past some boys playing by the side of an old barn. He noticed the youngsters were bouncing a ball, then tossing it through a bottomless peach basket hung on the side of the barn. Joe stopped his wagon to watch the boys at play, and was impressed by their obvious enjoyment of this "new game."

When he got back to Saint Stephen's, Mr. Duran and some friends erected a barrel hoop on a tree, managed to obtain a non-regulation ball—and the game of "basketball" was introduced to the Wind River Reservation.

Wind River Rendezvous, 1975

In 1975, Joe Duran was given "a special plaque of grateful recognition for his bringing of 'basketball'" to the reservation in 1910. And what a contribution it was—basketball caught on quickly. By the 1920s, it was being played by both boys and girls at all reservation boarding schools, and competitions between the schools were frequent. By the 1930s, St. Stephen's teams were traveling to national Catholic high school tournaments, and by the 1950s, they were winning state championships.

When Wyoming Indian High School was opened in 1972, basketball immediately became an important part of the school's identity. Students and board members chose the names Chiefs and Lady Chiefs for the teams. From the beginning, many of their coaches were Arapaho men and women, some of whom had played on championship teams for other schools.

By the mid-1980s, the Chiefs were a winning team. In fact, they were the winningest team in the state. They won fifty straight games between 1983 and 1985 and three consecutive Wyoming State 2A championships. Their coach, Alfred Redman, obtained national recognition for his unprecedented string of victories, a still-unsurpassed record. The Chiefs have continued to have winning seasons and have become the subject of intense media attention, including an award-winning film, *Chiefs,* that documented their highly successful 2000 and 2001 seasons. The film, however, received mixed reviews at home. It was seen by some as an invasion of privacy and controversial because of scenes showing drug and alcohol use by players.

<

Diana Sounding Sides was interviewed by Associated Press reporter Rob Black immediately following the 2003 Wyoming State 2A championship game. "I was so excited I don't even remember talking to him," she said.

The Lady Chiefs were slower to win championships and recognition. According to head coach Aleta Moss, who was a member of one of the first teams in 1975, in the beginning it was hard to create dedication in the girls. For the first few years, the team struggled, and many girls dropped out. Gradually, the older girls started helping the younger ones by teaching team cooperation and by becoming role models. "All the past girls helped the program become what it is today," said Coach Moss. For years, the Lady Chiefs were overshadowed by their male counterparts, and hardly anyone except parents attended their games. Now, following a series of strong teams, the Lady Chiefs draw their own large crowds. Moss said that she and her assistant coach, Al C'Bearing, "keep wanting to empower our girls to be strong young ladies and live lives for themselves." The girls now get lots of media attention, too. "Our girls aren't shy anymore," she said.

In 2003 and 2004, the Lady Chiefs won back-to-back state championships. Among their players was Diana Sounding Sides, for whom basketball is a family tradition: two of Diana's brothers were outstanding players for the Chiefs who were profiled in the film. In February 2004, she received national attention when *Sports Illustrated* reported that "Diana, a sophomore guard at Wyoming Indian High, made 14 of 16 three-pointers and was 18 of 21 from the field overall to score 55 points in a 111–44 victory over Big Piney. She set a school record (male or female) for three-pointers and points in a game."

The Wyoming Indian and St. Stephen's high school basketball teams have assumed symbolic importance on the reservation. In a social and economic environment that is viewed by many Indians as hostile if not racist, basketball is one way in which Indians feel they can compete and excel. According to Coach Redman, at away games players and fans are often exposed to racist remarks and actions such beer bottles thrown at the bus, gunshots outside a gym, taunts, fake war whoops, tomahawk chops, and people following them out of town. But, Redman says, "Our students tolerate the behavior of the fans and students of schools that we have visited with quiet dignity few high school students would be able to maintain."

>

At a home game in 2003, the Lady Chiefs broke from a post-victory huddle. *From left:* **Contessa Bonds, Charelle Martin, Diana Sounding Sides, Chanice Glenmore, Quannah Glenmore, Darsyl Posey, CheNara Harjo, Marrisa Goggles, Mary Brown, and Cacey Sage.**

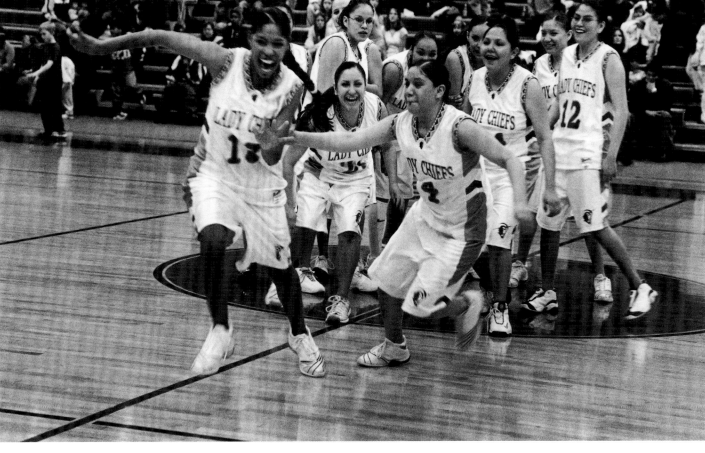

Annin Soldier Wolf **Hista**

The wolves will always be coming back—for good or bad. That's how society's run, how people are living. Be wary—it could be a new start or an end.

Annin Soldier Wolf, 2005

A stick figure with extended arms supporting hoops made of rawhide was positioned in a large open area adjacent to the Northern Arapaho Powwow grounds at Arapahoe. Draped over the stick figure was a wolf pelt, and over the pelt there was a "trail" or strip of hide to which eagle feathers were attached. Riders on horses took turns approaching the figure and attempting to grab a hoop with a stick. This is a traditional "counting coup" game, to train warriors in the art of touching without killing their enemies and to train horses to be unafraid to closely approach the animal pelts and fluttering feathers that enemies often wore. It was one of several horse races and games sponsored by the Soldier Wolf family during the 2003 Northern Arapaho Powwow weekend, held in honor of the naming of four-year-old Hista Soldier Wolf, son of Annin and Cathi. Hista is Annin's Indian name, taken from a Cheyenne word he translates as Bear Heart. Later that day, the boy Hista was given his own Arapaho name, Hooxei Kokteen, or Painted Wolf, by his grandfather.

As a child growing up in the 1970s, Annin Soldier Wolf would ride a horse from his remote home to school, even though there was bus service. He wore moccasins and had long hair, and other students called him "caveman." He would run away from school because he preferred spending time with horses. "When I was growing up, I was always with horses and animals. It was a good start. I learned the patterns and everything that follows. That helped me a lot. I'm still praying for them, taking back any stories I get from them. Animals are here for us to be taught."

After graduating from St. Stephen's High School, Annin worked as a firefighter and sold his artwork to pay his way to the Institute of American Indian Arts in Santa Fe. He only stayed a year—without much money, it was too hard to keep going, and he also felt that he had already taught himself what he needed to know. He returned to the reservation and went through a period of partying and drinking. During this period of his life, he had a near-fatal fall with a horse, while he was getting a colt used to crossing a ditch. "He was learning, 'I'm a horse, that's what I'm used for.' The horse was going pretty good with me. I stopped, let him calm down. I did it one more time—he did good. Then he slipped, got stuck in the mud, and fell on my leg." Annin's leg was broken backwards.

<

Annin Soldier Wolf dismantled the stick figure, covered with a wolf pelt and "trail" of eagle fathers, that was used for horsemanship games sponsored by his family in honor of his son's Indian naming in 2003. Thurlo Jenkins visited with him.

He crawled toward home, a distance of more than a mile, until someone came to find him and took him to the hospital. "I didn't blame the horse. My parents said, 'When you go through life, things happen. You never blame the horse. Take it as a lesson. Let it go.'" Doctors said he would lose his leg. Annin felt that their attitude was, "It's only an Indian, chop it off." After he attacked the doctors with his crutch, they tried harder and successfully to save it.

In 1994, Annin met Cathi, a horsewoman visiting the reservation from her home in Northern Territory, Australia. When they were introduced by mutual friends at a Christmas powwow, the first thing he asked her was, "Do you like Yothi Yindi?" (an Australian Aboriginal musical group he liked). People started scheming to get them together, and three months later they were married. For two years, they lived in a shack on land given to Annin by his father, with no running water. Cathi was used to the lifestyle—she had grown up in stock camps in the outback. "We started from scratch," she said. "People would say to me, 'Oh, you married an Indian.' I said, 'No, I married Annin, who happens to be an Indian.'"

Annin and other members of the Soldier Wolf family are performers who frequently travel to powwows and special events, such as the 2002 Winter Olympics in Salt Lake City. There, the family was given the wolf pelt that Annin now uses as part of his performance regalia—and on the stick figure at the horse games in 2003. The wolf is an important symbol to the Soldier Wolf family—they still identify themselves as descendents of the Wolf Society. In the 1990s, they were actively involved in promoting the reintroduction of the wolf into the greater Yellowstone ecosystem, which includes the reservation—or, as Annin's father said, they "called the wolves back from the north." Their efforts were the subject of a 1995 video titled *Wolf Nation*.

Today, Annin has an image problem. The former "caveman," now a sought-after dancer, performer, and model, sees his image used everywhere, usually without his permission. Photographs snapped at powwows turn into paintings worth tens of thousands of dollars, for which he receives no compensation.

Annin and Cathi now live in a small trailer home on Annin's land with their two children, whom they are teaching horsemanship, traditional crafts, and performing arts. In addition to training horses, they have both worked at various jobs off the reservation, and in 2006 they started their own business selling Indian and southwestern-style blankets, rugs, and tapestries. They hope to take their family to Australia someday, to visit Cathi's family and to see an opera performed at the Sydney Opera House. Annin loves all forms of music, but especially opera.

Janie Brown **Behniitou'u**

Janie Brown has been head cook at the Ethete Senior Center for over ten years. Five days a week, every week of the year, she makes over a hundred meals. Some are distributed as meals-on-wheels to shut-ins, but most are served at the center to elders who come not only to eat but also to visit with friends and catch up on community news. Janie arrives early and works through the morning to be ready for the 11:30 serving hour. In between stirring pots of soup and checking roasts, she catches a few minutes to bead. In midafternoon, when her workday is done, she goes home and beads some more.

Janie started beading when she was thirteen years old. She said she "bothered" her aunt about it until her aunt showed her a can of beads and told her to go learn. Janie also picked up some pointers from a teacher in a Neighborhood Youth Corps summer program. "From there, I would just see things and try different things. I had to learn myself."

Born Elizabeth Jane Wallowing Bull in 1953, she spent her first eleven years living in a frame tent next to her grandpa's log home near Ethete. It had a dirt floor, a wood frame around the bottom, a canvas tent covering all of it, and a wood stove. Her grandpa would shovel a path through the snow to the road so the children wouldn't get their feet wet going to school. She lived with other relatives for a while after that and attended a local elementary school. She started high school at a boarding school, St. Mary's Episcopal School for Indian Girls in Springfield, South Dakota. After the first semester, her family couldn't afford to send her back, so she tried Lander Valley High School. "A white girl kept staring at me, and after three days I couldn't stand it any more, so I told her to stop staring or I would beat her up." The principal sent Janie home and told her not to come back. A scholarship came through, allowing her to return to St. Mary's.

At St. Mary's school, Janie thrived. The school was known for its rigorous education—Latin and Spanish were taught, along with etiquette. It was one of the first schools in the country to teach classes in American Indian history and culture, and students were encouraged to be proud of their heritage. When she graduated, she briefly thought about becoming an Episcopal nun but knew it meant she would be away from her family for long periods of time. Instead, she applied for and was accepted into the Rhode Island School of Design and the Institute of American Indian Arts (IAIA) in Santa Fe. She chose the latter because it was not as far from home.

Once, while a student at IAIA, she and three friends decided to go to an American Indian Movement (AIM) protest in Washington, D.C. They started walking, occasionally getting rides. The first night they slept in a highway underpass in Albuquerque, then hitched rides to St. Paul, Minnesota, then

"hopped on" with a caravan of cars headed to the protest. After the caravan reached Washington, the peaceful protest turned angry, and on November 2, 1972, four hundred Indians occupied the Bureau of Indian Affairs headquarters. Janie and her friends had been at another location, taking phone calls from people wishing to help. When they heard the building was barricaded, they raced there and climbed in through a bathroom window. They were inside for three or four days.

On the inside, things were bad. Protestors tore up restrooms and offices and even destroyed the artwork of Indian people hung on the walls—including art by a friend of Janie's from IAIA. Although she agreed with many of AIM's principles, Janie was appalled by the destruction, especially of the art. "They were creating havoc. There was no control," she said. When money came through to send people home, she accepted it and returned by bus to Santa Fe. Her mother didn't approve of Janie's involvement with AIM. "I didn't raise you to be like that," she told Janie.

After two years at IAIA, Janie returned to Wind River where she met her future husband, Jim Brown, who was working on the farm at St. Michael's Mission at Ethete. "People joked that I was chasing behind him on his tractor," she said. They were married in 1976 and have four children and one grandchild. Jim had been in the military and was stationed near Washington, D.C., in 1972. His unit was on call to help end the takeover of the BIA by AIM, violently if necessary.

Today, Janie's beadwork is done almost exclusively for her family. In fact, it is the primary reason she wanted to learn to bead. "I wanted my kids to all have moccasins and didn't have anybody to make them for me," she said. She also makes them dancing outfits, dresses, leggings, shirts, and barrettes when these are needed for a special reason. "Traditionally, you do everything for a reason," she explained. "It doesn't mix with making things to sell." Today, however, Janie occasionally sells things to help support her family.

When her older daughter, Danielle (who works at the senior center with her), was about to give birth, Janie made a cradleboard for her grandbaby. An outer frame of willow and inner frame of rawhide are both covered with white buckskin. The beaded design at the top of the cradleboard was one of many Arapaho designs collected by anthropologist Alfred Kroeber in the late nineteenth and early twentieth century; it represents the head of the child. A beaded strip of yellow, red, and blue framing the head opening represents the child's hair. The cradleboard is lined with a flannel baby blanket, and the casings for the ties that secure the baby are also beaded and represent the baby's ribs. It was finished by the time baby Kenyon, named after Dr. Kenyon Cull (the director of St. Mary's school, to whom Janie was very close), came home from the hospital.

Janie's lifelong Indian name is Behniitou'u, or Hollering All Around. "Maybe that's why I'm the way I am," she laughed.

>

Janie Brown displayed her beadwork on a float (a truck covered with Pendleton blankets) during the 2004 Ethete Celebration Powwow parade. Following the parade, she held up the cradleboard she had made for her grandson, as her sister-in-law Lori Brown and niece Kenzie Monroe helped her put things away.

Danielle Brown **Beishe'inoneihit**

In 1996, it took Janie Brown three and a half months to make a white buckskin dress with a fully beaded top for her daughter Danielle's graduation from Wyoming Indian High School, where traditional American Indian dresses and outfits are worn instead of caps and gowns. Danielle wasn't sure what designs she wanted on her dress—"Just something I can use," she told her mother. So Janie told her of an idea she had after watching the movie *The Man from Snowy River*—a man on a horse chasing other horses. Danielle agreed, and they picked out the colors: a medium shade of pastel green for the background and maroon for the borders, with many other colors for the individual motifs.

Janie describes the top as a Sioux-style cut—straight across, almost square—with Sioux, Arapaho, and nontraditional design elements. On the back left of the dress is the man on horseback, but "it's an Indian with braids, not a white guy like in the movie," Janie explained. He is chasing horses of many colors that move to the right across the back, and then across the front from right to left. The Arapaho design elements include a cross called the morning star, stripes and bars known as life symbols, a pyramid-shaped mountain around the neck, and, intermingled with the horses, a horse track motif. A turtle at the front center of the top is a Sioux design in honor of Danielle's Sioux grandmother.

For many years, Janie didn't know anything about traditional Arapaho symbols. When she and her older son were looking for designs for his dancing outfit (her own design ideas were running out, she thought), they discovered *The Arapaho* by anthropologist Alfred Kroeber, a book published in the early twentieth century that contains many examples of what Kroeber called "decorative art." "I didn't know of any before. That's how I started—I thought I might as well implement our own symbols." Then she thought, "Well, maybe I shouldn't be doing this," so she approached an elder, one of her grandmothers, and asked about using the old designs. Her grandmother said it would be good to see the old designs used again.

When the dress top, beaded on canvas, was complete, Janie lined it with cotton and sewed white buckskin fringe to the sleeves. Tassels made of buckskin and horsehair and strung with beads were attached to the lower edges, front and back. It weighs over thirty pounds.

When Danielle wears the dress, a beaded turtle containing her umbilical cord is attached to the back of the neck. More tassels and turtles beaded separately are attached to the white buckskin skirt. The outfit is completed with matching moccasins and leggings, braid ties, and a barrette. Just as each element of the dress design has a specific meaning, so do the other parts of her outfit, such as a scarf

>

In 2004, Danielle Brown modeled her buckskin dress at the Ethete Senior Center, where she and her mother work. Her mother, Janie, was sitting behind her at the table, beading.

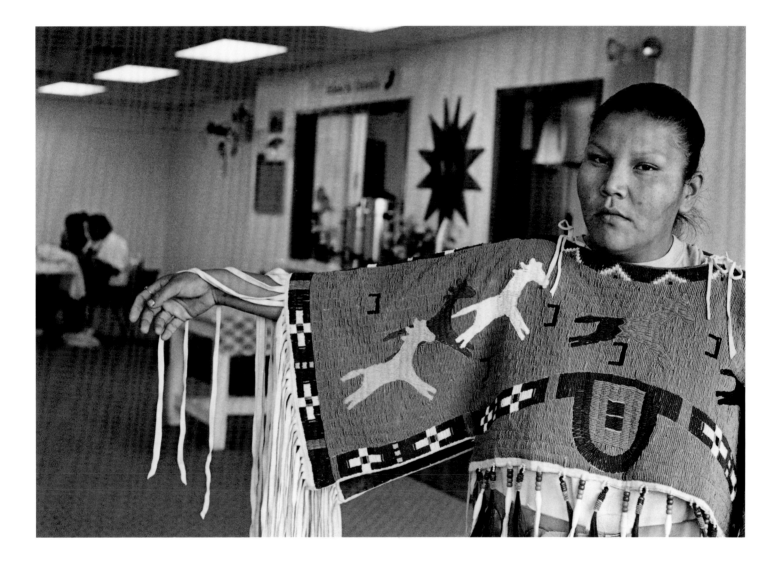

worn at the neck and a plume worn in the hair—a gift from a relative, perhaps, or an item that has been ceremonially blessed.

For her younger daughter's high school graduation, Janie made another fully beaded buckskin dress with both contemporary and traditional bear symbols in honor of the girl's middle name—White Bear. Designs were primarily of white and yellow floating across a black background. She borrowed black bear tracks from a Wyoming Game and Fish brochure and a bear face from a powwow poster. Her husband drew a whole bear for the back, and a traditional Arapaho "bear paw" symbol was used for the tassels on the skirt. For her younger son's graduation, she made a "hair shirt"—a smoked (tan-colored) buckskin shirt with strips of beadwork and tassels made of hair from his mothers, sisters, grandmothers, and aunts.

Danielle works full time with her mother at the Ethete Senior Center—driving the bus to pick up the elders, delivering meals to shut-ins, and helping prepare meals. She is slowly learning to bead and helped her mother work on her younger sister's dress—she beaded the Arapaho bear paw designs that were attached to the skirt. Her Arapaho name (Beishe'inoneihit, or Everybody Knows Her) was given to her in a spiritual meeting when she was young.

>

Danielle's beaded buckskin dress, seen here from the back with beaded turtles and fringe.

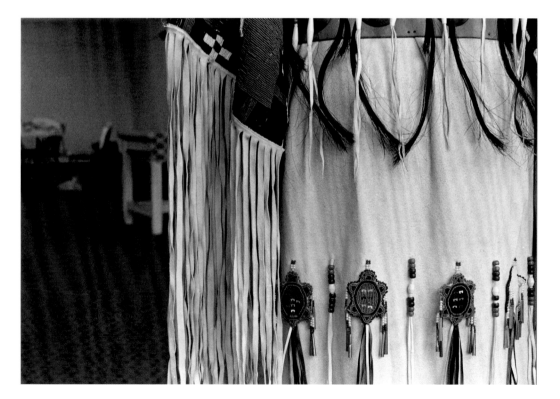

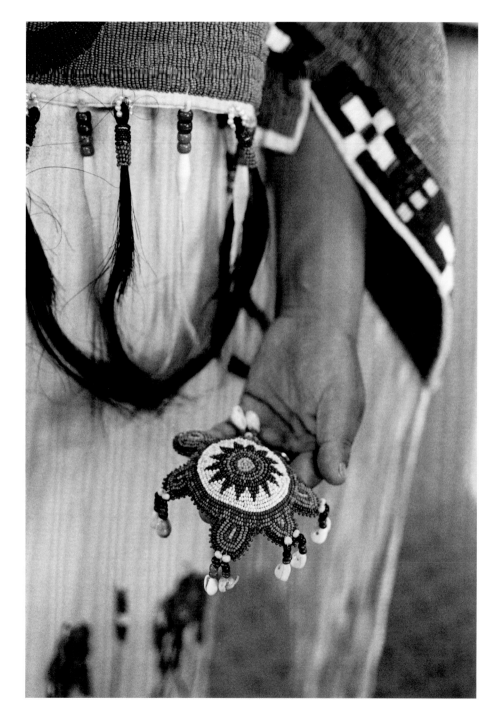

<
As she modeled her buckskin
dress in 2004, Danielle showed
the beaded turtle containing her
umbilical cord that she attaches
to the back of her dress when she
dances.

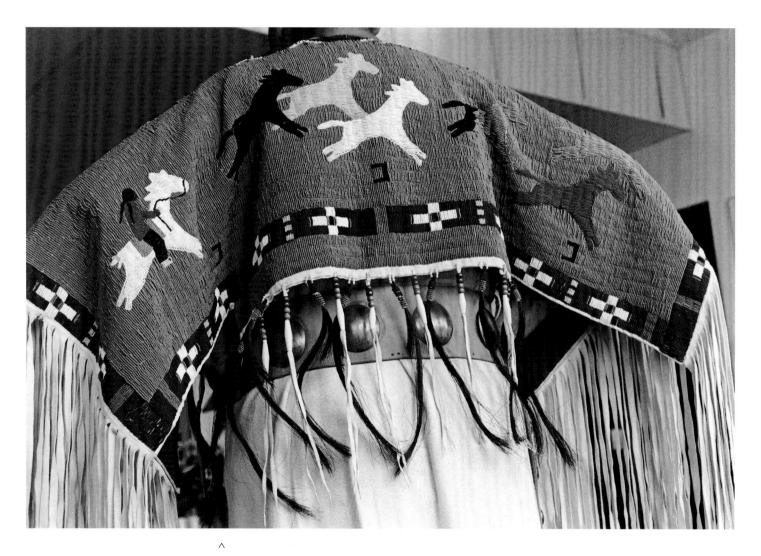

∧

The back of Danielle's dress displayed the Indian man on
horseback chasing horses of various colors.

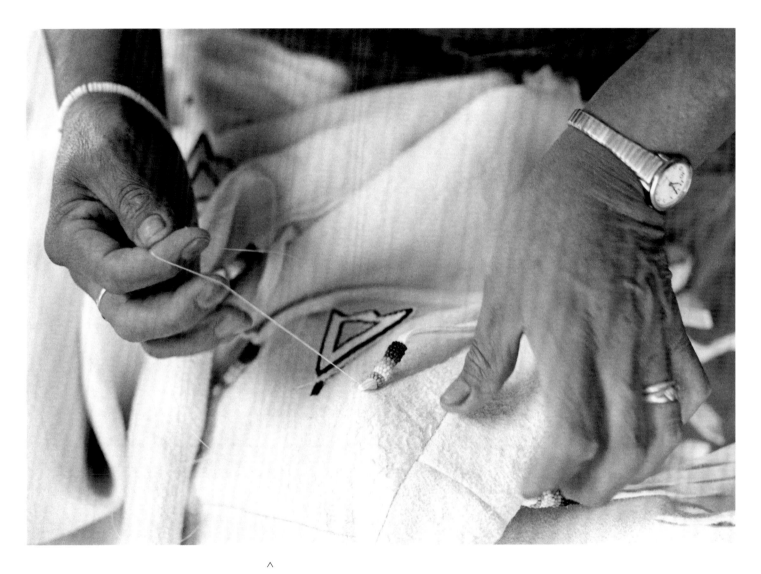

∧

**Janie attached "bear paw" designs made by Danielle to her
younger daughter's dress.**

Martin Luther King Day Walk
Diversity Is Our Strength

I've lived through the "no Indians allowed" on doors, and going into business places and have someone come and say they don't serve Indians. I still feel it's still there. I can feel a negative feeling from salespeople and then I just leave and very seldom go back, if ever. There's still a lot of very rude salespeople. I still experience not being waited on—but a non-Indian comes in and they'll immediately get service. It still happens. It will never go away. It is a learned thing through families. Children don't know prejudice and discrimination—it's a learned attitude.

I realize some of our people do bad things, but not all. Fifty to a hundred people make it bad for five thousand. The news that's put out is bad. That just kind of stereotypes us. There are many Lander and Riverton residents who've never been on the reservation. They say they're afraid. What are they afraid of? The same things happen to us in Lander and Riverton.

Even though it doesn't alleviate the prejudice, I think the demonstrations are good. The classes made a difference for students. They're more aware of what's happening and they're prepared for it. I think through classes, demonstrations, and responses, students are more aware of the attitude of our neighbors.

Annette Bell, 2006

>

Walkers, including Riley Tallwhiteman, carried banners as they walked in the 2005 Martin Luther King Day Walk.

Despite intense cold, David Valdez and a large group of people, including students from Wyoming Indian High School as well as non-Indians from the surrounding communities, participated in the Martin Luther King Day Walk in January 2005. They walked from Blue Sky Hall at Ethete to Wyoming Indian High School, a half mile south on Blue Sky Highway. David carried a sign with the logo and words "All My Relations." There are many "walks" on the reservation, often honoring individuals or sponsored by organizations for the awareness of causes such as diabetes or alcohol abuse, and David participates in many of them. "People around here see me walking all the time," he said. "That's why I'm in pretty good shape."

But the Martin Luther King Day Walk was different from other "walks." It grew out of a class entitled "Facing History and Ourselves" taught by Annette Bell and Colleen Whalen at Wyoming Indian High School. The class focuses on cultural interaction, using American Indian history and the

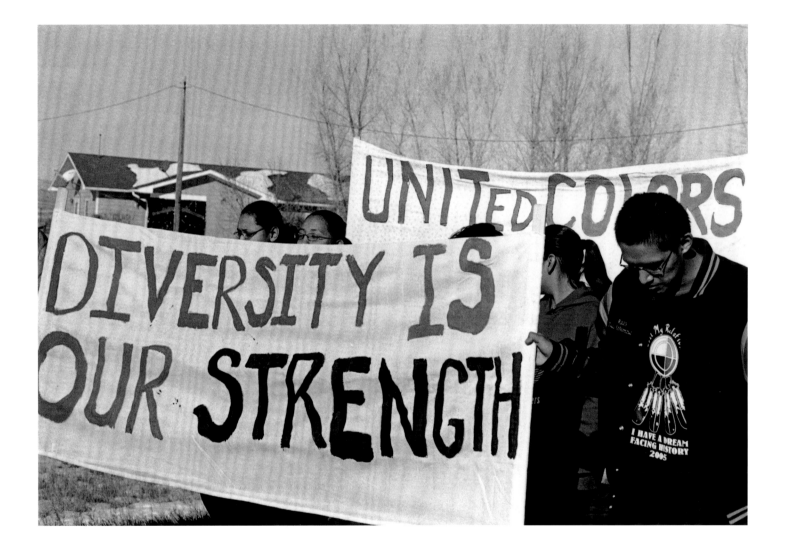

Holocaust as examples. The class also encourages students to become politically active citizens, and inspired by the class, students formed an "Erasism Club."

The "Facing History and Ourselves" class was faced with a challenge in December 2002 when the World Church of the Creator, a white supremacist organization, announced that it was moving its world headquarters to Riverton. Reaction throughout the county, both Indian and non-Indian, was strongly in opposition to the organization, and many community meetings were held to discuss possible courses of action. The students in the class took the lead and immediately started organizing a protest march and rally to be held in Riverton on Martin Luther King Day 2003, less than a month away. They contacted police and speakers, laid out the route, arranged for transportation and refreshments, made banners and posters, and widely publicized the event. They composed a tolerance pledge that was signed by over 300 individuals and businesses from both Indian and white communities, and two students created a logo with four colors and four feathers and the words "All My Relations"—a frequently heard slogan in Indian country that refers to the unity of all people. Over 650 people participated in the event.

By 2005, the Riverton headquarters of the World Church of the Creator had been abandoned. Segregated restrooms and signs on doors saying "No Dogs or Indians Allowed" that were common in Fremont County in the first two-thirds of the twentieth century are no longer seen. But racism of a more subtle kind continues to exist throughout the county. Many non-Indians are resentful of and hostile to tribal members and express fear of coming to the reservation. This resentment is felt by Indian people on a daily basis, and they often feel mistreated and uncomfortable in offices and businesses off the reservation. The "Facing History and Ourselves" class continues to promote awareness by participating in Martin Luther King Day and other activities each year, reusing the banners and signs made hurriedly in 2003.

David Valdez is of Mexican descent, born in Colorado in 1934. He moved with his family to Wyoming when he was young and well remembers the "No Dogs or Indians" signs—he was often turned away as well. In 1962, he married an Arapaho woman; they have five children and many grandchildren, all of whom live in Ethete. When asked whether he still encounters racism in his own life, he said, "Some, but it don't bother me. I get along with everybody."

>

David Valdez, carrying a poster with the Wyoming Indian High School and All My Relations logos, paused at the entrance to the school after participating in the 2005 Martin Luther King Day Walk. Standing behind him was Hubert Redman.

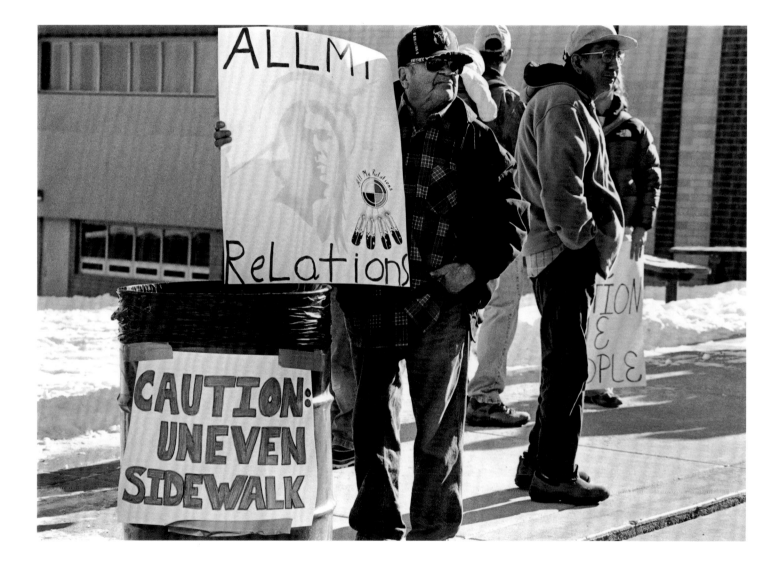

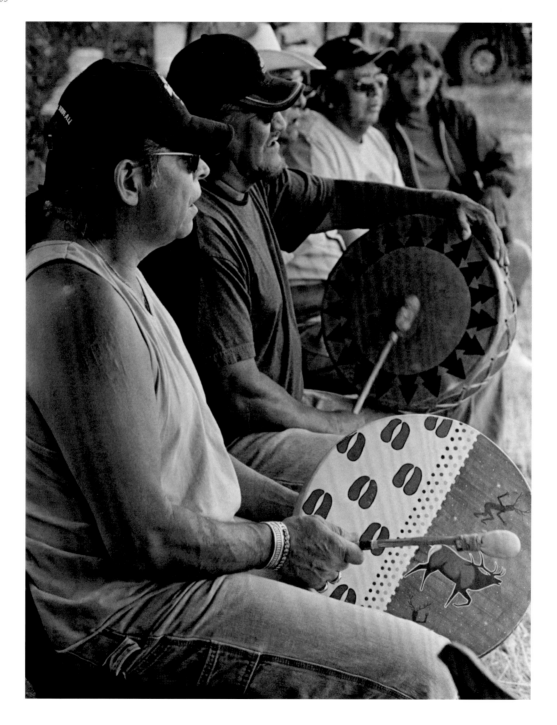

Hand Games **Koxuhtiitono**

It was July 2005, and Cora Willow and her sister Flora were running hand games, *koxuhtiitono,* for the language and culture camp sponsored by the Wind River Tribal College at Ethete. In a grove of trees behind the Arapaho tribal office building that also serves as the home for the college, they set up two rows of chairs facing each other. Another chair was placed at the end, in the middle, facing down the rows. Behind the rows, they placed additional chairs for the singers and for those wishing to "watch on."

Before her death in 2003, Flora and Cora's mother, Clina Willow, used to run hand games for schools and organizations on the reservation, and now Cora and Flora are taking her place. Their large extended family still plays frequently at home, especially in winter. The winter playing season always begins after the first snow, Cora said. "Long time ago, at the first snow, Dad would say, 'We're having hand game.'" They play at Thanksgiving and over the Christmas holidays and at other times, too. Neighbors and friends often join them, organizing themselves into informal teams. "For the first game of the season, everyone brings food. If you lose, you have to cook for the next time they gather to have a hand game." The Willows don't play for money, though tournaments with prize money and betting on the side are held at Wind River and on other reservations.

The Willows brought their own set of hand game sticks to the camp. Cora explained the history of this family set: "We still have these sticks, but they're old and coming apart. First our grandfather had them, then mom, and now us. These sticks have been in our family a long time, and we all learned to play with them." The set is kept in two handmade bags of a blue cotton fabric and consists of twenty-four counting sticks and two guessing sticks. The guessing sticks are covered in rawhide looped at the top. They show signs of fading red paint and are covered with dog hair and bells attached with sinew.

"Look, she's even got a Durham bag for those little sticks," Cora said. In a little white Bull Durham Tobacco bag, there were several small flat pieces of chokecherry wood, worn smooth from years of use. These are the small pieces that players hide in their hands during a game.

Meanwhile, informal groups of players took turns sitting in the two rows of chairs facing each other. Each row, or side, was a team. Two players on a team were given one of the small flat sticks; they put their hands behind their backs to hide a flat stick in one of their hands, then brought their hands to the front and started moving them in time to music. Hand-game songs were sung by

<

Lessert Moore joined Richard Willow, Clyde Wallowing Bull, Sr., and John C'Hair, Sr. *(left to right),* to sing hand-game songs during hand games sponsored by the Wind River Tribal College in 2005. Sitting behind them was Sylvia Dewey.

a group of men seated a few yards from the players; they accompanied their singing with hand drums.

A person then came forward to act as the guesser. The guesser was blessed by the blesser, who sat in the chair placed at the end of the rows but facing down the middle. At the 2005 camp, Irma Grosbeck assumed the role of blesser—she would bless the guesser by taking all the counting sticks in her hands and moving them from his left shoulder to his right shoulder twice, and end by shaking them over the top front of his head.

After being blessed, a guesser representing the opposing team moved up and down the row of players, shaking the guessing stick in time to the music. When ready, he pointed the guessing stick in one of four ways: standing in front of the players, he would point the stick to the right or to the left to indicate their right hands or left hands; if standing between two players, he pointed to the center, hoping the two players would have the stick in the hand close to each other; or he kept it parallel to the players, hoping the players had the sticks in opposite hands. Cora, an experienced guesser, said, "Some don't move their hand with the stick as fast, or hold their hand funny, so I can guess." Points are tallied with the counting sticks.

The students at the camp were just learning, and some seemed rather confused. But when played by experienced players, the hand game is an entrancing performance of music and movement, laughs and exclamations. Singers beating hand drums sing fast-paced songs that belong exclusively to the hand game tradition. The motions of the participants are all done to the rhythm of the songs, almost like a dance, while bells attached to the guessing sticks jingle.

Richard Willow, Cora's brother, led the singing at the camp. He is one of the few who still remember the old hand-game songs. Richard would like to pass his songs on, but few of the young people seem interested. "I won't be here forever to sing it. At the same time I don't want to force it on anybody. My dad said not to force."

>

Clyde Wallowing Bull, Sr., took a turn as guesser, moving up and down the rows of players and moving the guessing stick in time to the music, during the 2005 hand games sponsored by the Wind River Tribal College. Irma Grosbeck, seated at the head of the rows, was the blesser, while Clyde's daughter Jessica turned to look at the camera.

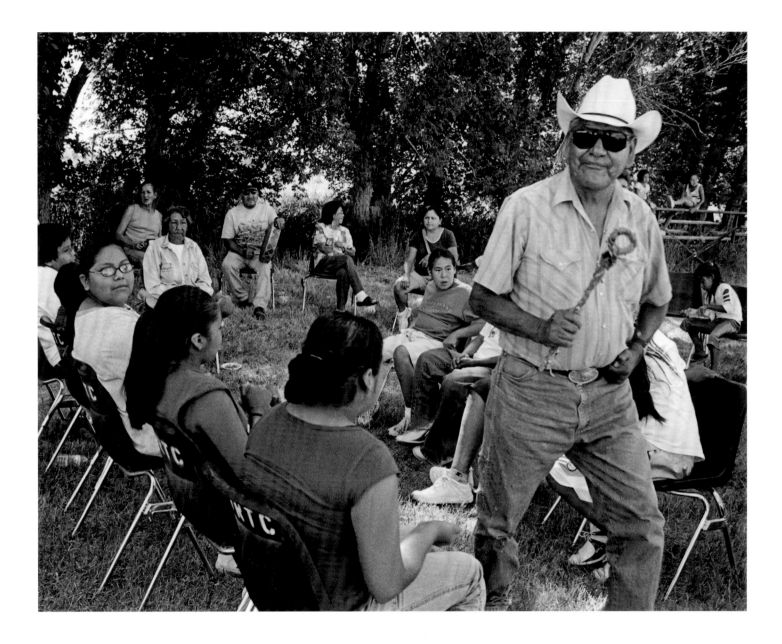

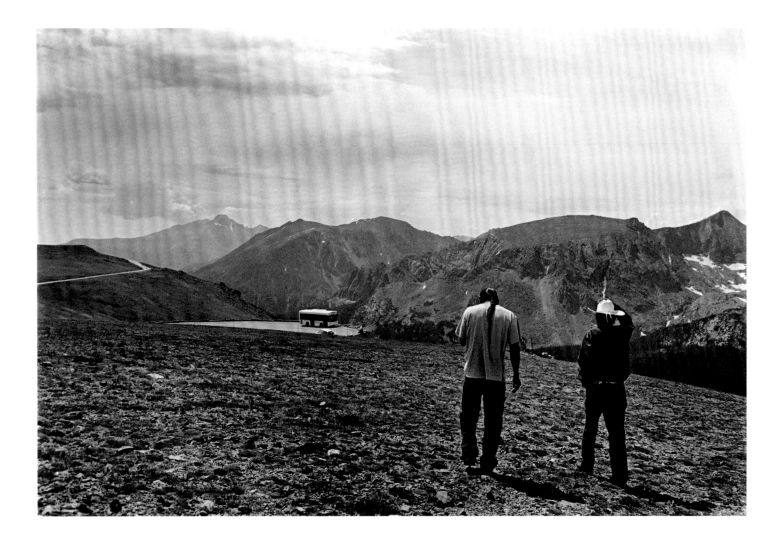

The Circle **Heetko'einoo'**

The whole country was covered with Indian trails. In open parks, the trails would generally be very vague, as there was no reason for going in any one path; but over the mountains the trails were distinct and occasionally marked by monuments, 3io'yoono (put-up monuments). These piles of stones were on the average about four feet in diameter.

In following a trail, the Arapaho passed to the same side of all the monuments on the trail. As they passed, it was customary for everyone to put a rock on the monument, and if there were children in the party they would say, "May this child live as long as these rocks last."

Oliver Toll, 1962

In the summer of 1914, three Arapahos from Wyoming—Sherman Sage, Gun Griswold, and Tom Crispin—journeyed by train to Longmont, Colorado. Sage and Griswold, elders who had lived in the area before Arapaho bands were forced north, spoke no English; Crispin was their interpreter. They had been asked by members of the Colorado Mountain Club, who hoped to establish a national park in the central Colorado Rockies, to provide Arapaho names for the area's landmarks. During a two-week pack trip through what soon became Rocky Mountain National Park, place-names and historical information provided by Sage and Griswold were translated by Crispin and recorded by a young Coloradoan named Oliver Toll. Toll was a careful observer and recorder who took extensive notes; the notes were published in 1962 in a short book called *Arapaho Names and Trails.*

In the summer of 2005, ninety-one years later, other Wyoming Arapahos journeyed to Colorado to participate in a workshop in Rocky Mountain National Park. Funded by a historic preservation grant from the National Park Service, Northern Arapaho tribal members toured the park and examined landmarks and trails mentioned in Toll's manuscript. With the help of a linguist and park service employees, they conducted ethnobotany workshops to identify plants and discuss their uses. Together, they examined both the historical implications of and their personal feelings about this homecoming.

Although the Arapahos were a tribe of the Great Plains who participated fully in the buffalo-hunting culture, the game-rich mountain valleys of the central Rockies were part of their annual migration routes. According to Toll, Arapahos followed the game into these mountains in summer

<

During the 2005 tour of Rocky Mountain National Park, Vincent Redman *(left)* **and Alonzo Moss, Sr., returned to the bus after examining monuments or markers along the "Child's Trail," now Trail Ridge Road. The high peak to the left is Long's Peak.**

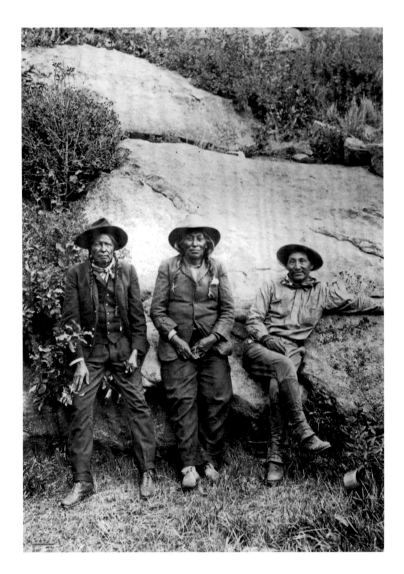

>

Sherman Sage, Gun Griswold, and Tom Crispin *(left to right)* **were photographed during the 1914 pack trip through the central Colorado Rockies.** (Copyright, Colorado Historical Society [Indians-Tribes-Arapahoe-Places Estes Park, scan # 10025974])

and back to the plains in winter, but he also mentioned winter camps. In these mountains, Arapahos frequently battled other tribes for the territory that each considered theirs.

The Estes Park area, on the east side of the mountains, is called Heetko'einoo' (The Circle). Trail Ridge Road, today the primary highway through the park, follows Tei'yoonbo'o (Child's Trail). It was called Child's Trail, according to Toll's manuscript, because it was so steep that children had to get off their horses and walk. This was one of several trails from Estes Park heading west over the mountains to Grand Lake, which was called both Heebe3ni'ec (Big Lake) and Beteeni'ec (Spirit, or Holy, Lake). It was once a place of ceremonial and fasting sites, as well as the home of mythic creatures. Historical battles occurred here as well. Like many other places near the park, it is now a highly commercialized tourist resort.

Tei'yoonbo'o is still marked by stone monuments or markers called 3io'yoono, placed there by Arapahos. Monuments were also built to mark the site of an event or to denote a fasting site. According to park employees, other circular markers along the trail and elsewhere in the park align with Long's Peak, the highest mountain in Colorado. Long's Peak and Mount Meeker together were called Neniisotoyou'u (There Are Two Mountains). When seen from the plains to the east, these mountains were used as a guide.

Gun Griswold's father (Kokiy, or Old Man Gun) used to catch eagles on the top of Long's Peak. "Right on top of Long's Peak," Toll reported,

> *there is a hole dug in an oval shape. The top of it is big enough for a man to get down through, but it widens out below and is big enough for him to sit in. . . . He had a stuffed coyote up there and some tallow. Gun used to sit in this hole so that he couldn't be seen, and put the coyote on the ground above him and the tallow by it. The eagles would see the coyote from a great distance, and would come to get it. When the eagles lit by the coyote, Old Man Gun would grab the eagles by the feet, reaching up by the back of the coyote. . . . The reason that he had the trap up on top of the peak was that he had to have it some place where there weren't any trees around, for if there were trees, the eagles would have lit on the trees instead of going straight to the tallow, and then the other eagles would have seen the first one caught and so would have been scared away.*

The Arapaho relationship to the Estes Park and Rocky Mountain National Park area as recorded by Oliver Toll was often utilitarian—where things happened, the names of places. But the names he recorded also reflect Arapaho myths and traditional symbols and provide a glimpse of a sacred

geography. The idea of Heetko'einoo', or The Circle, as a spiritual homeland has been passed down through Arapaho oral traditions, including stories of survivors of the Sand Creek Massacre retreating to The Circle.

Today, Northern Arapaho people are reconnecting to their spiritual Colorado homeland through the establishment of the Sand Creek Massacre Historic Site, Sand Creek Memorial Runs, honoring ceremonies such as the "No'eeckoohuut—Coming Home" Arapaho Nation Cultural Festival and Powwow in Boulder in 2001, and the inclusion of their voice in Rocky Mountain National Park interpretive programs.

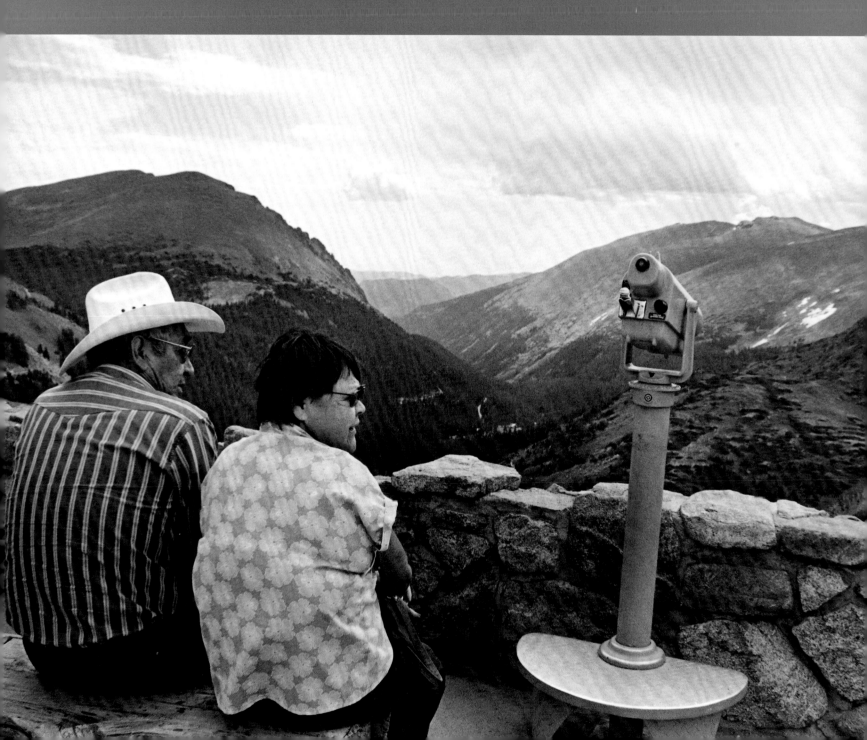

That's the Way It Is **Nohuusoho'**

*When you talk about history—I've always had a problem with history. Arapaho history was
never told to me—only in bits and pieces from my folks, from my relatives. Whereas when
I went to school, it was drilled into me to learn the history of the United States. I was always
part of that history but I wasn't mentioned. My tribe wasn't mentioned. When the signing of
the constitution happened, where were we, where were the Arapahos? In 1492, when they
landed on this earth, on this continent, where were Arapahos? We were around. We were doing
something. But we're not supposed to know that because that wouldn't give us our grade in
school. . . .*

*In the year 3000, what kind of Arapahos are we going to be? Some say we're going to
be the same. Same as what? Traditional, bicultural, mainstream? Or are we going to be on a
spaceship like* Star Trek New Generation, *or what? I wonder how far our traditions will live,
in that era. We've come a long ways. We've come a long ways from the moccasins, from the
horses, from the buffalo, to modern technology. And Arapahos living through the generations,
the emotions, the loving, the livelihood, have all changed in time, with that.*

Elizabeth Lone Bear, 2005

In photographing Arapaho people of the Wind River Indian Reservation for the past thirty-five years, my
desire has been to show my friends and neighbors as they see themselves: as complex and dignified
individuals living in a viable (if difficult) cultural, economic, and political environment. Similarly, in
collecting the stories that accompany the photographs, I have hoped to expand readers' knowledge of
reservation communities and their understanding of the lives of individuals.

Though unintended, some ideas have emerged from the combination of stories and photographs
presented here. There is a sense of loss, especially among the elders, and a longing for what is seen
as an authentic past. It is the loss of not hearing the Arapaho language spoken, of not hearing the old
songs sung, of not hearing the old stories told. It is the loss of elders who have gone home, taking
with them their knowledge of the old ways. It is the loss of many traditional ways of doing things: food
preparation, working with horses, or reckoning kinship in the way unique to Arapaho people.

Yet there is strong resistance to this loss. Revitalization—bringing back and maintaining Arapaho
ways—is the focus of much effort, money, and time by individuals, organizations, and the Northern

<

**During the 2005 tour of Rocky
Mountain National Park, Elizabeth
and Leo Lone Bear rested at the
top of Trail Ridge Road.**

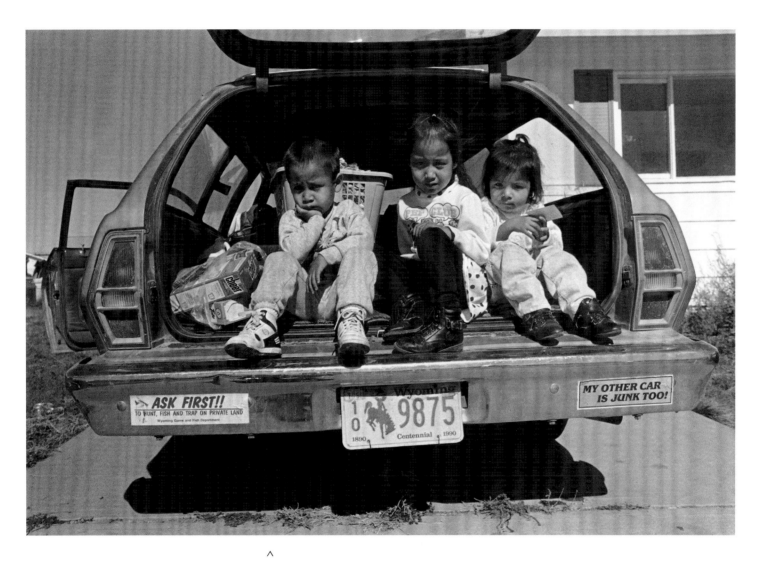

∧

In 1990, Coulton Armour, Kayla Jean Armour, and Robin Whiteplume *(left to right)* sat in the back of their grandparents' station wagon after a morning at the Laundromat.

Arapaho Tribe. Language and culture camps have been held since 1987. Language preschools have flourished since the 1990s, and more public school and community language classes are being taught. Elders are asked to pass on their knowledge to younger generations at schools, community events, and family gatherings. There is an ongoing community discussion about the importance of the revitalization effort and the appropriate way in which to pursue it.

Through 160 years of change, many traditional Arapaho ways have continued to thrive, and newer ways have become traditional. Religious ceremonies and spiritual observances passed on for generations are vital to the community; new ways of worship introduced in the nineteenth and twentieth centuries, including the Native American Church and Christian churches, are now part of Arapaho life. Organizations such as the Yellow Calf Memorial Club have been created to replace some prereservation societies. Economic and social cooperation within large extended families still forms the basis of Arapaho life, even as the old kinship terms have fallen into disuse. For many Arapahos living on the Wind River Indian Reservation today, it is still possible to live *ni'iihi'*—in a good way.

Although not usually noticed by outsiders, Northern Arapaho life in the twenty-first century is dynamic: powwows, hand games, giveaways, and Arapaho name-givings are frequent. Traditional Arapaho music is heard daily, along with many other types of music. Hunting is still important, both symbolically and economically. Younger Arapahos are actively continuing beadwork and other artistic traditions that combine old and new ideas; others are combining traditional horsemanship skills with new ways of using them. Excellence in competitive basketball continues to bring a sense of pride to almost everyone on the reservation.

As Elizabeth Lone Bear so clearly states, for many years Arapaho history was made irrelevant and went untaught. But today, many Arapaho people are examining their history and asking non-Indians to do the same. The Sand Creek Massacre is being discussed more openly, and annual Sand Creek runs bring awareness of and healing from the event. School classes are examining the history of racism. As a tribe and individually, Arapaho people are reestablishing connections with their Colorado homeland through participation in a variety of events, including honorings, "welcome home" weekends, and explorations of Rocky Mountain National Park.

This book is not a definitive account of the Northern Arapaho people of the Wind River Indian Reservation and their world—contemporary or historic. It is instead a mosaic ethnography that touches upon some history, traditions, and revitalization efforts, as well as the lives of a few individuals. There are many other stories remaining to be told. But for now, I will end the way many Arapaho storytellers end their stories: *nohuusoho' nee'eesinihii3e3enee*—that's the way it is, that's what I have to say to you.

Notes

Introduction

2 *The People Hinono'eino':* Information on the history of the Northern Arapaho Tribe until 1940 is summarized primarily from the work of ethnohistorian Loretta Fowler, especially *Arapahoe Politics* and "Arapaho," unless other sources are noted below. Arapaho history since 1940 has been summarized from a variety of sources, including interviews, newspaper articles, and personal observation and participation.

2 *it means "wandering people":* Alonzo Moss, Sr., personal communication, 2008.

2 *it refers to "sky people":* Commonly used by Arapahos today.

2 *or "wrong root people":* Jeffery Anderson, *Four Hills of Life,* 6.

2 *including Traders, Many Tattoos:* Loretta Fowler, "Arapaho," 859–61. Many other names are presented on these pages as well.

2 *Ethnohistorians believe:* Loretta Fowler, "Arapaho," 840.

2 *in the eighteenth century:* Loretta Fowler, "Arapaho," 840–43.

2 *A description of their territory:* Andrew Cowell and Alonzo Moss, Sr., *Hinono'einoo3itono,* 247.

2 *The word* neseihiiniine'etiit: Alonzo Moss, Sr., in the video *Telling Stories* (2001). Further explanation provided by Andrew Cowell, personal communication, 2008.

4 *"to find and annihilate" all Arapahos:* H. G. Nickerson, "Early History," 3.

4 *In 1874, federal troops:* Loretta Fowler, *Arapahoe Politics*, 50–52. This is known as the Bates Battle.

4 *On March 18, 1878:* Loretta Fowler, *Arapahoe Politics,* 67.

4 *Niitiine'etiino', "Where We Live":* Alonzo Moss, Sr., personal communication, 2005.

7 *The Arapaho population at Wind River dropped to 829:* Loretta Fowler, *Arapahoe Politics,* 90.

8 *In 1927, the Eastern Shoshone Tribe:* Loretta Fowler, *Arapahoe Politics*, 197.

9 *to separate federally funded programs:* Prior to this time, all federal funds coming into the reservation were divided equally between the Eastern Shoshone and Northern Arapaho tribes, despite the fact that the number of enrolled Arapahos was almost three times that of enrolled Shoshones. The Northern Arapaho Tribe now contracts directly with the federal government for funds for housing programs, social service programs, and other governmental infrastructure programs.

11 *the Arapaho population has grown to exceed 9,000:* Northern Arapaho Tribe, personal communication, January 15, 2010.

16 *portrayed as nameless winos:* Marc Gaede, *Bordertowns.*

18 *photos that were supposed to be commercially viable:* See Mick Gidley, *Edward S. Curtis, Incorporated.*

18 *Volume 6 of* The North American Indian: See http://memory.loc.gov/award/iencurt/ct06/ct06toc.html.

18 *their Arapaho names, Hinen Hi3eih and Nii'eihii Neecee:* Mark Soldier Wolf, personal communication, 2009.

19 *including Joseph K. Dixon:* See Mathers Museum of World Cultures, Indiana University, *Wanamaker Collection of Photographs of American Indians,* http://www.indiana.edu/~mathers/collections/photos/wanamake.html.

Benjamin Goggles, Jr. Hoonino'

Information for this section was taken from an interview with Gladys Goggles Moss by the author at Lthete, Wyoming, on July 29, 2004, except where other sources are noted below.

Epigraph:
Zona Goggles Moss interview by the author at Ethete, Wyoming, on November 6, 2004.

24 *more involved in Arapaho ceremonial and spiritual ways:* Benjamin Goggles, Jr., was one of the few individuals to hold several of the ceremonial positions of the tribe simultaneously. He participated in the Sun Dance twenty times and sponsored the Sun Dance eleven times before being named leader of the Sun Dance. See Ted Duncombe, "Keeper of the Sacred Wheel Is Dead at Age 73," *Casper Star-Tribune,* March 11, 1978.

24 *son-in-law Abraham Spotted Elk:* Abraham Spotted Elk interview by the author at Ethete, Wyoming, on January 8, 2007. All information from and quotations attributed to Abraham are from the same interview.

26 *the Goggles family held a giveaway:* Powwows are tribally sanctioned community events that consist of giveaways, music, dancing, games, and athletic competitions. Giveaways are held not only during powwows but also during funeral rituals and other community occasions. In *Arapahoe Politics,* Loretta Fowler talks extensively about giveaways in the twentieth century being an important part of Arapaho life: "Giveaways are a common feature of all-tribal celebrations. By large distribution to nonrelatives, families display their support of the relative in whose honor the giveaway is held and affirm ties of mutual obligation and affinity with other Arapahoes" (277).

The Yellow Calf Memorial Club Niiwohoeneseino'

Information and quotations in this section were obtained during a recorded interview with members of the Chief Yellow Calf Memorial Club by the author at Ethete, Wyoming, on January 23, 1999, except where other sources are noted below.

Epigraph:
Chief Yellow Calf Memorial Club powwow program, 1994.

31 *the Ethete Memorial Club was founded:* Details of Memorial Club history provided by Loretta Fowler in *Arapahoe Politics* differ slightly from those provided by the Memorial Club members. For example, Fowler reports that the club was probably established in the late 1920s and was originally referred to as Bebii3oobe'iiyeihiiho', 'Those Who Fix Up Graves' (162–63). However, members are certain of the year the club was founded (the spring of 1937) and of the continual use of the name "Niiwohoeneseino'," given to them by Yellow Calf (Helen Cedartree interview by the author at Ethete, Wyoming, on March 22, 2005). Other similar clubs may have formed in the 1920s and 1930s in the Ethete and Mill Creek areas of the reservation. According to Arapaho linguist Alonzo Moss, Sr., bebii3oobe'iiyeihiiho' refers to messing around in the dirt, not necessarily to fixing up graves, and was probably used as a descriptive term (Alonzo Moss interview by the author at Ethete, Wyoming, on November 28, 2005).

31 *Yellow Calf was born in 1861:* Memorial Club members give 1861 as the date of Yellow Calf's birth as well as other facts of his life in a statement titled "Chief Yellow Calf" in the Yellow Calf Memorial Club powwow program, 1994. Many additional details of the life of this remarkable man, including his time on the Chiefs' Council, are found in Loretta Fowler, *Arapahoe Politics* (95–99, 125–53).

32 *the age-graded men's societies:* Much of prereservation Arapaho life revolved around the men's societies. Boys were inducted into the first of the societies at an early age and moved up through the societies as they grew older. Each age-grade had its own

responsibilities and duties in the areas of defense, warfare, hunting, social life, and ritual participation. For a full description of these societies, see Jeffery Anderson, *Four Hills of Life*, 137–64.

32 *"He was a great one":* Helen Cedartree interview by the author at Ethete, Wyoming, on June 13, 2007. Helen was referring to Yellow Calf's involvement in the revitalization of community dances, his work with the Eagle Drum to provide music for dances, and his creation (based on a vision) of a ceremonial dance called the Crow Dance. In another interview, conducted by the author on January 16, 2007, Helen stated that Yellow Calf had gone around the community talking to elder women in an effort to reestablish the dance of the prereservation women's society, or lodge. According to Helen, her mother told Yellow Calf "it is lying flat now" (meaning it is dead) and should not be brought back. Although Helen did not mention the name, it is probably the Buffalo Lodge described in Jeffery Anderson, *Four Hills of Life,* 175–78.

32 *Chief Yellow Calf had several names:* Helen Cedartree interview by the author at Ethete, Wyoming, on June 22, 2004; Alonzo Moss, Sr., interview by the author at Ethete on March 8, 2005.

Josephine Redman Beeh'eenesei

Information about Josephine was provided by Josephine's daughter Alvena Oldman in an interview by the author at Ethete, Wyoming, on June 6, 2004, except where other sources are noted below.

Epigraph:
Josephine Redman quoted in Joan Willow, "WIEA Elder of the Year Stresses Importance of Education," *Wind River News,* June 12, 1990.

34 *Josephine Underwood Redman's long life:* Information in this paragraph was taken from "Josie Recalls Mission School Days," an article written by Josephine's granddaughter Joan Willow and published in the *Wind River News,* December 24, 1985.

34 *Josephine also gave away or burned:* The tearing down of buildings and the giving away or burning of personal belongings of a deceased person are common Arapaho practices. In *Arapaho Child Life* (160–69), Inez Hilger notes that these and other rituals surrounding death were practiced in the 1930s.

34 *established in 1972*: Prior to the establishment of Wyoming Indian High School, there was no high school on the reservation. Some Indian students attended high school in one of the towns surrounding the reservation, where they felt uncomfortable; the dropout rate was extremely high.

34 *When she received the award:* The quotation is from Joan Willow, "WIEA Elder of the Year Stresses Importance of Education."

34 *made her own dresses:* As late as 1973, many older women dressed in the same fashion as Josephine, in dresses and moccasins they had made themselves; they wrapped themselves in a shawl or blanket and covered their heads with a scarf. When she died in 1998, Josephine was one of the last to still wear this traditional style of dress. In 1946, Molly Peacock Stenburg made the following observation, indicating that dress styles at that time were both traditional among the elders and in transition among younger generations:

The "blanket Indian" and "long-haired boys" have practically vanished. Occasionally one will see an old man wearing braids, but the only place one sees an Indian man wearing a blanket is in the Sun Dance or the Peyote Lodge. Women are likely to cling to the tribal habits of dress; older ones wear shawls in summer and warm blankets in winter, over the inevitable shapeless cotton dresses, and buckskin moccasins which they make themselves. . . . Younger women, especially the teenage group, dress the same as their contemporaries: in bobby socks, oxfords, skirts and bright-colored blouses. They have adopted coats and jackets to take the place of the blankets worn by their mothers. ("Peyote Culture," 98)

36 *Her Arapaho name, Beeh'eenesei:* Family members are not sure of the exact meaning of Josephine's Arapaho name. Although family members, elders, and linguists have made guesses at what it might mean, they are hesitant to definitely say because they do not know the story or context within which it was given. The true meaning of any name derives from the story that surrounds it. As the Arapaho language is gradually being lost, stories that were told in the language are also being lost, including stories of names.

Ben Friday, Sr. Nonookuneseet

This interview conducted with Ben Friday, Sr., by Debra Calling Thunder (a student at Lander Valley High School) in 1982 has been edited for length. Entitled "Beautiful Traditions," it was published by Fremont School District Number One in *Wind River Cache: A Cultural Journal of West Central Wyoming;* financial support was provided by the Wyoming Humanities Council. Other sources are listed below.

37 *"when I first went to school":* One of the primary ways the federal government attempted to reeducate and detribalize American Indians was the Indian boarding school system. Children were removed from their homes and often sent far away to places such as Carlisle, Pennsylvania, and Genoa, Nebraska (the two boarding schools mentioned by Ben). More often, Indian students from Wind River attended one of the boarding schools on the reservation, such as the Government School at Fort Washakie and St. Michael's at Ethete, both of which Ben attended. Today, only a few of the off-reservation boarding schools are still operative, and the schools on the reservation are public day schools.

39 *The job of the Business Council:* When Ben refers to the Business Council, he is referring to the six-person elected governing body of the Arapaho tribe, of which he was a member. The General Council is a gathering of enrolled tribal members who vote on important tribal issues. For a detailed discussion of the history and role of the Northern Arapaho Business Council and the General Council, see Loretta Fowler, *Arapahoe Politics.*

40 *His Arapaho name:* Information about Ben's Arapaho names was provided by Garret Goggles, Ben's grandson, in an interview by the author at Ethete, Wyoming, on January 16, 2007. Ben's name at the time of his death, Nonookuneseet, translates as "he or she is white" and refers to the light-colored hair often seen on grizzlies. Ben had at least six Arapaho names during his life: some were taken from him and some he gave away.

We Are Arapaho, Speak Arapaho
Hiinono'einino', Hinono'eiti'

Epigraphs:

Harold Moss quoted in "We Are Still Arapaho to the Present," *Wind River News,* August 16, 1988; William C'Hair quoted in Hunter Penn, "To Keep Their Tongue Alive," *Riverton Ranger,* August 3, 1992.

43 *Each morning:* Richard Moss provided information during many informal conversations prior to his death in 2005, including a recorded interview by the author at Lander, Wyoming, on April 14, 2002. According to linguist Andrew Cowell (personal communication, 2009), the species of wood used to make bows is *Cornus stolonifera* (red osier dogwood), commonly referred to by Indians and non-Indians in the Wind River area as red willow. Its Arapaho name, *bo'ooceibiis,* translates as "red stem (or branch) bush." Other bushes were also used for making bows.

Chris Goggles Neecee Nookoe'et

Information for this section was taken from interviews with Caroline Goggles, Chris's wife, by the author at Ethete, Wyoming, on April 5 and May 9, 2005, unless otherwise noted below.

50 *he was "taken around the drum":* A detailed discussion of the importance and meaning of this ceremony is found in Loretta Fowler, *Arapahoe Politics,* 148–51.

53 *"I don't want no lounging around in the manor":* "The manor" is a reference to the nursing home on the reservation, Morning Star Manor, but the term has become synonymous with nursing homes in general.

53 *Bruce Armour was "taken around the drum":* This information was provided by Bruce Armour in an interview by the author at his home near Ethete, Wyoming, on May 30, 2005.

53 *there are several other Arapaho men:* Further information about the role of announcers today was provided by Garrett Goggles in an interview by the author at Ethete, Wyoming, on January 16, 2007.

Hugh Ridgely Ho'nookee Niibei'i

Information for this section was taken from an interview with Hugh Ridgely by the author at Lander, Wyoming, on March 2, 2005.

56 *his military service:* Hugh is understandably proud of his military record. Among the medals that Hugh was awarded are the Korean Service Medal with three battle stars, Combat Action Ribbon, United Nations Service Medal, National Defense Service Medal, Navy Unit Commendation, and Korean Presidential Unit Citation.

56 *as a gandy dancer:* Hugh described a gandy dancer as someone who replaces ties, lines up tracks, and puts in anchors to keep the tracks straight and level; the Gandy Company was the maker of tools for this kind of work.

56 *a judge in the Wind River Tribal Court:* The tribal court where Hugh has worked for many years had been organized by the BIA early in the twentieth century and until 1988 was officially called the Wind River Court of Indian Offenses. That year, the Shoshone and Arapaho tribes assumed responsibility for the court, and the name was changed to Wind River Tribal Court. Judges in the court, with the exception of the chief justice, are not required to have a law degree but, like Hugh, do receive many hours of legal training. The

tribal court hears cases involving disputes between tribal members and misdemeanors committed by Indians on the reservation; in recent years jurisdiction over non-Indians on the reservation has begun to be established. The court also hears child custody and probate cases, as well as appeals. Serious crimes are turned over to federal authorities and tried in federal courts. See Janet Flynn, *Tribal Government,* 69–78.

Eddie America: A Gulf War Veteran's Return

Information for this section was taken from an interview with Diane Yellowplume, Royce "Jake" Yellowplume, and Alice Thomas by the author at Riverton, Wyoming, on March 19, 2004.

58 *"Back in the old days, warriors achieved honor":* The importance of military service to American Indian communities cannot be underestimated. Veterans are frequently honored, and being a veteran is considered by some a prerequisite for tribal leadership. Some Arapahos say that only a veteran can wear a feathered headdress, still an important leadership symbol. U.S. flags are seen everywhere: in offices and homes and most noticeably at powwows. Enlistment for American Indians is far higher than for non-Indians. In *Blood Struggle,* Charles Wilkinson states that during World War II one-third of the eligible Indian population served— three times the rate for non-Indians (103). Anecdotal information indicates that enlistment rates from high schools on some reservations nears 50 percent. One can readily see the connection between American Indians' current respect for military service and the prereservation importance of warriors. But many Indians, during and following the turbulence of the nineteenth century, had to prove their loyalty to the United States and provide income for their families by serving as scouts for the military. Today, on reservations where unemployment is high and opportunities for young adults are limited, military service is a respected choice and a chance for upward mobility.

61 *has adopted twenty-three others:* Adopting children "in the Indian way" refers to an informal relationship common in Indian communities in which individuals are "taken" as relatives, for various reasons. This creates or acknowledges a special bond between two people.

Annie Martina Bull Ceeh'eenesei

Information for this section was taken from interviews with Irene Houser by the author at Riverton, Wyoming, on May 7, 2005, and May 17, 2010.

62 *Her niece (or daughter, in the Arapaho way):* In Arapaho kinship, the mother's sisters are also called mother. Although Annie had no children of her own, the inclusive nature of Arapaho kinship allowed her to become a mother, grandmother, and sister-in-law and to fully participate in Arapaho life.

62 *government-sponsored Housing Improvement Program:* HIP houses were provided at low cost to elderly and disabled tribal members. If there were no descendants or other family members who wished to take over payments or inherit a house at the Ben Gay Heights development, the house was often abandoned. Many HIP houses built on land belonging to the resident, however, have been used continually. For a detailed description of this program and the people who participated, see Sara Hunter, "Northern Arapahoe Grandparents." The practice of giving funny nicknames to housing developments (and lots of other things) on the reservation is common, and some of the names become permanent: a new housing development built next to Annie's house in 2010 is officially called Ben Gay Heights; the road in front of Annie's house has been renamed Black Bull Lane in her memory.

65 *Annie had packed:* Placing suitcases and other things in graves are common Arapaho practices. See also Inez Hilger, *Arapaho Child Life,* 160–69.

65 *smudging or blessing with cedar smoke:* The act of blessing with cedar smoke, or incense, is frequent on the reservation. Annie used cedar she had dried and crushed herself, then burned in an iron skillet on her stove. Some Arapahos combine other ingredients with cedar to create different varieties of incense, which they sprinkle over hot coals; all are referred to by the generic term "cedar" and are used for blessing, healing, and ceremonies. The waving of incense over a person, referred to as "smudging," is performed by respected elders such as Annie.

William Calling Thunder Woonbisiseet

Information for this section was taken from interviews conducted by the author at Ethete, Wyoming, with Verna Thunder on February 23, 2004; with Clarinda Thunder Burson on February 25, 2004, and April 19, 2006; and with Marvene Thunder on April 24, 2006.

69 *in Big Horn Draw:* This rugged area in the center of the Wind River Reservation (administered by the Wind River Bureau of Indian Affairs) extends from the Little Wind River north to the Big Wind River, from Wyoming Highway 287 east to Blue Sky Highway. For many years, Big Horn Draw was loosely monitored. Although the Thunders had permits for their livestock, a lot of other horses and cattle were turned out into this area without permits. The BIA determined that Big Horn Draw and other ranges on the reservation were overgrazed, and in 1988 much of the stock was rounded up and returned to owners or sold. Today a limited number of grazing permits are allowed for Big Horn Draw, but out in the draw and a few other areas of the reservation, there are still some wild horses that have never been caught, because no one can get close to them. Information provided by Ray Nations, BIA, interview by the author at Fort Washakie, Wyoming, on November 3, 2005.

Herman Walker Hoowoobeh'ei

Information for this section came from an interview with Avis Blackie by the author at Rock Springs, Wyoming, on April 1, 2004, except where other sources are noted below.

73 *the Gros Ventre tribe:* The Gros Ventre speak a different dialect of the Arapaho language. The name Teestou' gave Herman is based on the word for chokecherry bush in Gros Ventre (Andrew Cowell, personal communication, 2009).

74 *"park ranger":* This term is used by Arapahos themselves; the majority of Arapaho people avoid Riverton City Park because of the presence of these "park rangers" who pester them. The term "wino" is used by Arapahos to describe people with severe alcohol addiction who often have no home.

74 *"Stick with your education, Avis":* Quoted from David Eisenhauer, "Quiet Wind's Resurrection."

Iron Cloud: A Powwow Family

Information for this section was taken from an interview with Sandi Iron Cloud by the author at Ethete, Wyoming, on March 25, 2004.

77 *forms its own drum group:* Detailed information on drum group formation and etiquette on the Wind River Reservation is available in Judith Vander, *Songprints* (195–285), particularly the interview with Lenore Shoyo, a member of the Eastern Shoshone Tribe. Vander's comment on Lenore's life as a powwow participant might also be applicable to the Iron Cloud family and members of other drum groups: "This is Lenore's second home: an intertribal, multicultural, but exclusively Indian world" (205).

79 *when the Eagle Drum:* As the principal drum group of the Arapaho tribe, the Eagle Drum is present at all tribal events and ceremonies. A Keeper of the Eagle Drum, selected by elders, keeps the drum and is the lead singer. The symbolic importance of the drum to

Arapaho people is described in Loretta Fowler, *Arapahoe Politics*, 148–51.

Ada Whiteplume Hiseikusii

Information for this section was taken from an interview with Lucy Whiteplume Mesteth by the author at Ethete, Wyoming, on March 16, 2004, except where other sources are noted below.

80 *The Arapaho name that she had been given:* Ada's brother, Joe Waterman (personal communication, 2007), confirmed her Arapaho name but pronounced it slightly differently: Hiiskusii, possibly a shortened version of a longer name. Joe, who died in 2009, was one of the Four Old Men—traditional spiritual leaders of the community—whom Ada often helped by preparing food.

82 *she was getting tired and wanted to go home:* Arapaho people refer to death as "going home."

Ben Friday, Jr. Wo'teenii'eihii

Information about Ben's life was provided by his wife, Alvina Friday, and his children Melissa Friday, Belle Friday Ferris, and Raleigh Friday in interviews by the author at Ethete, Wyoming, on February 25, 2004, and November 13, 2007, except where other sources are noted below.

Epigraph:
Ben Friday, Jr., interview in National Park Service, *Sand Creek Massacre Project,* vol. 1, *Site Location Study,* 177–78.

86 *Sand Creek Massacre Oral History Project:* The oral history project conducted by the National Park Service in 1999–2000 was in preparation for the establishment of the Sand Creek Massacre Historic Site. The story of the 1864 massacre of Cheyenne and Arapaho people in southeastern Colorado is still alive in Arapaho oral history.

86 *Chief Friday moved his band to Wind River:* Loretta Fowler's details of the capture and early life of Chief Friday in *Arapahoe Politics* (39–42) differ slightly from Ben's, and she adds many details of his later life as a chief.

The Name Giving Neniisih'oot

Information for this section was obtained from a recorded interview with Paul Moss, Sr., by the author at Ethete, Wyoming, on May 4, 1994.

89 *"They call that eagle* hiinooko3onit*—with the black-tipped feather":* Paul was very precise about distinguishing the different species of eagles, saying that the eagle whose name he gave to Raphael Glenmore was the eagle with the black-tipped tail. Linguists Alonzo Moss, Sr., and Andrew Cowell translate *hiinooko3onit* as "it has a white rump," which refers to the tail of the immature golden eagle (white on the rump, with black tips at the end of the feathers). The golden eagle (whose feathers, talons, and other body parts are frequently used in ceremonies and regalia by Arapahos and other tribes) is described by Cowell and Moss as "probably the single most powerful bird for the Arapaho" (*Birds and Birdnames,* 10).

Flora Dewey Noobesei

Information for this section was taken from an interview with JoAnn Dewey Birdshead and Frances Dewey by the author at Arapahoe, Wyoming, on April 4, 2004.

94 *women belonging to St. Anne's Sodality:* According to an article titled "Further Mission Achievements" in the *Wind River Rendezvous* (published by St. Stephen's Mission), St. Anne's Sodality was founded at St. Stephen's Mission in 1942. It was active for many years, and the members "sponsored many group activities and often attended Mass in a body, usually wearing a very distinctive, brightly colored shawl." Flora's daughters remember it as a special group of women, mostly elders, who worked well together and stayed together for many years, cooking for feasts and helping with mission activities. The organization gradually faded away, as few younger women joined.

Eugene Ridgely, Sr. Nebesiiwoo Beni'inen

Information for this section was taken from interviews with Eugene Ridgely, Sr., by the author at Ethete, Wyoming, on March 10 and March 12, 2004, except where other sources are noted below.

98 *They bought an old railroad car:* Non-Indian ranchers and farmers in Fremont County in the first half of the twentieth century used old railroad cars for houses. They were considered an improvement over cabins and tents. Eugene's old railroad car home is still standing and is used for storage.

100 *His military record continues to be recognized:* Eugene's military record was clarified by Tom Meier, a historian and friend of Eugene's (personal communication, 2007). Meier has written about extensively about Eugene, including an unpublished manuscript titled "Eugene Ridgely, Sr., a Short Biography" and his efforts to have the Sand Creek Massacre site recognized.

101 *Eugene gave his name:* Information on Eugene's giving of his old name and receiving a new name after his death was taken from an interview with Eugene Ridgely, Jr., by the author at Ethete, Wyoming, on March 8, 2005.

The Arapaho Language Preschool Hinono'eitiino'oowu'

Information in this section was taken from an interview with Steve Greymorning by the author at Ethete, Wyoming, on February 23, 2004, and from notes taken during a workshop taught by Greymorning for language teachers at Wyoming Indian Schools at Ethete on June 14, 2005, except where other sources are noted below.

Epigraph:

Steve Greymorning, "Going Beyond Words: The Arapaho Immersion Experience."

103 *Arapaho language instruction:* Greymorning's article and other information and articles on language loss and revitalization are available at http://jan.ucc.nau.edu/~jar/TIL.html.

104 *Marcus White attended:* Information provided by Marcus White and his family during an interview by the author at Fort Washakie, Wyoming, on March 18, 2004.

104 *"There are plenty of successful methods":* Andrew Cowell, e-mail to author, January 20, 2007.

Jessie Swallow Hicei

Information for this section was taken from an interview with Gloria St. Clair by the author at Ethete, Wyoming, on May 20, 2004.

106 *Out of respect, she never talked to him:* In the traditional Arapaho kinship pattern, mothers-in-law and sons-in-law strictly practiced what anthropologists call "avoidance" relationships. Fathers-in-law and daughters-in-law also followed the avoidance pattern, though less strictly. This avoidance relationship was complicated among Arapaho people because the terms "mother" and "father" were also applied to the mother's sisters and the father's brothers, potentially extending the avoidance pattern on both sides of the family to many individuals. See Fred Eggan, "Cheyenne and Arapaho Kinship," 55–56. Sister M. Inez Hilger indicated that at the time of her research (the 1930s), avoidance patterns were still being followed (*Arapaho Child Life,* 210).

The Butchering Ceniihooot

Information for this section is from interviews with Ardeline Spotted Elk by the author at Estes Park, Colorado, on May 25, 2004, and at Ethete, Wyoming, on November 3, 2004.

The Volleyball Game: Just to Be Having Fun

Information for this section is from an interview with Flora Willow, Cora Willow, and Darren Willow by the author at Ethete, Wyoming, on May 6, 2004, and an interview with Flora and Cora Willow by the author at Ethete on September 24, 2005, except where other sources are noted below.

115 *Powwows are characterized by performance:* Powwows were started at Wind River in the communities of Ethete and Arapaho in the mid-1950s. At that time, powwows were becoming common throughout the West as part of a pan-Indian intertribal movement (Loretta Fowler, *Arapahoe Politics,* 221). Today, a powwow will include a variety of activities including queen contests, honor dances, giveaways, games, and sporting events. Prize money is awarded for different categories, or styles, of dancing, as well as to winners of games and athletic contests At Wind River, powwows replaced older and more exclusively Arapaho community social dances that were held in the summer and at Christmas, which many elders still miss.

115 *Her niece (or daughter in the Arapaho way):* Rubena Felter provided background information in an interview by the author at Ethete, Wyoming, on March 16, 2004. In Arapaho kinship, the sister of a person's mother was also called mother.

The Native American Church Hoho'yoox

Epigraph:

"Certificate of Incorporation of Native American Church of Wyoming for Arapahoes and Other Tribes," April 3, 1967. Given to the author by Abraham Spotted Elk.

120 *introduced to the Northern Arapahos:* The story of William (Bill) Shakespeare bringing knowledge of peyote to Wind River comes from a first-person narrative by John Goggles that appears as an appendix to Molly Peacock Stenburg, "Peyote Culture." It is also the basis for Loretta Fowler, *Arapahoe Politics,* 125; Omer C. Stewart,

Peyote Religion, 189; and Virginia Cole Trenholm, *The Arapahoes, Our People,* 295–97. However, as Trenholm indicates, other people were involved in the spread and acceptance of the ceremony, including John Goggles. A narrative by Paul Moss, Sr., tells of a man named White Horse who also made a journey to receive peyote-related knowledge (see Andrew Cowell and Alonzo Moss, Sr., *Hinono'einoo3itoono,* 165–209). As Cowell and Moss indicate, "Sending young people, especially men, to other tribes to find out about their languages and customs was . . . a traditional Arapaho practice" (*Hinono'einoo3itoono,* 165).

120 *at the urging of anthropologist James Mooney:* "Native American Church of North America: Official History and Statement," p. 1, 1983. Given to the author by Abraham Spotted Elk.

120 *In 1967, the "Native American Church of Wyoming":* Certificate of Incorporation of Native American Church of Wyoming for Arapahoes and Other Tribes, April 3, 1967. Given to the author by Abraham Spotted Elk.

122 *In 1978, the Native American Religious Freedom Act:* "Legislative History and Implementation of American Indian Religious Freedom Act (AIRFA) and Proposed Amendments," National Congress of American Indians, 1992. Given to the author by Abraham Spotted Elk.

122 *In 1994, President Bill Clinton:* The American Indian Religious Freedom Act Amendments of 1994, Public Law 103-344 (H.R. 4230), 103rd Congress, 2nd sess., 103-675, October 6, 1994. See also Robert M. Peregoy, Walter Echo-Hawk, and James Botsford, "Congress Overturns."

122 *"Hiram very rarely refused to assist anyone in need":* Written statement given to the author by Arleigh Armajo, Hiram's son, on March 30, 2006. Additional information is from an interview with Arleigh Armajo by the author at Ethete, Wyoming, on March 21, 2006.

122 *Theresa Hanway White occasionally assisted him:* Interview with Theresa Hanway White by the author at Arapahoe, Wyoming, on October 14, 2004.

Royce Lone Bear Ce'eiino3ei

Information for this section was taken from an interview with Royce Lone Bear by the author at St. Stephen's, Wyoming, on March 30, 2004, except where other sources are noted below.

124 *"pulled out for the LeClair ditch":* Royce is referring to a large irrigation project that takes water from the Wind River and distributes it to non-Indian farmers north of the river; it frequently drains the river. For a description and discussion of the LeClair and other water projects in the Wind River drainage, see Geoffrey O'Gara, *What You See in Clear Water.*

127 *"The artwork has been lost":* From Christina Gould, "Youth Revive Traditional Art," *Lander Journal,* May 28, 2007.

127 *it was still legal to trap golden eagles:* American Indian tribes have used and continue to use eagles and eagle parts (including plumes, feathers, talons, wings, and bones) in ceremonies and for ceremonial regalia. The golden eagle, a year-round resident of the northern and central plains, is especially sacred to the Arapahos. In 1940, the Bald Eagle Protection Act was passed, primarily because populations were declining from the shooting of bald eagles as predators. In 1962, the act was amended to extend the same protection to golden eagles, and in 1972 the act was again amended to include penalties for the unlawful taking of eagles. See Rebecca F. Wisch, "Detailed Description of Bald and Golden Eagle Protection Act," from the Animal Legal and Historical Center of the Michigan State University College of Law, 2002. Available at http://www.animallaw.info/articles/ddusbgepa.htm.

127 *The name of Lone Bear (a translation of:* According to Loretta Fowler, during the administration of H. G. Nickerson (Indian agent at Fort Washakie during the first decade of the twentieth century), "Indian names on the agency rolls were changed from approximate English translations of native terms to more 'civilized'-sounding ones: Lone Bear, for example, became Lon Brown" (*Arapahoe Politics,* 97).

Mary Ann Whiteman Hinooko3onesei

Information for this section was taken from an interview with Valaira Whiteman Cardenas by the author at St. Stephens, Wyoming, on February 3, 2005, with the second epigraph from an interview with Forrest Whiteman by the author at Lander, Wyoming, on February 16, 2005.

Byron Makeshine: To Provide for Others

Information for this section was taken from an interview with Byron Makeshine by the author at Lander, Wyoming, on March 30, 2004, except where other sources are noted below.

132 *traditional attitudes toward overharvesting:* Additional background information about the Tribal Game Code was provided by Dick Baldes (retired U.S. Fish and Wildlife Service manager for the reservation), who helped implement the game code in the 1980s, in a telephone interview by the author on March 30, 2006.

132 *populations have increased by over 200 percent:* See Ty Stockton, "Wildlife of the Reservation," 35.

132 *Most hunters think the hunting is easier:* See Walter Cook, "Officials Praise Wild Game Code," *Wind River News,* January 2005.

Burton Hutchinson, Sr. Neecee Wo'teeneih

Information for this section was taken from an interview with Burton Hutchinson by the author at Ethete, Wyoming, on January 19, 2005, except where other sources are noted below.

Epigraph:
Burton Hutchinson, "Candidate Speaks Out," *Wind River News,* April 9, 1981.

138 *"and grandchildren behind you":* In the Arapaho community, it is commonly said that people wishing to move into positions of leadership should do so when they can see their grandchildren "coming up behind them," or when they reach an age appropriate for political involvement. For a detailed description of appropriate age-based involvement in Arapaho political leadership, its relationship to traditional values, and military service, see Loretta Fowler, *Arapahoe Politics,* 267–71.

Marjorie Shotgun Pizarro Seibe'eih

Information for this section was taken from interviews with Margie Pizarro by the author at Ethete, Wyoming, on March 8, February 15, and November 30, 2004, and February 23, 2006, except where other sources are noted below.

144 *"winos" seeking shelter:* The term "wino" is used by Arapahos to describe people with severe alcohol addiction who often have no home.

146 *Shotgun, or Ceebouu:* Margie's grandfather Old Man Samuel Shotgun was identified by several elders in the Ethete community in 2009 as the man in Edward S. Curtis's 1910 photograph titled "A Smoke." Caroline Goggles remembered that he and other elders would frequently gather at St. Michael's boarding school at Ethete to visit and talk to the children. He always carried a pipe and frequently smoked, and he often gave the children candy. (Interviews with Caroline Goggles by the author at Ethete, Wyoming, on September 9 and September 17, 2009.)

146 *she was given her mother's name:* Many Arapaho names are shortened forms of longer names; Margie's name Seibe'eih, or Red Woman, is probably a shortened form of Hiseibe'eih (Alonzo Moss, Sr., personal communication, 2005).

Flossie Brown: Making Flowers

Information for this section was obtained from an interview with Flossie Brown by the author at Arapahoe, Wyoming, on May 11, 2005, except where other sources are noted below.

151 *According to elders:* Helen Cedartree, interview by the author at Ethete, Wyoming, on March 2, 2006. Other quotations by Helen are from this interview.

153 *At Ethete, flowers were made:* Helen Cedartree, interview by the author at Ethete, Wyoming, on March 2, 2006, and Chief Yellow Calf Memorial Club interview by the author at Ethete on January 23, 1999. Today, Memorial Club members still decorate graves, but they buy the wreaths and flowers at one of the large stores in Riverton or Lander.

The Arapaho Language Hinono'eitiit

Epigraph:
"'The Clock Is Ticking' and Time Is Running Out," Northern Arapaho Council of Elders, November 2004, one-page document circulated on the reservation.

154 *It is a member:* See Ives Goddard, "Algonquian Languages," 74–76.

156 *The Arapaho Alphabet:* This simplified version of Arapaho pronunciation is based on Salzmann's original alphabet and on materials used in Arapaho language classes.

157 *Salzmann's* Dictionary: This English-to-Arapaho dictionary has seen many additions and changes to the original 1983 edition and has been republished by reservation programs. Linguist Lisa Conathan expanded the English-to-Arapaho dictionary, compiled an Arapaho-to-English dictionary, and created an audio dictionary containing words pronounced by fluent Arapaho speakers. Her work is collected in *The Arapaho Language: Documentation and Revitalization,* available online at http://linguistics.berkeley.edu/~arapaho/.

157 *He feels that "the weakness":* Steve Greymorning, workshop at Wyoming Indian Schools, June 14, 2005.

157 *Many Arapaho elders agree:* The idea that some Arapaho elders hold—that writing the Arapaho language will forever change

it—echoes the theory presented by Walter J. Ong in *Orality and Literacy* that literacy (the writing and reading of a language) has the potential to "restructure thought." Although Ong is speaking very broadly about the effects of literacy on the history of thought, it would be interesting to compare his ideas to those of elders who feel that literacy changes their language—not just the sound but something much more fundamental.

157 *The language policy for the Northern Arapaho Tribe:* Arapaho Language and Culture Commission Statement in "Language Policy for the Northern Arapaho Tribe," written by the Arapaho Language and Culture Commission and officially approved by the Northern Arapaho General Council in 1988 (William John C'Hair, personal communication, 2010). Document provided to the author by the Arapaho Language and Culture Commission.

Rosaline Addison Neci'3i'ookuu

Information for this section was taken from interviews conducted by the author with Anthony "Al" Addison at Ethete, Wyoming, on June 22, 2004; Polly Addison Redfield and Mary Addison Arthur at Riverton, Wyoming, on June 15, 2005; and Ava Addison Headly at Lander, Wyoming, on June 15, 2005, except where other sources are noted below.

158 *"Rosaline told them to wrap toilet tissue around their heads":* The story told by Polly Redfield about her mother and the grandchildren in a car during a thunderstorm reflects traditional Arapaho customs. Covering your head with a towel or scarf during a thunderstorm was important because hair was believed to draw electricity. According to a story by Mae Friday (told by Pat Arthur in *Arapaho Stories, Legends, and Recollections*),

When there was a storm, my grandmother Mae Friday would make us cover the mirrors, windows, and take the dog and cat out. They would put us on separate sides of the room, boys on one side and girls on the other side of the room. She had us cover our heads with a towel. They

would even wake us and make us sit up, unless we were sick. Then they would let us lay on our right side.

I think everyone knows this part, where they made you jump up and down when you heard thunder. This was so you could grow up and live a good life and grow tall. (23)

161 *inseparable best friends:* According to Inez Hilger, who did ethnographic fieldwork at Wind River during the 1930s, lifelong friends, called chums, were a traditional Arapaho custom. "Arapaho boys and girls played together until they were about 9 or 10 years old, after which they played apart. It was during the late preadolescent period—sometimes earlier—that each boy found his chum. Girls did likewise. Chums were institutional. Often chums were lifelong friends" (*Arapaho Child Life,* 106).

161 *"As far as I can remember":* Al C'Bearing interview by the author at Ethete, Wyoming, on May 24, 2005.

161 *Her Indian name, Heebetees:* According to Arapaho linguist Alonzo Moss, Sr., "Heebetees" might refer to a large female animal such a horse (personal communication, 2006).

Edna Moss Sooxei

This story of Edna Moss's arranged marriage was slightly edited from an interview with Marie Moss Willow by the author at St. Stephen's, Wyoming, in December 2000; additional information was taken from the same interview.

162 *"arranged the meeting, the marriage":* The details of Edna Moss's arranged marriage and wedding closely follow the details of other arranged marriages described by Sister Inez Hilger in *Arapaho Child Life* and Truman Michelson in "Narrative of an Arapaho Woman," which provides a description of one woman's experience.

Arranged marriages were common among the tribes of the Great Plains, including Arapahos, but exhibited a great deal of variation: from elopement and sweetheart marriages to arranged marriages between people who did not know each other. Arranged marriages proper were a reflection of the bands being separated for much of the year, making courtship more difficult, as well as the need to adhere to traditional kinship. Hilger, who conducted research among Arapaho people in Wyoming and Oklahoma in the 1930s, quoted an informant: "An Arapaho cannot marry a blood relative, and that includes cousins, we call them brothers and sisters, to the nth degree" (195).

Hilger's description of a wedding celebration includes information that closely follows Edna Moss's experience: "A conventional marriage ceremonial of the Arapaho included the following: An exchange of gifts between relatives of the man on one side and those of the girl on the other, the erection of a tipi for the use of the couple, the furnishing of the tipi with household equipment, and a feast attended by the couple and invited relatives at which older men prayed for the couple and addressed words of advice to them" (202).

According to elder Helen Cedartree, marriage traditions changed slowly. In the 1920s and 1930s, it was common for couples to have known each other but to follow the pattern of an arranged marriage such as horse exchange and using male relatives as intermediaries. Some families, however, were still very traditional and arranged marriages between young men and women who did not know each other (interview with Helen Cedartree by the author at Ethete, Wyoming, on August 4, 2004). The last "semi-arranged" marriage known at Wind River, that of Eugene Ridgely, Sr., and Lucille Goggles Ridgely, occurred in the late 1940s (interview with Eugene Ridgely by the author at Ethete, Wyoming, on March 10, 2004).

165 *the per capita check:* This refers to the monthly payment received by each enrolled member of the tribe. The money comes from income-generating activities taking place on reservation land, primarily grazing leases and oil and gas leases.

The Warrior's Horse Race: Back to the People

Information for this section was taken from an interview with Annin and Cathi Soldier Wolf by the author at St. Stephen's, Wyoming, on May 29, 2005, except where other sources are noted below.

166 *Karl Whiteplume was the winner:* Interview with Karl Whiteplume by the author at Arapahoe, Wyoming, on January 21, 2005.

168 *Once, gatherings like this:* Information on the history and background of the warrior's horse race was provided by Mark Soldier Wolf in an interview by the author at St. Stephen's, Wyoming, on March 24, 2004.

Echo Soldier Wolf Hooxeihino' Nono'eici3oot

Information for this section was taken from an interview with Mark Soldier Wolf by the author at St. Stephen's, Wyoming, on March 24, 2004.

Epigraph:
Interviews by the author at St. Stephen's, Wyoming, with Florita Soldier Wolf on March 24, 2005, and with Annin and Cathi Soldier Wolf on May 29, 2005.

The Buffalo Road Heneeceibo'o

175 *The Vivions' ranch stretches:* Background information on the Vivions' participation in Wyoming Indian High School's cultural education program as well as the background of the program was taken from an interview with Jim Stewart and Gloria Goggles by the author at Ethete, Wyoming, on February 23, 2004, and an interview with Jim Stewart by the author at Lander, Wyoming, on February 2, 2005.

175 *According to information provided in 1914:* In *Arapaho Names and Trails,* Oliver Toll recorded the information on Arapaho movements, locations, and happenings in Colorado and southern Wyoming mentioned in this paragraph.

175 *Mark Soldier Wolf provided a slightly different:* Mark's information on the Buffalo Trail was taken from an interview by the author at St. Stephen's, Wyoming, on May 5, 2005.

175 *the Overland Trail:* The purpose and use of the Overland Trail and Fort Halleck in the 1860s is told by John D. McDermott in *Dangerous Duty* (31).

176 *Fort Steele on the Union Pacific:* The purpose of Fort Steele is described by G. B. Dobson on the Wyoming Tales and Trails Web site: http://www.wyomingtalesandtrails.com/lincoln3.html.

Sand Creek: Why They Run

Epigraphs:
Jerome Goggles, letter to the author dated January 11, 2007; Jenna Black, "Sand Creek"; Tom Meier, quoted in an article titled "Why They Run," *Hei'towoot, Newspaper of the Northern Arapaho Nation,* October 2000.

179 *the Sand Creek Massacre Runners:* The organization of runners that participated in the Sand Creek Runs was called the Eagle Staff Runners by their organizers, Leo and Mary Cowboy. Because of their repeated participation in the Sand Creek Runs, they were often referred to as the Sand Creek Massacre Runners.

Sand Creek Noobeiniicii

Epigraphs:
Cleone Thunder and Singing Under Water Moss (Underwood), as told to Hubert Warren, quoted in National Park Service, *Sand Creek Massacre Project,* vol. 1, *Site Location Study,* 170, 164–65; quotation attributed to Colonel John M. Chivington by Lieutenant Joseph A. Cramer, 1864, from Jerome Green and Douglas Scott, *Finding Sand Creek,* 17

181 *The Arapahos call it Noobeiniicii:* Names were provided by Alonzo Moss, Sr. (personal communication, 2006). Sand Creek is in southeastern Colorado and is called Big Sandy on maps.

183 *A complex series of events:* Information on the Sand Creek Massacre comes from National Park Service, *Sand Creek Massacre Project,* vol. 2, *Special Resource Study,* 23–39; and Jerome Green and Douglas Scott, *Finding Sand Creek,* 3–25. Clarifications and corrections were made by historian Tom Meier in a telephone interview by the author on January 12, 2007.

183 *hatred and howitzers:* Four howitzers, as well as ammunition and equipment, were pulled by mules (Jerome Green and Douglas Scott, *Finding Sand Creek,* 16).

183 *more than 150 Indians had been killed:* Many more Indians may have been killed; Tom Meier, telephone interview by the author on January 12, 2007.

184 *In 1998, Senator Ben Nighthorse Campbell: Sand Creek Massacre Project,* vol. 1, *Site Location Study,* 7–8. The text of the Sand Creek Massacre National Historic Site Preservation Act of 1998 (Public Law 243, 105th Cong., 2nd sess.) is available online: http://www.gpo.gov/fdsys/pkg/PLAW-105publ243/pdf/PLAW-105publ243.pdf.

184 *National Historic Site Establishment Act:* Bill McAllister, "Memorial at Sand Creek OK'd," *Denver Post Online,* October 24, 2000. The text of the Sand Creek Massacre National Historic Site Establishment Act (Public Law 465, 106th Cong., 2nd sess.) is available online: http://ftp.resource.org/gpo.gov/laws/106/publ465.106.txt.

184 *In 2005, President Bush:* "Bush Signs Sand Creek Historic Site Bill," *Wind River News,* August 4, 2005. The text of the Sand Creek Massacre National Historic Site Trust Act of 2005 (Public Law 45, 109th Cong., 1st sess.) is available online: http://www.access.gpo.gov/cgi-bin/getdoc.cgi?dbname=109_statutes_at_large&docid=1p119stats-46.

184 *In April 2007, the Sand Creek Massacre National Historic Site:* Walter Cook, "Sand Creek Massacre Site Dedicated Saturday," *Wind River News,* May 3, 2007. For further information about the Sand Creek Massacre National Historic Site, visit the following Web sites: http://www.nps.gov/sand/ and http://www.sandcreeksite.com/.

186 *In 2006, the Wyoming State Legislature:* "Sand Creek Trail Commemorated," *Wind River News,* August 24, 2006.

186 *According to anthropologist Alexa Roberts:* National Park Service, *Sand Creek Massacre Project,* vol. 1, *Site Location Study,* 188–89.

186 *As Josephine White said:* National Park Service, *Sand Creek Massacre Project,* vol. 1, *Site Location Study,* 176.

Leo Cowboy: The Eagle Staff Runners

Information for this section was taken from interviews with Leo and Mary Cowboy by the author at Ethete, Wyoming, on February 12, 2004, and March 28, 2006.

187 *Each staff was made from red willow:* According to linguist Andrew Cowell (personal communication, 2009), the species is *Cornus stolonifera* (red osier dogwood) but is commonly referred to by Indians and non-Indians in the Wind River area as red willow.

189 *to a sweat lodge ceremony:* The traditional American Indian sweat lodge ceremony as conducted by Northern Arapahos on the Wind River Reservation is a time of prayer, blessings, healing, and meditation.

The Arapahoe Ranch Koonootoo'hoene'

Information for this section was taken from an interview with Forrest Whiteman by the author at Lander, Wyoming, on February 16, 2005, except where other sources are noted below.

190 *Padlock and adjacent ranches:* In 1905, the federal government pressured the Eastern Shoshone and Northern Arapaho tribes to relinquish the northern part of the reservation, lands north of the Big Wind River that had not been allotted to individual tribal members, then opened this land to non-Indian homesteading. In 1940, the secretary of the interior returned 1.25 million acres of

this land to the tribes—the land that had not been homesteaded. Shortly before, the Shoshone tribe had been awarded a monetary judgment against the government for the settlement of Arapahos on Shoshone lands, and part of the money was to go toward land purchases. The Northern Arapaho Tribe was pressured into borrowing money from the Eastern Shoshone Tribe to participate in land purchases, and it was at this time that the Padlock Ranch and other homesteaded properties within and adjacent to the northeastern corner of the returned portion were purchased. See Loretta Fowler, *Arapahoe Politics* (196–201) and "Arapahoe Ranch."

By 1947, the loans from the Shoshone tribe had been repaid, and the ranch was showing a profit. At first the ranch was run by the Bureau of Indian Affairs and only non-Indians were hired, but the Northern Arapaho Business Council soon began to exert control, and within a few years the tribe had gained control and implemented Indian-preference employment policies. In 1954, the council transferred oversight to a board of three trustees, selected by the council. See Loretta Fowler, *Arapahoe Politics* (196–201) and "Arapahoe Ranch."

The ranch continues to hire many Arapahos as cowboys, cooks, and foremen. Managers, though selected by the board, have usually been non-Indians. The ranch continues to be profitable, and occasionally profits are divided among enrolled tribal members. Since 2009, a large grass-fed organic beef operation has led to a lot of publicity and many new markets throughout the region.

190 *Today, the Arapahoe:* Earlene Engavo, "David Stoner, Arapaho Ranch Manager," *Hei'towoot Tribal Newsletter,* March 20, 2003. Interview and article by Earlene Engavo, Public Relations Department of the Northern Arapaho Tribe.

192 *Forrest's Indian name, Bad Horses:* Although Forrest does not know the Arapaho word for his Indian name, linguist Alonzo Moss, Sr. (personal communication, 2005), suggests that it might be *heseinooxobei,* a word that refers to wild, scared, or alarmed horses.

Lady Chiefs: Not Shy Anymore

Epigraph:
"As the World Turns," *Wind River Rendezvous,* 6–7.

197 *In 1975, Joe Duran was given:* "As the World Turns," *Wind River Rendezvous,* 6–7.

197 *By the 1920s, it was being played:* "Further Mission Achievements," *Wind River Rendezvous.*

197 *By the 1930s, St. Stephen's:* "High School Years," *Wind River Rendezvous.* St. Stephen's Mission school was a government-funded boarding school for elementary and junior high–age Indian children until the 1940s. It then continued as a parochial school, and in 1954, it opened a high school for Indians and non-Indians that continued into the mid-1960s.

197 *They won fifty straight games:* For an evocative description of the reservation basketball milieu in the mid-1980s, see Geoff O'Gara, *What You See in Clear Water,* 113–27.

197 *an award-winning film,* Chiefs: *Chiefs* (2002) was directed by Daniel Junge and produced by Donna Dewey and Henry Ansbacker. For a detailed review of the film and the controversy that surrounded it, see Sara Wiles, "Indian Basketball: Two Films." Although *Chiefs* is an excellent film in many ways, it became controversial for several reasons: some who appeared in the film thought it an invasion of privacy (though others did not); some thought that it created a false picture of reservation life in several ways, such as an overemphasis on poverty (scenes of abandoned houses) and an emphasis on basketball over all other community activities. Most controversial, however, were scenes of drug use by players. Coach Redman was especially critical of the film, saying that it was not what he had expected and that it reflected badly on the school ("WIHS Teams Subjected to More Than Boos," letter to the editor written by Alfred Redman, *Wind River News,* February 6, 2003). At least one of the players featured in the film made a public apology for scenes of drug use and partying in which he participated.

People were appreciative, however, of scenes showing racist name-calling and taunting.

198 *The Lady Chiefs were slower to win:* Interview with Aleta Moss by the author at Ethete, Wyoming, on March 25, 2004.

198 *she received national attention:* "Faces in the Crowd," *Sports Illustrated,* February 23, 2004, p. 24.

198 *According to Coach Redman:* Alfred Redman, "WIHS Teams Subjected to More Than Boos," letter to the editor, *Wind River News,* February 6, 2003.

Annin Soldier Wolf Hista

Information for this section was taken from an interview with Annin and Cathi Soldier Wolf by the author at St. Stephen's, Wyoming, on May 29, 2005, except where other sources are noted below.

202 *the Wolf Society:* The Northern Arapaho Wolf Society has not previously been recorded in historical or ethnographic literature. According to Mark Soldier Wolf (personal communication, 2010), Annin's father, the Wolf Society is an ancient Arapaho society, composed of both men and women, who used the strategies of wolves in hunting and warfare.

202 *a 1995 video entitled* Wolf Nation: *Wolf Nation* (1995) was produced by the Northern Arapaho Wolf Society and Victoria Costello Productions.

Janie Brown Behniitou'u

Information for this section was taken from interviews with Janie Brown and Danielle Brown by the author at Ethete, Wyoming, on January 28, 2005, and May 2, 2006.

203 *she "bothered" her aunt:* Traditional Arapaho learning patterns foster observation followed by experimentation rather than direct instruction.

204 *four hundred Indians occupied:* For a summary of the American Indian Movement (AIM) takeover of the Bureau of Indian Affairs building in Washington and other incidents in the context of the Indian civil rights struggle, see Charles Wilkinson, *Blood Struggle,* 129–49.

204 *Arapaho designs collected:* Alfred L. Kroeber, *The Arapaho.* The cradleboard Janie made for her grandson resembles the cradleboard seen in Kroeber's book (fig. 14, middle, p. 67).

Danielle Brown Beishe'inoneihit

Information for this section was taken from interviews with Janie Brown and Danielle Brown by the author at Ethete, Wyoming, on January 28, 2005, and May 2, 2006.

206 *they discovered* The Arapaho: Alfred L. Kroeber collected Arapaho designs in the late nineteenth century and published them in what would become the book *The Arapaho.*

206 *"Well, maybe I shouldn't be doing this":* In a world where "everything is done for a reason," these designs were symbols used in specific meaningful ways in both daily and ceremonial life. Because of the importance of these designs and the role of elders in making decisions, Janie needed to ask permission of her grandmother to use them. For a discussion of the significance of symbols in prereservation Arapaho daily, philosophical, and ceremonial life, see Jeffery Anderson, *Four Hills of Life.*

208 *Janie made another:* Janie and her work (this dress in particular) are featured in the documentary *The Photography of Sara Wiles* (2006), produced by Wyoming Public Television.

Martin Luther King Day Walk: Diversity Is Our Strength

Epigraph:
Annette Bell, Interview by the author at Ethete, Wyoming, on May 18, 2006.

212 *"People around here see me walking":* David Valdez, interview by the author at Ethete, Wyoming, on April 19, 2006. All information from and quotations attributed to David are from the same interview.

212 *The "Facing History and Ourselves" class:* Interviews by the author at Ethete, Wyoming, with Colleen Whalen on April 24, 2006, and with Annette Bell on May 18, 2006.

214 *the World Church of the Creator:* The World Church of the Creator (WCOTC) was founded in 1973 to deify and promote white supremacy while denigrating the "mud races." The organization proclaimed itself to be nonviolent, but during the 1990s its members committed many violent acts. See "Riverton Opposes Racist Church," *Billings Gazette,* December 25, 2002. A trademark violation lawsuit was filed in 2000 by an unrelated organization challenging the use of its name. See "Supremacist Group Faces Trademark Infringement Suit," *Rapid City Journal,* December 18, 2002. In November 2002, a U.S. District Court judge in Illinois upheld the injunction against the use of the name, and in December 2002 the WCOTC announced that it was moving its world headquarters to Riverton, Wyoming, and would be run by a local man; this is thought to have been a move intended to avoid obeying the injunction.

Although the Riverton branch consisted of only one or two people, the announcement that WCOTC was moving its world headquarters to Riverton caused an intense reaction in Fremont County. See "Wyoming Community Opposes Racist Group," *Denver Post,* December 24, 2002. In turn, the county's reaction to it received national publicity in December 2002 and January 2003. Colleen Whalen and Annette Bell, teachers of the "Facing History and Ourselves" class, were nominated for a National Education Association Human and Civil Rights Award in 2005.

214 *two students created a logo:* The logo was created by Wyoming Indian High School students Dustin Coulston and Myron Chavez, Jr.

Hand Games Koxuhtiitono

Information for this section was taken from an interview with Flora Willow and Cora Willow by the author at Ethete, Wyoming on September 24, 2005.

217 *hand games,* koxuhtiitono: Varying versions of hand games were common among tribes of the Great Plains and are still played in many Indian communities. Today, tournaments complete with prize money and betting on the side are popular forms of entertainment that draw people from many reservations. The version of the hand game played by the Willows, however, does not involve money; their games reflect a spiritual or ritual aspect of their game that is seen today primarily in the role of what I have called "the blesser."

In *Shared Symbols, Contested Meanings,* Loretta Fowler examines the hand game among the Gros Ventre (closely related to the Arapahos) and Assiniboine tribes of Montana: Gros Ventres received hand-game bundles (a collection of the hand-game sticks and other items) from Arapahos in the late nineteenth century, and hand games were associated with both the Ghost Dance religion (a pan-Indian religious revitalization movement of the late nineteenth and early twentieth centuries) and other rituals (58–59). She also notes that the importance of the game and the bundle associated with it continued into the late twentieth century, becoming part of the cultural revitalization movement at Fort Belknap (188).

At Wind River, the hand game did not assume the same degree of ritual importance, although in *The Arapaho,* Albert Kroeber mentions that old games were revived during the time of the Ghost Dance and assumed a religious significance (319). James Mooney, in *Ghost Dance Religion,* provides a detailed description of a version of the hand game played by Arapaho women (which he calls the button game) and discusses it within the context of the

Ghost Dance (pp. 1008–1009). In *Arapahoe Politics,* Loretta Fowler quotes a description of a hand game held at Wind River in 1936. Though this game was described mostly as a fun time, joking references were made to prayer beads and the winner "proudly acclaimed his power to the four winds" (217).

218 *Richard Willow, Cora's brother:* Interview with Richard Willow by the author at Ethete, Wyoming, on October 3, 2005.

The Circle Heetko'einoo'

Epigraph:
Oliver Toll, *Arapaho Names and Trails.*

221 *In the summer of 1914, three Arapahos:* Oliver Toll, *Arapaho Names and Trails.*

221 *Sherman Sage:* A biography of Sherman Sage, titled *One Hundred Years of Old Man Sage,* by Jeffery Anderson, provides much more information about the life of this remarkable man.

223 *is called Heetko'einoo' (The Circle):* Linguists Alonzo Moss, Sr., and Andrew Cowell retranscribed Toll's renditions of Arapaho names in *Arapaho Place Names;* I have used their transcriptions here. Cowell and Moss provide in-depth grammatical analysis of the place-names and suggest that explanations for the names given to Toll were either incomplete or possibly even invented, to avoid the lengthy explanations needed to convey the full meaning of the names. Despite this, the names are not random but "clearly show a tendency to engage very regularly with the symbolic components of Arapaho culture" (*Arapaho Place Names,* 378).

223 *Tei'yoonbo'o is still marked:* Additional information about locations in and the archaeology of Rocky Mountain National Park was provided by interpretive ranger and Native American liaison Tom Collingwood during the tour and workshop held in August 2005. The data collected at that time are available on a set of two CDs sold by the University of Colorado's Center for the Study of Indigenous Languages of the West through their Web site: http://www.colorado.edu/csilw/outreach.htm.

That's the Way It Is Nohuusoho'

Epigraph:
Elizabeth Lone Bear, interview by the author at Arapahoe, Wyoming, on September 23, 2005.

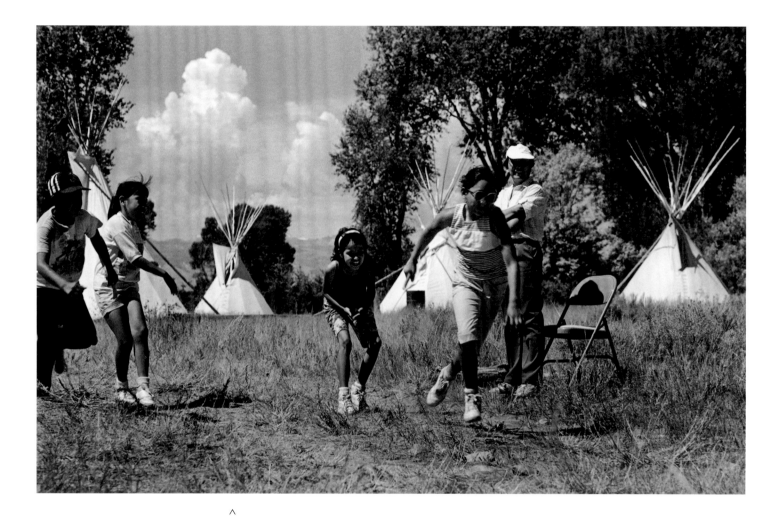

∧

LaDawn Smith won a footrace during the 1989 Arapaho
Language and Culture Camp. Other runners included her
brother Tyson *(far left)*. Nolita Wallowing Bull is cheering her
on, and camp counselor Darlene Whiting Conrad is watching.

Bibliography

Printed Materials

American Indian Religious Freedom Act Amendments of 1994. Public Law 344, 103rd Cong., 2nd sess. (October 6, 1994).

Anderson, Jeffery D. *The Four Hills of Life: Northern Arapaho Knowledge and Life Movement.* Lincoln: University of Nebraska Press, 2001.

———. *One Hundred Years of Old Man Sage.* Lincoln: University of Nebraska Press, 2003.

Black, Jenna. "Sand Creek: What It Means to Me." In *Woxuu Niibei: The Bear Singer Chapbook, 2002–2003,* 8. Ethete: Wyoming Indian High School, 2003.

Calling Thunder, Debra. "Beautiful Traditions." In *Wind River Cache: A Cultural Journal of West Central Wyoming.* Lander, Wyo.: Fremont County School District Number One, 1982.

Center for the Study of Indigenous Languages of the West. *The Arapaho Project.* http://www.colorado.edu/csilw/newarapproj2.htm.

Conathan, Lisa. *The Arapaho Language: Documentation and Revitalization.* Berkeley: University of California Department of Linguistics, 2006. http://linguistics.berkeley.edu/~arapaho/.

Cowell, Andrew, and Alonzo Moss, Sr. "Arapaho Place Names in Colorado: Form, Function, Language and Culture." *Anthropological Linguistics* 45 (2003): 349–89.

———. *Birds and Birdnames in Arapaho Life and Language.* Boulder: Center for the Study of Indigenous Languages, Department of Linguistics, University of Colorado, 2004.

———. *Hinono'einoo3itoono: Arapaho Historical Traditions, Told by Paul Moss.* Winnipeg: University of Manitoba Press, 2005.

Curtis, Edward S. *The North American Indian,* vol. 6. Seattle: E. S. Curtis, 1911. Available online at http://memory.loc.gov/award/iencurt/ct06/ct06toc.html.

Dobson, G. B. *Wyoming Tales and Trails, Featuring Photographs and History of Old Wyoming.* http://www.wyomingtalesandtrails.com/.

Eggan, Fred. "The Cheyenne and Arapaho Kinship System." In *Social Anthropology of North American Tribes,* edited by Fred Eggan, 33–95. Chicago: University of Chicago Press, 1937.

Eisenhauer, David. "Quiet Wind's Resurrection." *UWyo* 3 (2002): 18–23.

Fleming, Paula Richardson. *Native American Photographs at the Smithsonian: The Shindler Collection.* Washington and London: Smithsonian Books, 2003.

Flynn, Janet. *Tribal Government, Wind River Reservation.* Lander, Wyo.: Mortimore Publishing, 1998.

Fowler, Loretta. *The Arapaho.* New York: Chelsea House Publishers, 1988.

———. "Arapaho." In *Handbook of North American Indians,* vol. 13, *Plains,* edited by Raymond J. DeMallie, 840–62. Washington, D.C.: Smithsonian Institution Press, 2001.

———. *Arapahoe Politics, 1851–1978: Symbols in Crises of Authority.* Lincoln: University of Nebraska Press, 1982.

———. "The Arapahoe Ranch: An Experiment in Culture Change and Economic Development." *Economic Development and Culture Change* 21 (1973): 446–64.

———. *Shared Symbols, Contested Meanings: Gros Ventre Culture and History, 1778–1984.* Ithaca, N.Y.: Cornell University Press, 1987.

Friday, May, as told by Pat Arthur. "Short Story." In *Arapaho Stories, Legends, and Recollections.* Ethete: Wyoming Indian High School, n.d.

Gaede, Marc. *Bordertowns.* La Canada, Calif.: Chaco Press, 1988.

Gidley, Mick. *Edward S. Curtis and the North American Indian, Incorporated.* New York: Cambridge University Press, 1998.

Goddard, Ives. "The Algonquian Languages of the Plains." In *Handbook of North American Indians,* vol. 13, *Plains,* edited by Raymond J. DeMallie, 71–79. Washington, D.C.: Smithsonian Institution Press, 2001.

Green, Jerome A., and Douglas D. Scott. *Finding Sand Creek: History, Archaeology, and the 1864 Massacre Site.* Norman: University of Oklahoma Press, 2004.

Greymorning, Steven. "Going Beyond Words: The Arapaho Immersion Experience." In *Teaching Indigenous Languages,* edited by Jon Reyhner, 22–30. Flagstaff: Northern Arizona University, 1997.

Hilger, M. Inez. *Arapaho Child Life and Its Cultural Background.* Bureau of American Ethnology Bulletin 148. Washington, D.C.: Smithsonian Institution, Government Printing Office, 1952.

Hunter [Wiles], Sara. "Northern Arapahoe Grandparents: Traditional Concepts and Contemporary Socio-economics." M.A. thesis in anthropology, Indiana University, 1977.

Kroeber, Alfred L. *The Arapaho.* Lincoln: University of Nebraska Press, 1983. Reprint of Bulletin of the American Museum of Natural History, 1902, 1904, 1907.

McDermott, John D. *Dangerous Duty: A History of Frontier Forts in Fremont County, Wyoming.* Lander, Wyo.: Fremont County Historic Preservation Commission, 1993.

Michelson, Truman. "Narrative of an Arapaho Woman." *American Anthropologist,* n.s., 35 (1933): 55–610.

Mooney, James. *The Ghost Dance Religion and the Sioux Outbreak of 1890.* Lincoln: University of Nebraska Press, 1991. Reprint of *14th Annual Report of the Bureau of American Ethnology,* 1896.

Moss, Alonzo, Sr., and Andrew Cowell. *Arapaho Place Names.* Boulder: Center for the Study of Indigenous Languages of the West, Department of Linguistics, University of Colorado, 2004.

National Park Service. *Sand Creek Massacre Project,* vol. 1, *Site Location Study,* and vol. 2, *Special Resource Study and Environmental Assessment.* Denver: National Park Service, 2000.

Nickerson, H. G. "Early History of Fremont County." *Quarterly Bulletin of the State of Wyoming Historical Department* 2, no. 1 (1924): 1–13.

O'Gara, Geoffrey. *What You See in Clear Water: Life on the Wind River Reservation.* New York: Alfred A. Knopf, 2000.

Ong, Walter J. *Orality and Literacy.* New York: Routledge, 1988.

Peregoy, Robert M., Walter R. Echo-Hawk, and James Botsford. "Congress Overturns Supreme Court's Peyote Ruling." *Native American Rights Fund Legal Review* (Winter/Spring 1995): 1, 6–8.

Salzmann, Zdenek. *Dictionary of Contemporary Arapaho Usage.* Arapaho Language and Culture Instructional Materials Series 4. Wind River Reservation, 1983.

Sand Creek Massacre National Historic Site Establishment Act of 2000. Public Law 465, 10th Cong., 2nd sess. (November 7, 2000).

Sand Creek Massacre National Historic Site Preservation Act of 1998. Public Law 243, 105th Cong., 2nd sess. (October 6, 1998).

Sand Creek Massacre National Historic Site Trust Act of 2005. Public Law 45, 109th Cong., 1st sess. (August 2, 2005).

Stenburg, Molly Peacock. "The Peyote Culture among Wyoming Indians—A Transitional Link between an Indigenous Culture and an Imposed Culture." *University of Wyoming Publications* 12, no. 4 (1946): 85–156.

Stewart, Omer C. *Peyote Religion: A History.* Norman: University of Oklahoma Press, 1987.

Stockton, Ty. "Wildlife of the Reservation." *Wyoming Wildlife* 60, no. 3 (2006): 32–39.

Thunder, Debbie. "Beautiful Traditions." *Wind River Cache* 1, no. 2 (1982): 45–48. Lander, Wyo.: Fremont County School District 1.

Toll, Oliver W. *Arapaho Names and Trails: A Report of a 1914 Pack Trip.* Colorado: Rocky Mountain Nature Association, 1962, 2003.

Trenholm, Virginia Cole. *The Arapahoes, Our People.* Norman: University of Oklahoma Press, 1970.

Vander, Judith. *Songprints: The Musical Experience of Five Shoshone Women.* Urbana: University of Illinois Press, 1988.

Wiles, Sara. "Indian Basketball: Two Films." *Visual Anthropology Review* 18, no. 1–2 (2002): 102–109.

———. "Northern Arapahoe Grandparents." See Hunter, Sara [Wiles].

Wilkinson, Charles. *Blood Struggle: The Rise of Modern Indian Nations.* New York: W. W. Norton, 2005.

Wind River Rendezvous. "As the World Turns." January/February 1975.

———. "Further Mission Achievements." July/August/September 1984.

———. "High School Years." July/August/September 1984.

Videos

Chiefs. 87 min. Directed by Daniel Junge, produced by Donna Dewey and Henry Ansbacker. Distributed by Active Parenting USA, 2002.

Photography of Sara Wiles, The. 26 min. Directed by Geoffrey O'Gara. Produced by Wyoming Public Television for *Main Street, Wyoming.* Riverton: Wyoming Public Television, 2006.

Telling Stories: Arapaho Narrative Traditions. 30 min. Produced by Dr. Andrew Cowell and members of the Northern Arapaho Tribe. Laramie: Wyoming Council for the Humanities, 2001.

Wolf Nation. 30 min. Produced by the Northern Arapaho Wolf Society and Victoria Costello Productions. Mystic Fire Video, 1995.

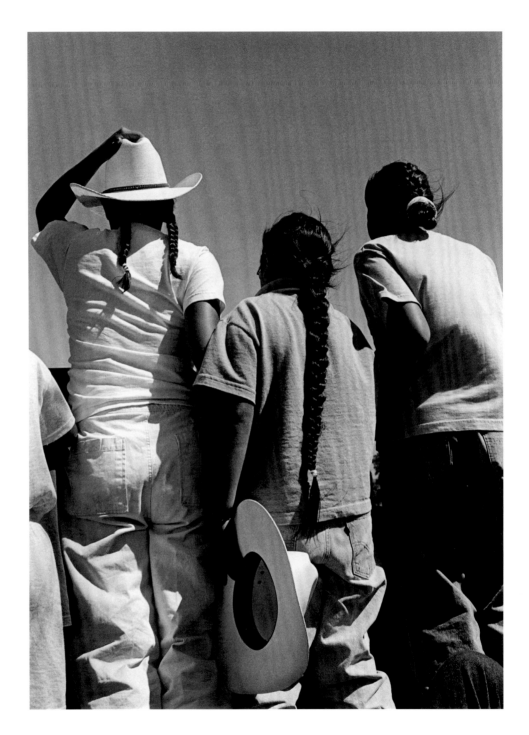

>

**Stormy Friday, Nikkita Shakespeare,
and Buffalo Soldier Wolf, 1999.**

Index